ABOUT THE AUTHOR

David Plummer is a passionate, experienced and respected wildlife expert and professional photographer. His images are featured in leading publications and he is a regular guest on TV and radio. David advises internationally on eco-tourism and is a proactive conservationist.

Wildlife and photography have always been David's two great loves. He is a wildlife photographer who only takes pictures of wild animals in their natural habitat. His extensive knowledge of the animals and birds and their environment is the first essential ingredient behind his breathtaking images. The second vital element is research: David studies relentlessly to get under the skin of a new subject before heading into the field. The third is endless patience: David regularly waits for hours, often in the most inhospitable environments, to get the perfect shot.

'Taking the perfect image is a great quest. The buzz that I get when I achieve it is the culmination of a lot of hard work and problem-solving to get inside the fear circle of that animal: there is nothing serendipitous about the perfect wildlife photo. And everything in the image is important to me: the animal, the perch, the background, the lighting. But it's never over: we can always get different shots, different behaviours.'

In 2016, when he was featured in a BBC film made for *The One Show*, David spoke publicly for the first time about living with Parkinson's disease. His unrelentingly positive attitude, combined with more than a touch of belligerence, has helped David prove that life with Parkinson's does not only go on but can be lived magnificently. It is widely regarded that David has achieved his best work since his diagnosis seven years ago, and he hopes that by showcasing these photographs he can inspire others to believe that Parkinson's does not have to mean the end of a life worth living. David is donating 50 per cent of his profits from this book to Parkinson's UK charity.

DEAR READER

The book you are holding came about in a rather different way to most others. It was funded directly by readers through a new website: Unbound. Unbound is the creation of three writers. We started the company because we believed there had to be a better deal for both writers and readers. On the Unbound website, authors share the ideas for the books they want to write directly with readers. If enough of you support the book by pledging for it in advance, we produce a beautifully bound special subscribers' edition and distribute a regular edition and e-book wherever books are sold, in shops and online.

This new way of publishing is actually a very old idea (Samuel Johnson funded his dictionary this way). We're just using the internet to build each writer a network of patrons. At the back of this book, you'll find the names of all the people who made it happen.

Publishing in this way means readers are no longer just passive consumers of the books they buy, and authors are free to write the books they really want. They get a much fairer return too – half the profits their books generate, rather than a tiny percentage of the cover price.

If you're not yet a subscriber, we hope that you'll want to join our publishing revolution and have your name listed in one of our books in the future. To get you started, here is a £5 discount on your first pledge. Just visit unbound.com, make your pledge and type **7years** in the promo code box when you check out.

Thank you for your support,

Dan, Justin and John
Founders, Unbound

7 YEARS OF CAMERA SHAKE

ONE MAN'S PASSION FOR PHOTOGRAPHING WILDLIFE

DAVID PLUMMER

Unbound

Unbound

This edition first published in 2017

Unbound
6th Floor Mutual House, 70 Conduit Street, London W1S 2GF
www.unbound.com

Photographs pp. 1, 110 © Viv Nicholas, 2017
Photograph p.188 © Jenny Foster, 2017
Photographs pp.242–47 © Ricardo Casarin, 2017
Photograph p.249 © Jimmy Tinka, 2017
All other photographs © David Plummer, 2017

Page design by Essential Works

A CIP record for this book is available from the British Library

ISBN 978-1-78352-393-1 (trade hbk)
ISBN 978-1-78352-394-8 (ebook)
ISBN 978-1-78352-392-4 (limited edition)

Printed in Italy by L.E.G.O. S.p.A.

To all my friends and family, who know I've
always been a bit bonkers but still had faith
that something might turn out right.

CONTENTS

FOREWORD

I first met David whilst presenting a piece for BBC's *The One Show*. I had been told by the series producer that I was going to meet a photographer who had built a floating hide and was getting incredibly intimate shots of water birds called Little Grebes on their nest.

Little Grebes can be notoriously difficult to get images of. Not only, as their name suggests, are they pretty small so you need to get close to them, but they're also very shy and have a habit of popping down under the water and disappearing whenever you get close.

It sounded a challenging and fun job.

I was going to go out with David, who had built me my own floating hide, and together we would set sail onto a lake in Surrey to find these elusive birds. A mini camouflaged armada, but with cameras not cannons, ready to fire shots if we could find the birds in question.

I had read about floating hides many years ago and seen some results by other talented photographers. The water level perspective gives you eye to eye contact with your subject and the results are very intimate, quite stunning and unlike anything you can get from a hide based on the side of a lake or river bank. These hides really are the best way to photograph water birds.

Despite knowing this, I had never built a floating hide myself; not only am I terrible when it comes to practical things involving drills and saws and the like, but I guess to be honest, I'm a bit lazy too. When it comes down to it, DIY is not for me and that has got in the way of me achieving many images I would've liked. I am certainly not a great example to follow when it comes to wildlife photography in this respect.

So this was a golden opportunity to use one of these hides for the first time and I couldn't wait.

When I met David on the day of the shoot I got a big smile and a firm handshake. We quickly got into the business of the day discussing how to best maneuver the hide into the water and how to approach the birds, and David gave me a few camera tips about photographing whilst floating about.

I was very taken with how well David knew what he was up to and how determined he was to make this work. It's one thing photographing wildlife on your own, but when you've got a TV presenter and accompanying camera crew in tow, you just made everything ten times more complicated for yourself.

But for David, none of this seemed to matter and true to his word, I got the best shots of Little Grebes on their nest that I could possibly imagine and *The One Show* got a lovely film too.

I'm sure some of David's Little Grebe photos will appear somewhere in this book, they should!

After we met I went on to look at more of David's work and found it all to be bold, direct and clear. Shining a characterful light on some of our best loved animal species.

If you know anything of wildlife photography you know, when looking at the images in this book, that these are photographs that have been thought about in great detail. Good ideas, well planned and then well executed. Just as my day with the Little Grebes had been.

And it's this kind of preparation that makes the difference between those that can photograph wildlife well, and those who cannot. David is most certainly a man that can!

With this in mind then, I'm tempted not to even bother mentioning the second time I met David. It was to make a film about the fact that David has Parkinson's Disease.

But mention it I have. Why? Well, it's important that Parkinson's has nothing to do with how we look at David's work, it speaks for itself. But I feel the disease has everything to do with how we should look at David's approach to life.

Where so many others have failed he's succeeded. He has turned his passion into a career and has done so whilst living a life that could have overwhelmed and sunk him before he had even begun to get close to his ambition.

Instead he found inspiration in the natural word and turned his energies into capturing it with his camera. He focused his mind on celebrating life, when he could be dwelling on darker things.

So the disease says nothing about his photographs, but his photographs say a lot about the disease and, how a life with it, can still be so well lived.

This book bursts with the determination, clarity and sense of purpose that belongs to an exceptional man and a talented photographer. It will sit very proudly on my bookshelf and be enjoyed time and time again, spurring me on to achieve the very best I can in every aspect of my life. I am sure it will do the same for you.

Richard Taylor-Jones
Naturalist, Presenter, Photographer

INTRODUCTION

Wildlife has always been my passion. My first memory is of playing with woodlice when I was about three years old. From then on most of my time was spent staring into ponds or rearing butterflies; pretty much anything but concentrating on schoolwork. I remember a key moment when my father built a bird table for the garden; I lined up a tiny, cheap telescope on a small tripod (which I still use to hold flashes or GoPros), and sat for hours watching a piece of stale bread. Eventually a female sparrow landed on the bird table and pecked at the bread. For the whole three seconds that she was there, I watched through the telescope and from then on I was hooked.

My first camera was a used Prinzflex, I think made by Dixons, or a Japanese model labelled by Dixons, bought with pocket money from a family friend. It was my first SLR camera and the longest lens was 135 mm. I still have this camera and the lens, although I don't use them. In fact, I think I've kept virtually every piece of kit that I've acquired, which both my garage and office are proof of.

Wildlife photography was expensive then as long lenses were hard to come by. As a child, I had no resources to buy this kit and so photography was beyond reach until my early twenties.

However, the wildlife was always there. My passion for the natural world around me grew. I was brought up in a suburban area but within cycling distance of the wild and bird-rich North Kent Marshes. I would occasionally, perhaps more than occasionally, bunk off school, cycling right past the gates and continuing down to the marshes. Beyond the dumped shopping trolleys poking out of the mud was a different world – flocks of overwintering waders shifting with the ebb and flow of the tides, their calls evocative and poignant. I make no apologies, but the double

lesson in religious education couldn't compete, especially when a short-eared owl first glided past me.

From birds I moved on to insects and small mammals. I would build breeding cages to rear butterflies and use red light bulbs to watch wood mice at night in the numerous vivaria in my bedroom. I realised Mum had a point about keeping my bedroom tidier when one day I moved a pile of Airfix boxes and was surprised to find a common frog underneath!

This passion has never waned; I still have vivaria in the house, rear butterflies, and find the occasional surprising visitor.

In the early 1990s, after working overseas for a few years, I joined a friend who was buying photographic equipment in a sale on Tottenham Court Road. On a whim, I bought a 70–300 mm used zoom lens for an Olympus OM10 camera body for about £20. At £20, not that great a whim.

However, that was the start of my real learning process and burgeoning passion. I started photographing flowers and butterflies; things that were readily available. The flowers also had the advantage of not being able to fly away from me, which is always a bonus when you're starting out. It was still the days of film, obviously, and I became addicted to the beautiful rendition of Fuji Velvia transparency film; I don't think the blues of bluebells have ever been captured so beautifully. But I was still on a tight budget, which I think was a very good thing in hindsight. I worked out that each image cost me about 30p, in film and processing – you rapidly become a master of exposure! It also taught me fieldcraft; how to get really close to wildlife, how to set up hides, how to make the most of a lens without just pulling longer lenses out of my bag. Every subsequent addition to my kit was carefully considered and fully appreciated

once acquired. I look back on those days now with great affection, remembering wet knees from the damp bluebell woodlands of Kent and Sussex. I was hungry for this art and I devoured any piece of information about it.

I was recently asked when my big break came, and my response was, 'I don't know – I'm still waiting for it!' As a wildlife photographer, turning professional is not an overnight thing; it's a slow and gradual chipping away at the industry. I had to do years of part-time work to finance equipment and trips overseas. Now I look back happy that I struggled and persisted, and continue to do so now. Wildlife photography is a never-ending process of learning and enhancing your existing knowledge. Learning obsessively about the species you are dealing with, as well as tackling the problems to achieve the images. It's a relentless process and I love it.

As a genre of photography, wildlife is arguably the hardest, most demanding, and possibly the most poorly paid. Yet the exponents of wildlife photography are fuelled by passion. It's what gets them out of bed at a stupid hour, to sit in the unbearable heat of hides for days at a time. Wildlife photographers are certainly not in it for the money.

The resulting image itself is an example of impressionism: the photographer is attempting to make the audience feel something, to compose an image that provokes a change in the viewer. With this aim in mind, I strive to add art and impact to my wildlife images; I do not merely wish to document nature.

Beyond the art, solving problems is ultimately what wildlife photography is all about. I feel that it is 15 per cent photography and 85 per cent everything else. The 15 per cent photography is grasped fairly easily,

given time and dedication, and certainly practice. The 85 per cent of everything else incorporates knowledge of the subject, fieldwork, logistics and experience, as well as that essential ingredient of wildlife photography: pure dogged persistence!

Now photographic equipment has moved on exponentially; it has never been so cheap or so available, and as such it has never been so popular. This level of accessibility does not detract from the subject in any way at all. The game has risen, and better and better images are being produced year after year. Not only are we much better able to capture high-speed events, but the overall image quality has gone skyward.

I guess this book was overdue; I wanted to put together a collection of striking, stand-alone images and, as such, there is no overall theme. The images have been primarily chosen for impact: they will sometimes please, sometimes challenge, and maybe shock the viewer. In essence – and this may help with some of the more challenging images – this book is merely a snapshot or glimpse of nature. Nature is brutal. It does not care. It is simply a process whereby all species wish to survive. It is not a 'thing' that can be labelled cruel – just an indifferent process.

I would also like to add in this introduction that I only ever photograph wild animals; I have an issue with big animals in cages and I do not photograph caged animals. I am a wildlife photographer, not a photographer of animals. Every image in this book is of a wild animal. Interspersed with the images are a few words on certain areas of my photography and some accompanying shots of the work that achieving them entailed. I hope you find it entertaining.

Thank you.

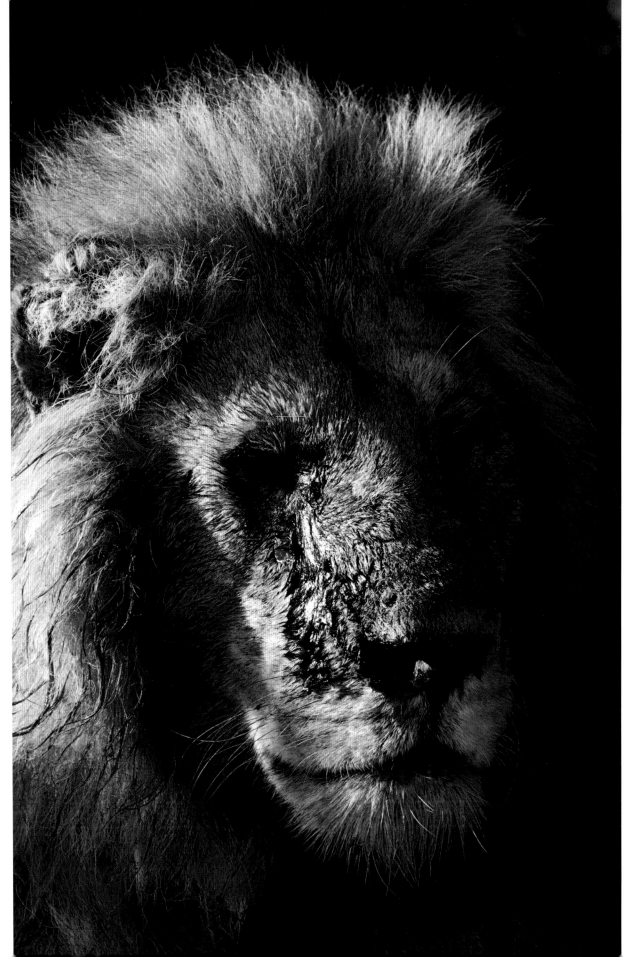

(left) **A victorious male lion after a fight with another male lion in a struggle for dominance**
Maasai Mara, Kenya

(right) **Cheetah and cub**
Maasai Mara

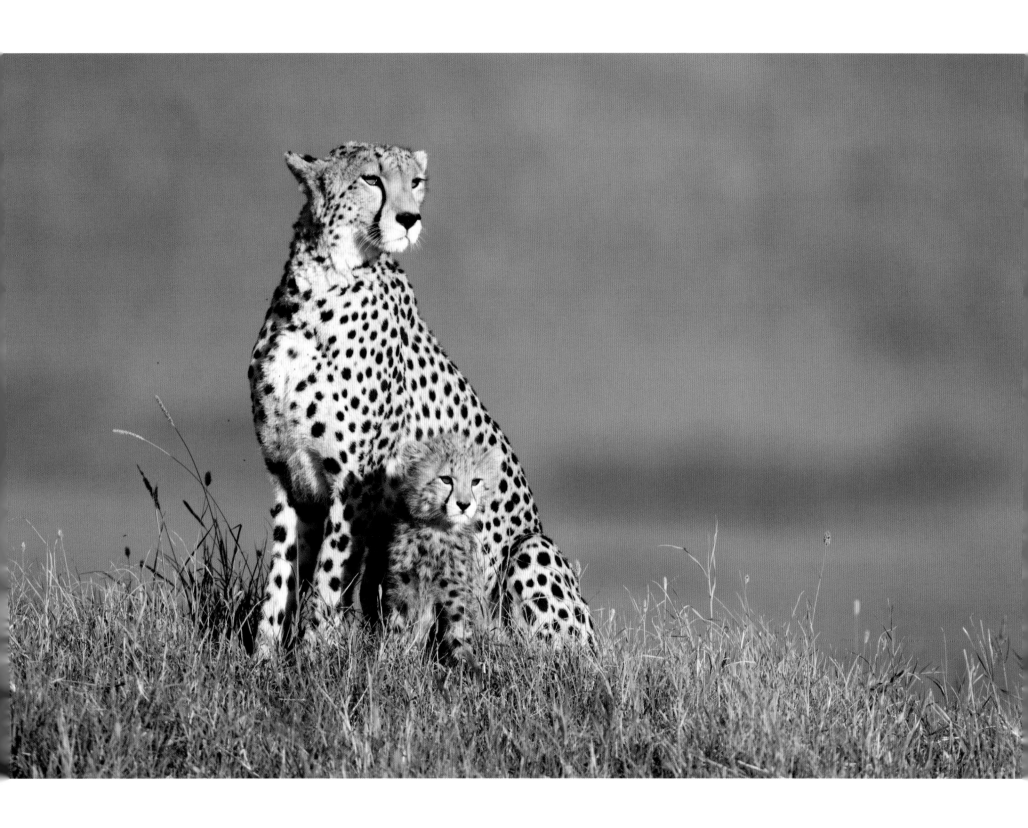

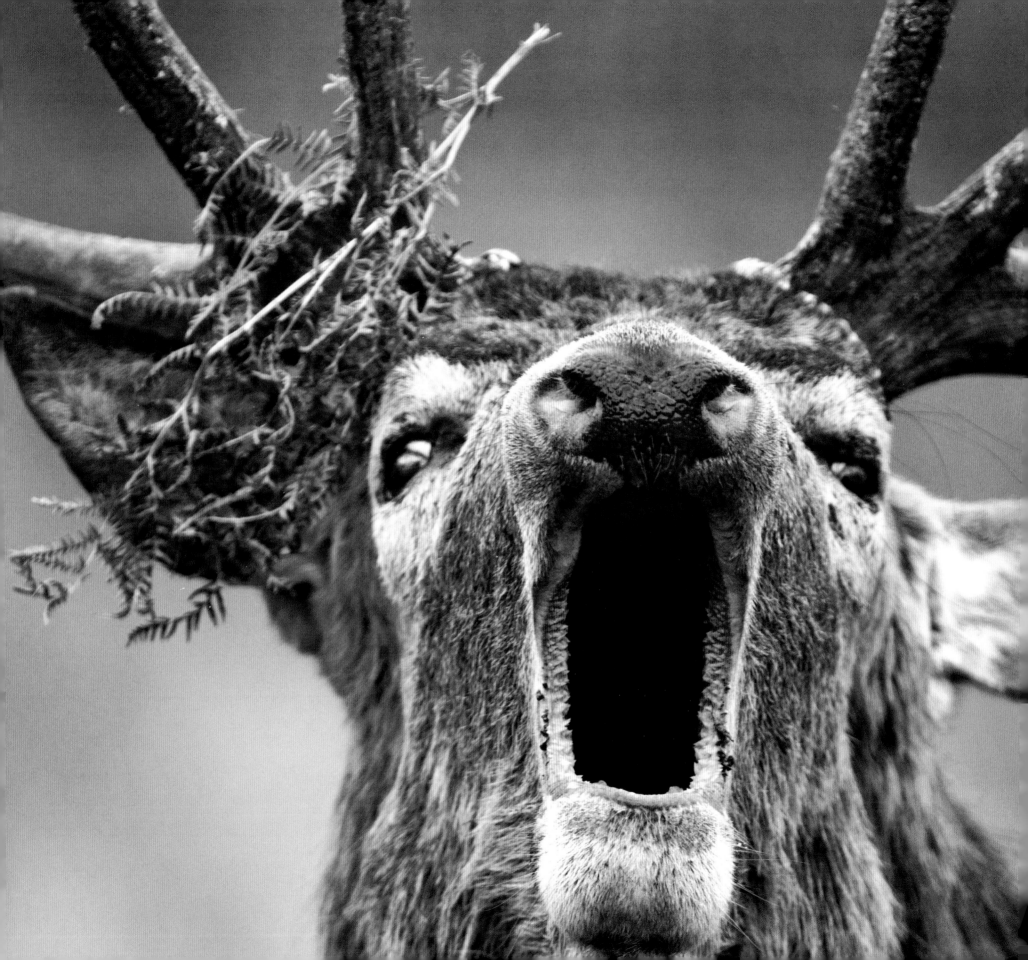

Red deer stag roaring during the October rut
Sussex, UK

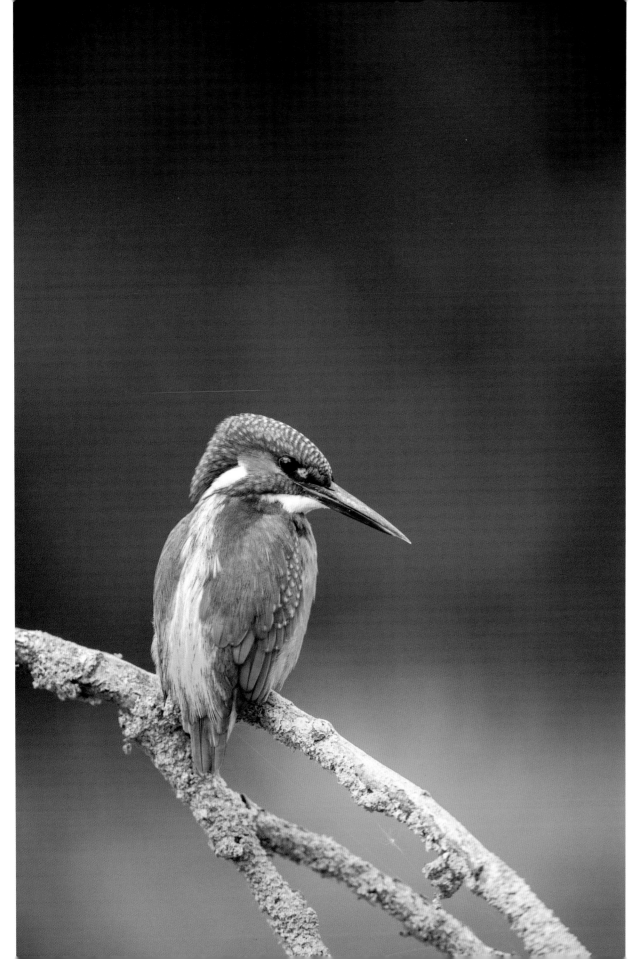

Common kingfisher
Sussex

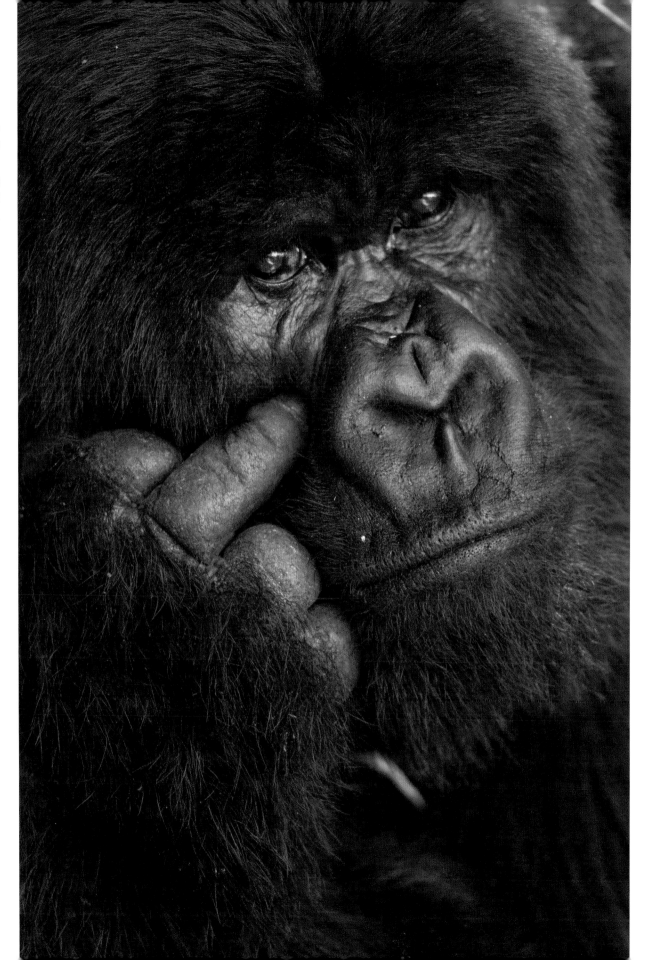

Mountain gorilla
Rwanda

Possibly what mountain gorillas think of human efforts at conservation and tackling climate change.

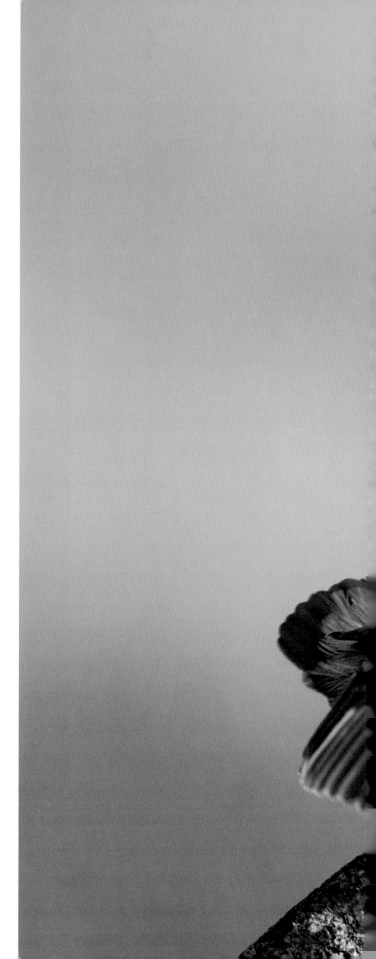

Common kingfishers fighting
Kiskunság National Park, Hungary

SEVEN YEARS OF CAMERA SHAKE

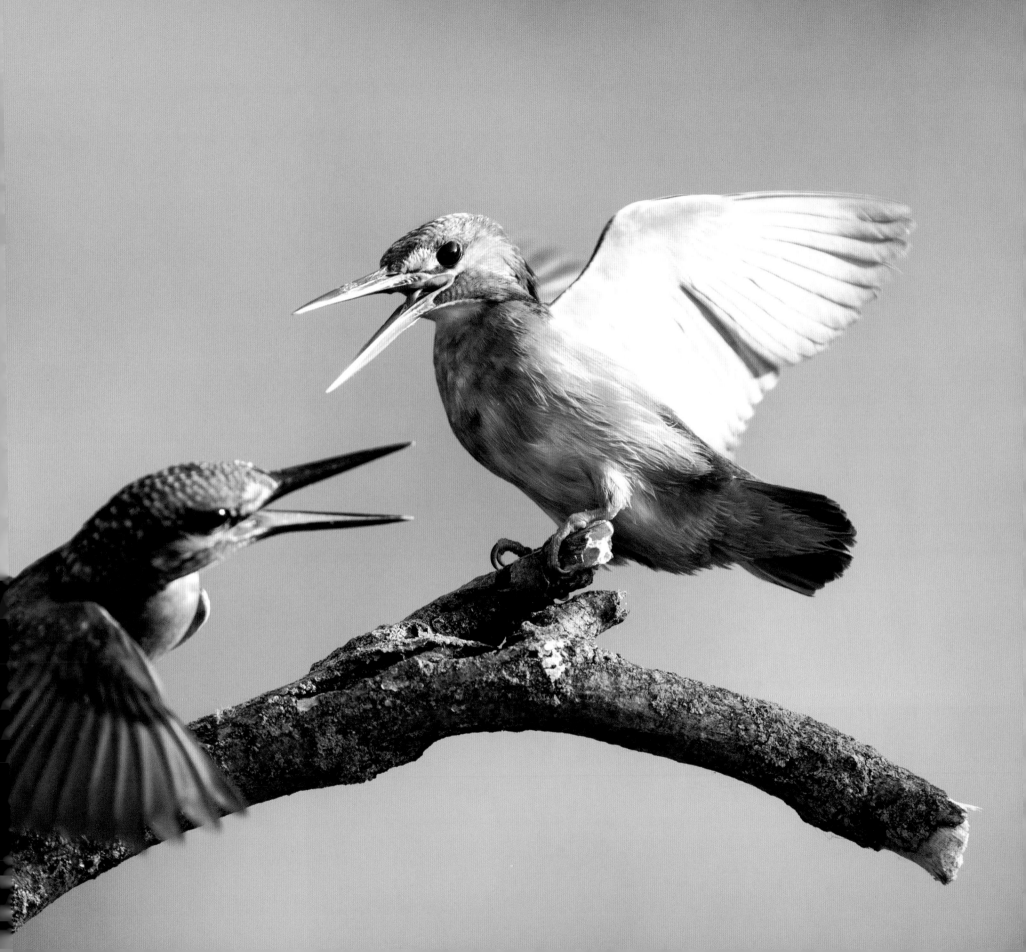

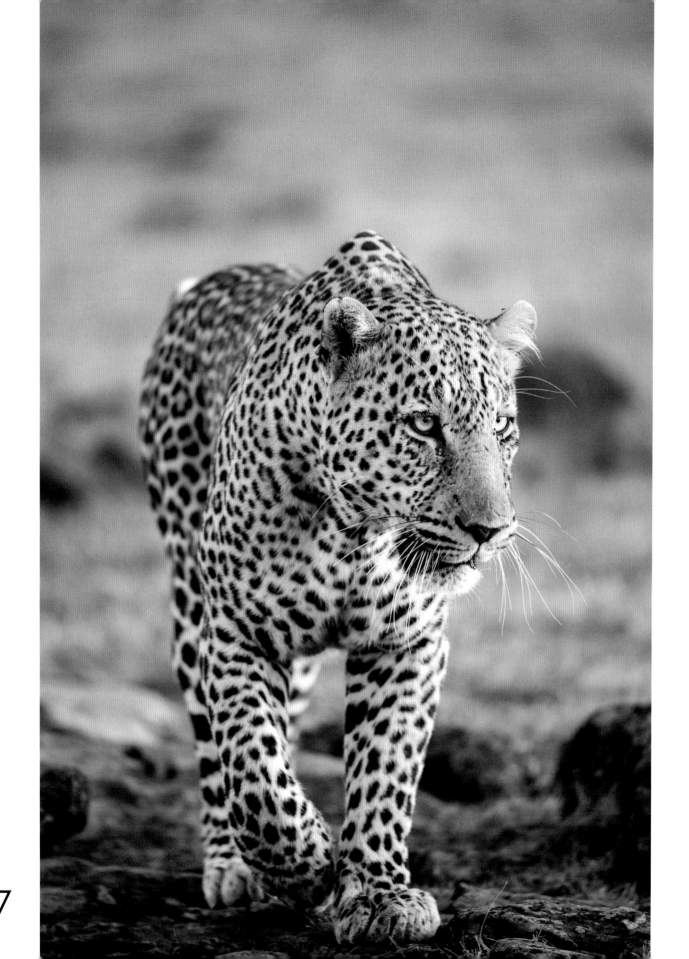

Male leopard

Maasai Mara

Leopards can be frustrating, remaining in vegetation or high up in trees.
However, they often take a walk at the end of the day and this is sometimes a
great opportunity to get clear shots. This leopard, known as Hugo, probably
walked for a mile or more as the day ended. Although the image looks calm,
the process of getting it involved driving in repeated arcs across very rough
terrain to stay ahead of the leopard; he was relaxed as he strolled, and we
bumped down potholes and through scrub to grab a quick burst of shots
as he came into a window of vegetation. He would pass by our vehicle, coming
within a metre of it, and we would arc round again and repeat the process.

OBSESSION

All art is a form of communication. As a child I obviously felt the need to communicate what I was seeing in the natural world, but, I realised early that I was pretty rubbish at drawing. My obsession with animals and the countryside was not being successfully communicated through drawing and painting, which were the only media available to working-class kids in the 70s. Carrying the weight of my equipment around today, I certainly wish I had been better at drawing!

When I took up photography initially, it didn't mean that much to me. I found it difficult to find inspiration – there seemed to be little art in wildlife photography. An image of a bird was invariably a black-and-white shot of a bird bringing food to a nest. I think it was only in the 80s and 90s that the art started coming into this genre with exponents like Stephen Dalton – I still pick up some of his books for reference. From my mid-twenties onwards, I think my mind was mature enough to understand what I was dealing with, and it was this mix of the artistic and the technical that really grabbed me.

In the early years, I was not original. I looked at other wildlife photographers' images and tried to copy or emulate them. In doing so, however, I was learning the craft, the formulaic elements that make up a good photograph – the background control, the depth of field, the composition. Once those elements have been grasped and practised repeatedly, they eventually become habit. An important moment came when I discovered that I could turn a relatively ordinary object or scene into an extraordinary image: the colours from a sunrise, or light hitting a leaf.

At that moment, I'd stepped over a line; I was not just documenting what was around me, but expanding it, enhancing it. That's when photography evolves from simple documentation and becomes art. The fact that I could create something beautiful out of a machine and some light-reactive paper was miraculous. I could then truly express my art, and boundaries seemed to fall away.

Now, I had a powerful tool at my disposal, one that allowed me to communicate my experience of the natural world. I wanted people to experience what I was seeing; I wanted them to become part of the woodland or marshes, to see the vivid mix of colours when a kingfisher lands in front of you. I strongly feel that your role as a photographer is to move your viewer psychologically with a single image. Maybe this is nothing more profound than making them feel part of the woodland floor amongst the fungi – visualising themselves walking down one of its paths through a sea of bluebells, or sensing the power behind the glare of a jaguar. Instead of just seeing a photograph, they are feeling it.

I suppose I've always been a fairly driven person, so long as the subject interested me, which is why I didn't do so well at school – nothing much really interested me. My obsession with wildlife was one that I initially kept quiet from my friends at school; it wasn't really cool to be into birds and butterflies in the early 70s. But the obsession was there. Add this to my new-found method of communicating it, and it was an intoxicating mix. I was hungry for information, and I learnt most of my photography from magazines such as *Practical Photography* and *Amateur Photographer*. Magazines were better than books: short, punchy pieces with lots of pictures and techniques that I could easily put into practice.

The obsessions have become quite intense over the years; I would fixate on getting the perfect image of a great spotted woodpecker or a kingfisher to the detriment of my career. Commercially, I would have been more successful if I'd done the 'wildlife rounds', gaining a wider portfolio of images, from more easily sought locations. But it was the elusive shots that appealed to me, the images of owls and ocelots that people weren't capturing.

I remember spending three days in the Amazon in a hide in super-hot, humid conditions from before dawn until after dusk, waiting for an ocelot to walk up a dry, sandy stream bed. I had seen the paw prints and I realised it was a habitual routeway. I was obsessed with capturing an image of this cat. Each day on the way to and from the hide I would brush the sand clear of footprints so I had an idea of what had passed. Leaving at the end of my third unsuccessful day, I noticed that the ocelot prints had come up the riverbed to a point just before they would be in view of the hide. Then they had veered off to the side – this gorgeous and elusive predator had realised my presence and simply circled around me! I loved this cat all the more, but it would take me a few more years to finally catch it on camera.

Sometimes these obsessions can be difficult for people around me to understand; but I cannot help it, and I've learned to accept them. I think that most people close to me now know that I'm invariably doing one bonkers thing or another to get a picture: wading through a marsh at dawn, sitting in a hedge in full camouflage, or following a jaguar on foot (which I really don't recommend, by the way). Wildlife photography is a niche area, and as wildlife photographers we have been pretty low in population density. It's difficult, then, to know how other wildlife photographers work; we see their images but not how they actually operate. I wouldn't be surprised to find that they are as obsessive as me.

I like nothing more than a burgeoning new project. Solving problems to not only get close to the subject, but capture a photograph of it – a perfect photograph. Maybe it's that primal hunting instinct; but hunting without killing. Indeed, to produce an aesthetic image, capturing the essence of a creature, is undoubtedly much harder than killing it. And that pursuit of perfection is a shifting thing; what was perfect ten years ago may no longer be perfect now. So the quest goes on. The Holy Grail. Always push for better, for different.

Male bee-eater passing food to female

Kiskunság National Park, Hungary

At a breeding colony of European bee-eaters, pairs of these striking birds
perch together close to their nest burrows, which they dig in very sandy soil.
The male bird frequently flies up from the perch to grab an insect before
returning and passing the food to his mate.

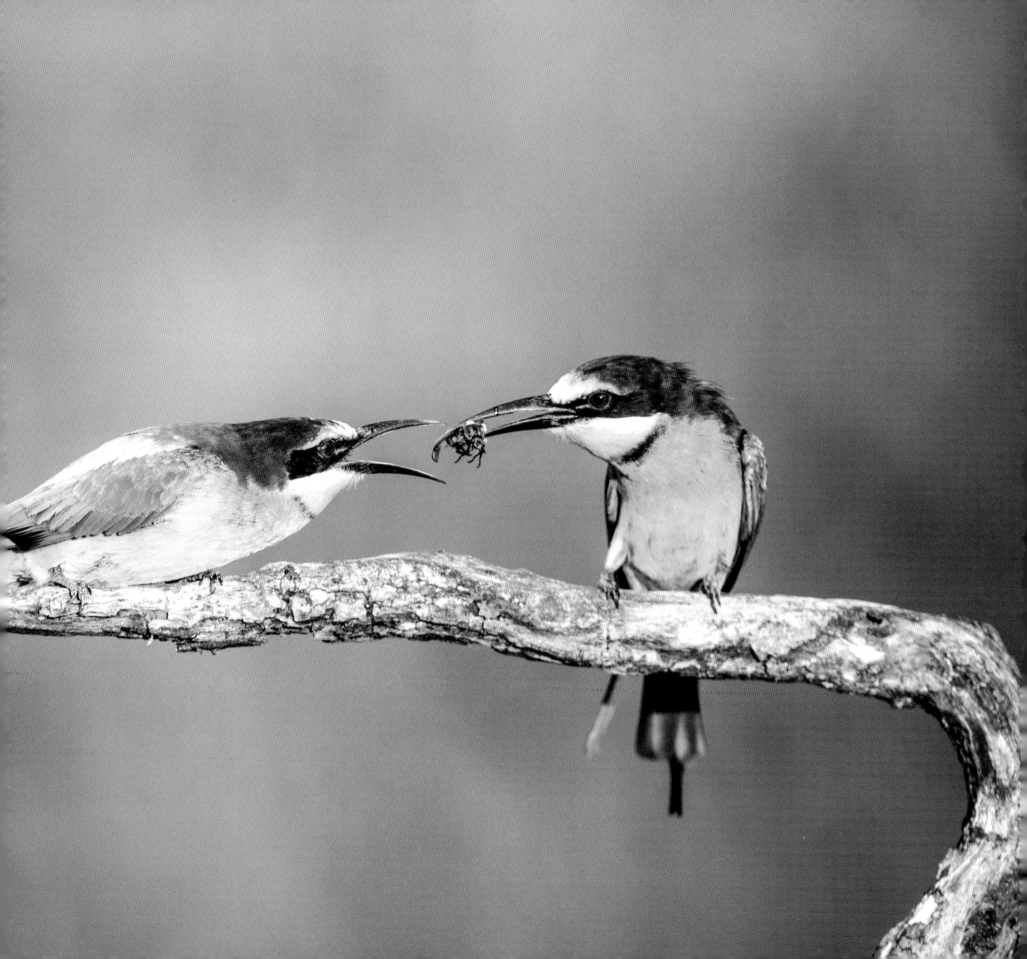

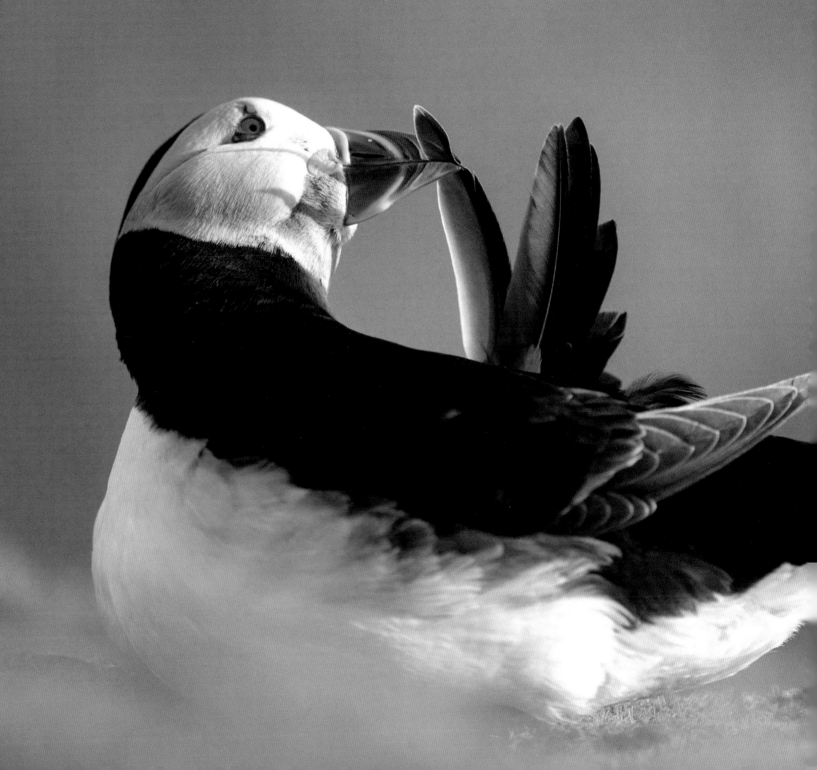

Atlantic puffin preening
Skomer Island, UK

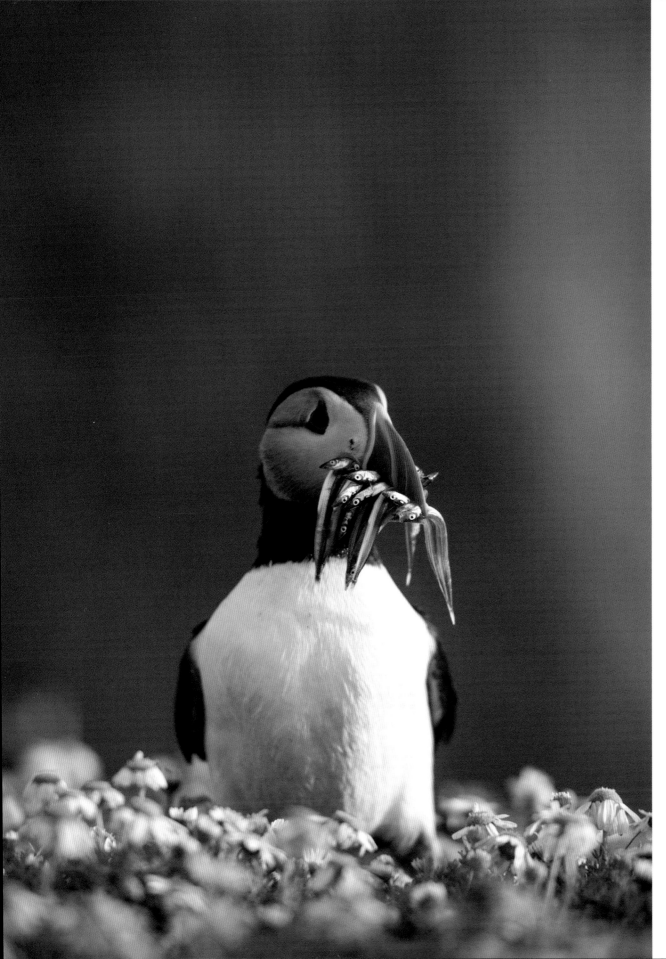

(left) Atlantic puffin with sand eels
amongst flowers
Skomer Island

(right) Atlantic puffin with sand eels
Skomer Island

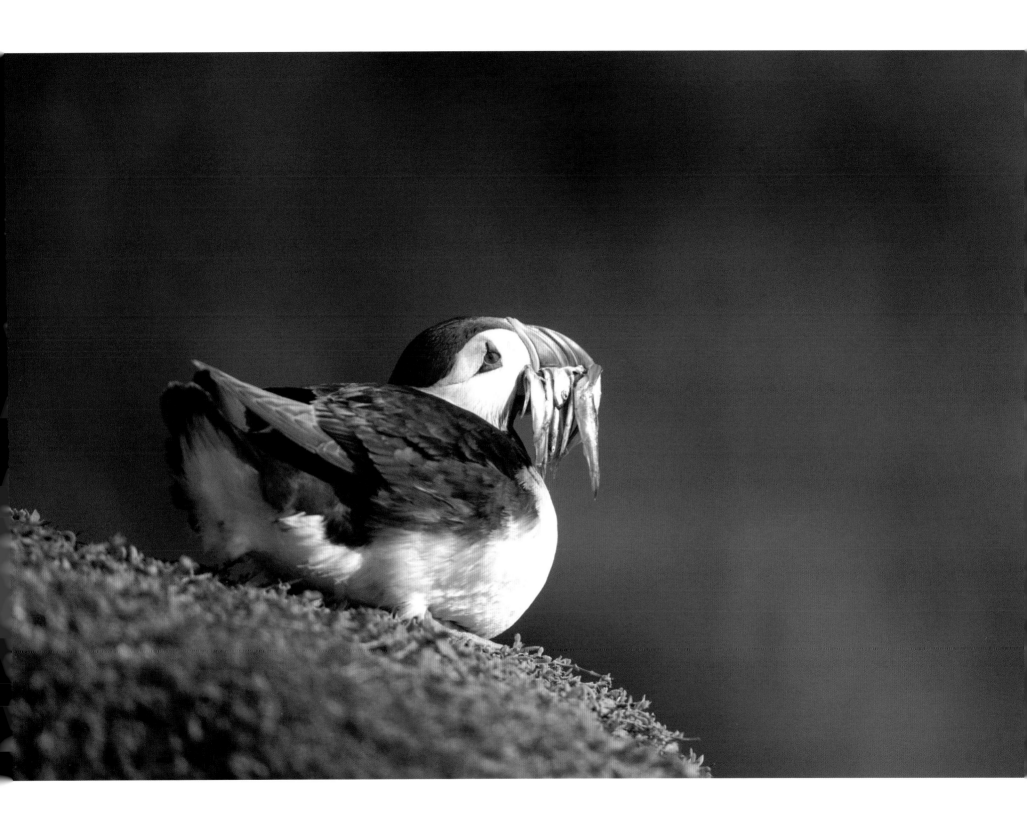

Atlantic puffin
Skomer Island

The comical, clown-like puffin's breeding success is directly related to its main prey source, the sand eel. Fortunately, like a lot of seabirds, they are long-lived – some on Skomer Island, off Pembrokeshire, have been recorded at about thirty-eight years old. Their island nest sites, which they only visit during the breeding season, are crucial locations and must be devoid of ground predators such as hedgehogs or cats, the presence of which would decimate the puffin population. Endearing but clumsy on land, they are adapted for life under the waves – their bills open and close like a vice, with spines on the tongue allowing them to catch multiple sand eels on one trip. Like all birds, the maintenance and condition of their plumage is essential and they frequently preen and fluff their wings in order to align their flight feathers and keep their general condition in tip-top shape.

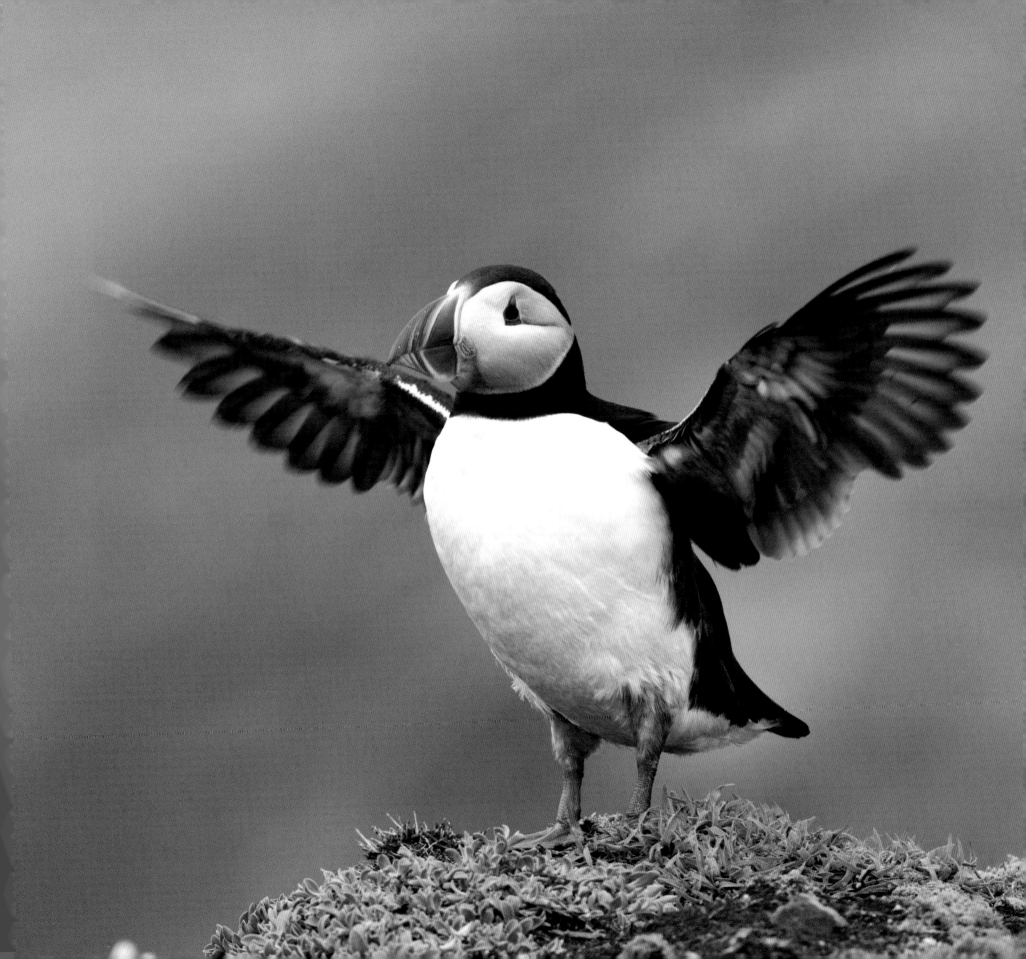

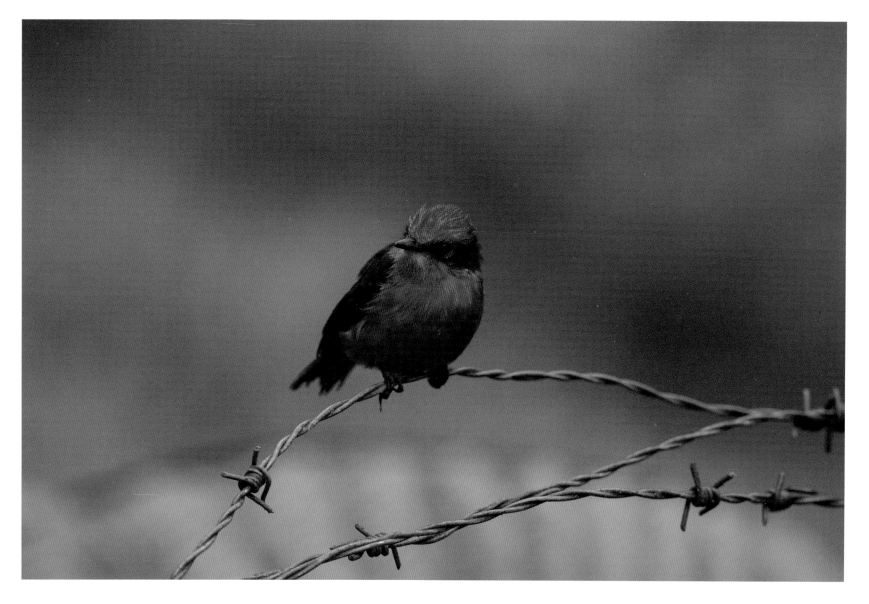

(above) Vermilion flycatcher

Galápagos Islands, Ecuador

(right) Spotted hyena with prey

Maasai Mara, Kenya

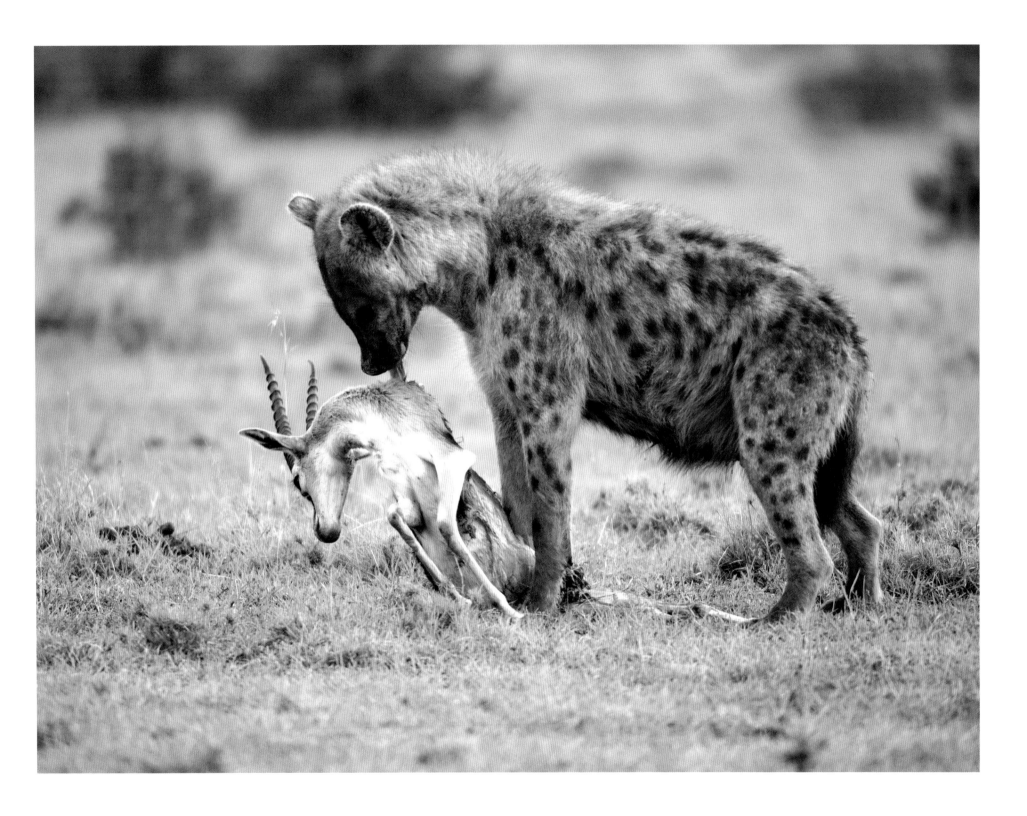

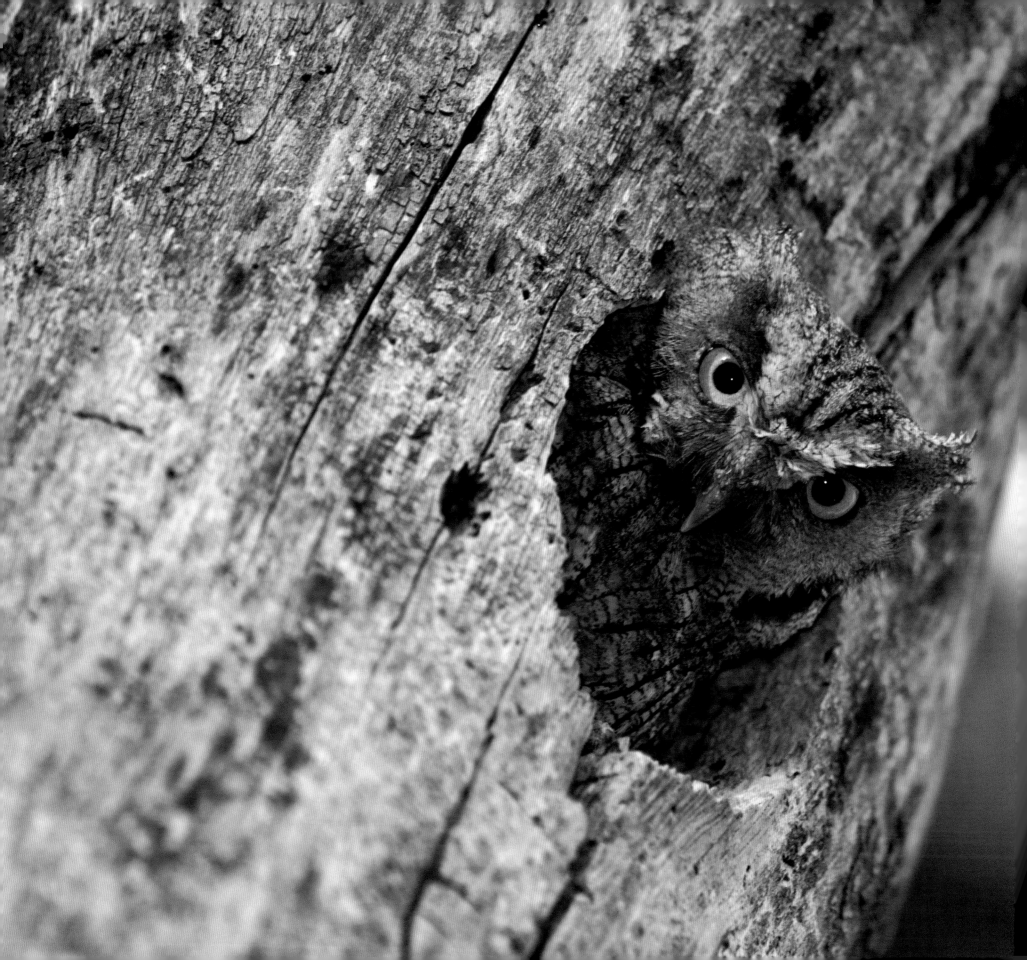

Tropical screech owl at nest
Chapada, Brazil

I had been told that a pair of tropical screech owls were occupying the hole in a dead tree in the Chapada region of Brazil. Apparently they would regularly poke their heads out if anyone passed by, but the tree was situated on a working farm and they were very used to people. As predicted, as soon as I went to the base of the tree, the inquisitive owl poked his head straight out, and as he was looking down at me I pointed the lens straight up the trunk of the tree and grabbed a few shots before backing away so as not to disturb the bird. And as if nothing had happened, the owl just sank straight back into the hole.

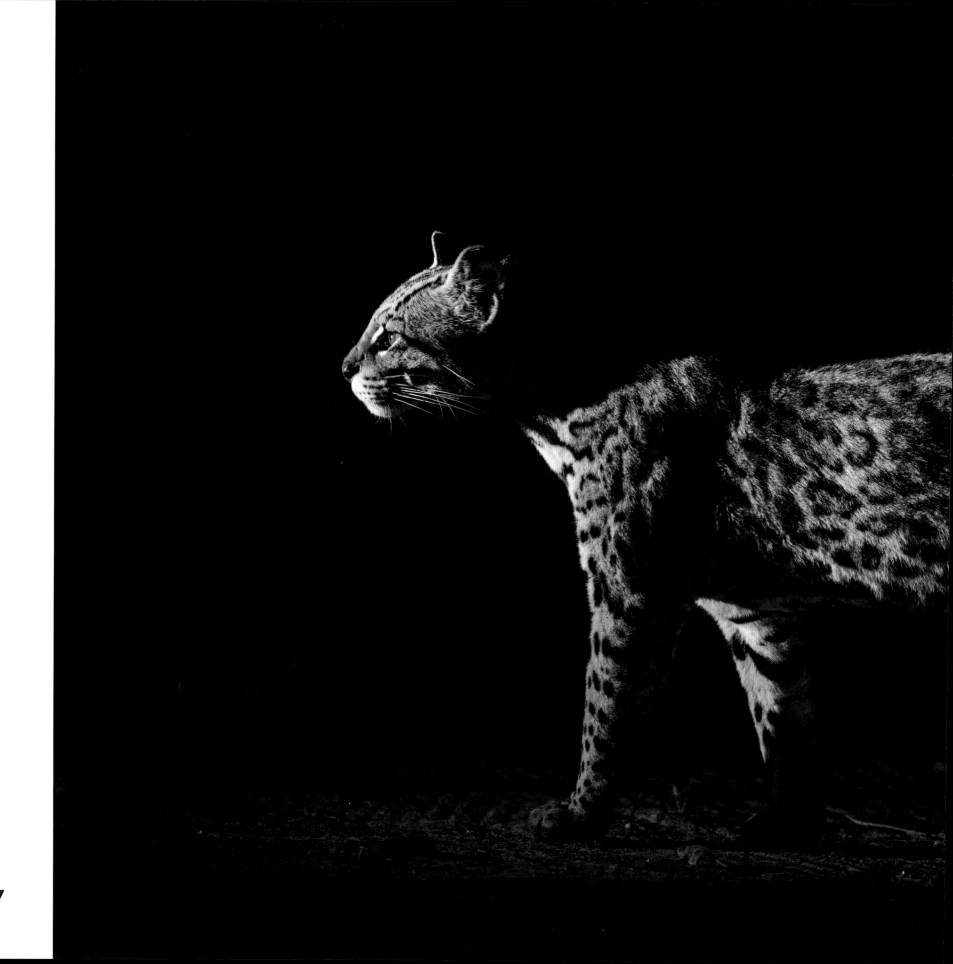

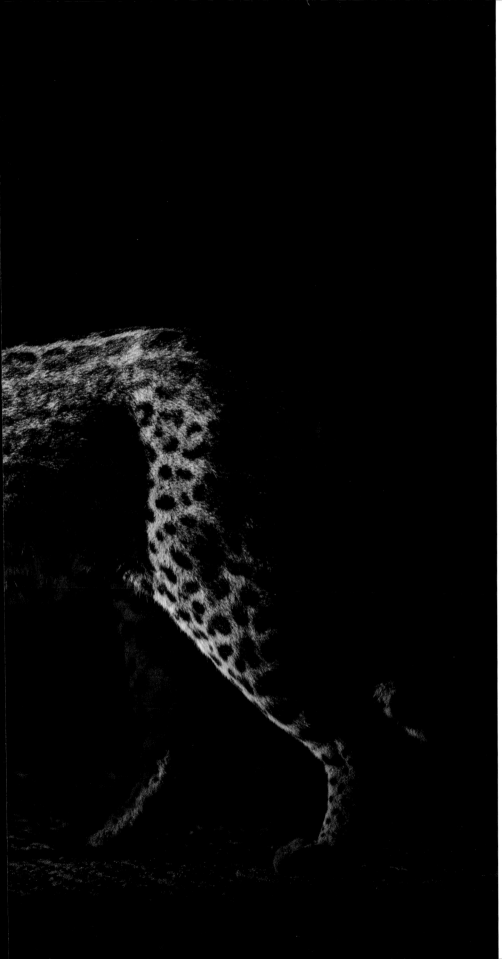

Ocelot
Pantanal, Brazil

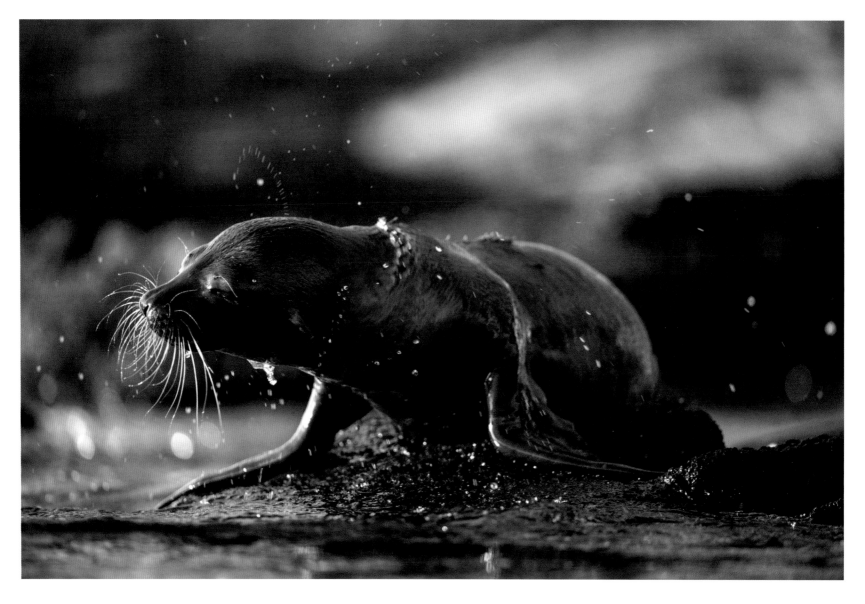

(above) Galápagos sea lion
Galápagos Islands

(right) Young Galápagos sea lions play play-fighting
Galápagos Islands

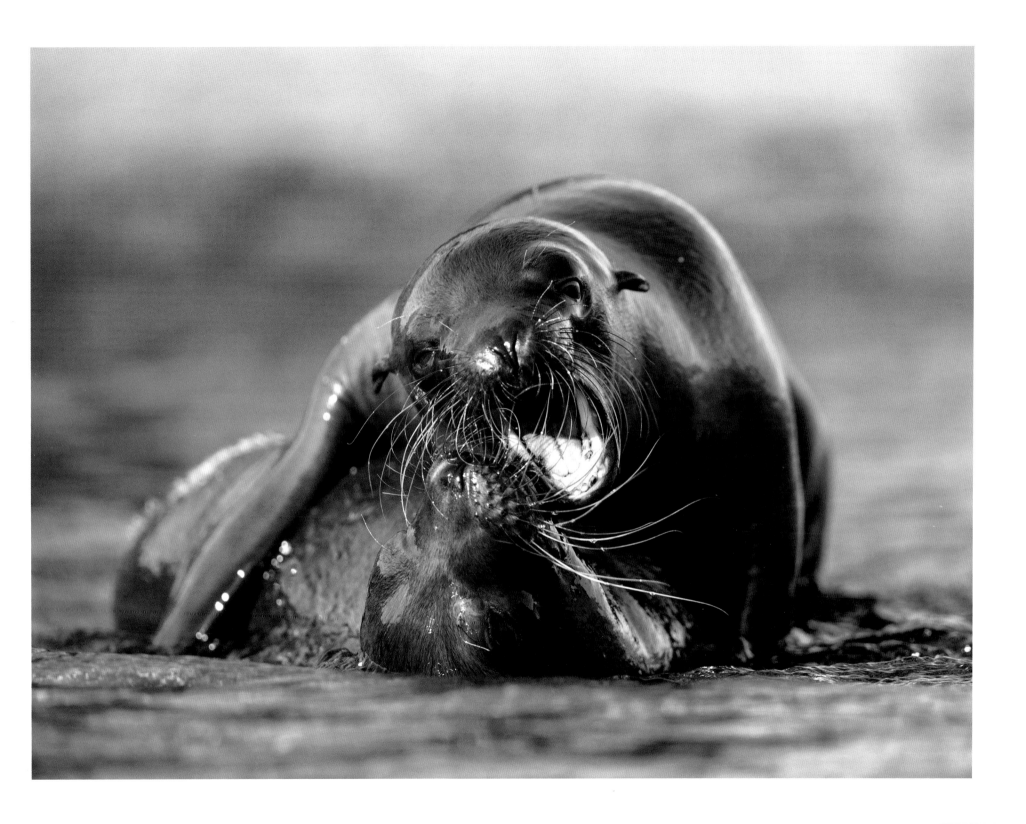

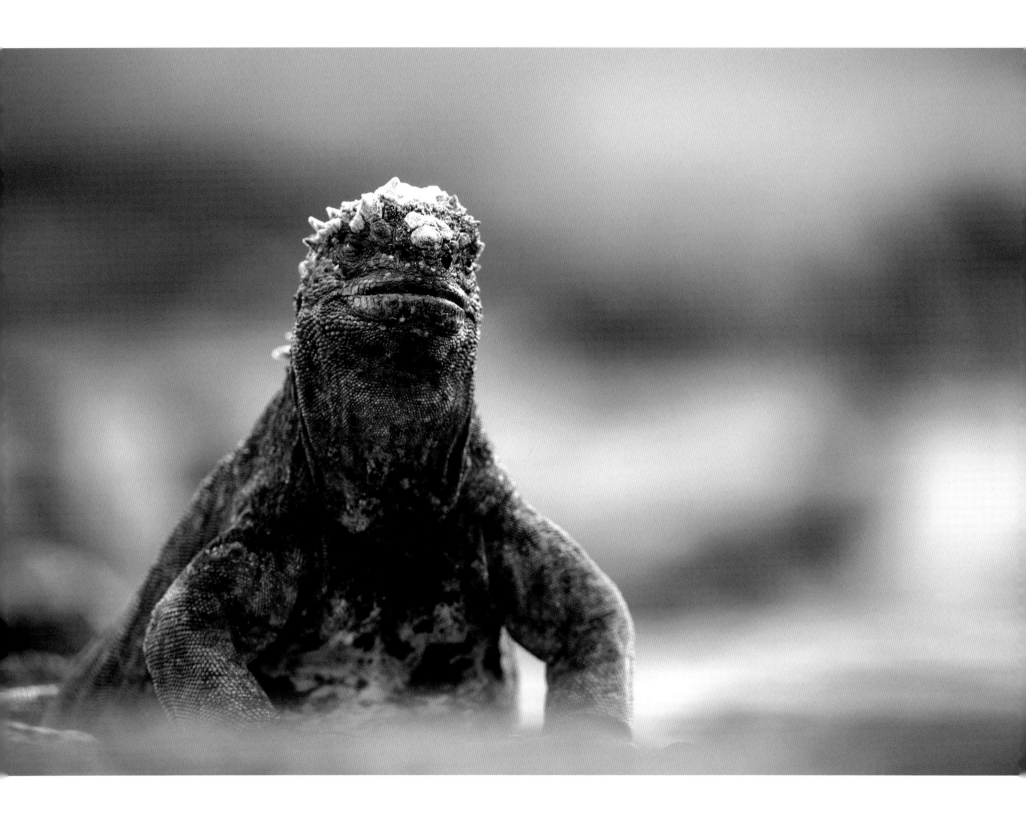

7 YEARS OF CAMERA SHAKE

(left) **Marine iguana**
Galápagos Islands

(right) **Land iguana**
Galápagos Islands

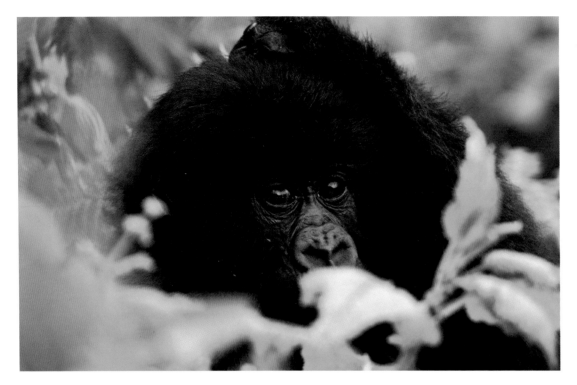

**(left, above and below)
Young mountain gorillas**
Rwanda

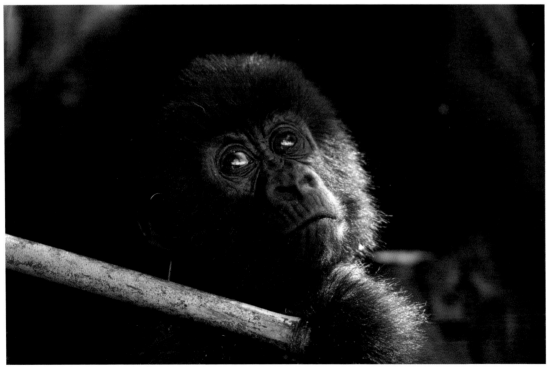

(right) Mountain gorilla
Rwanda

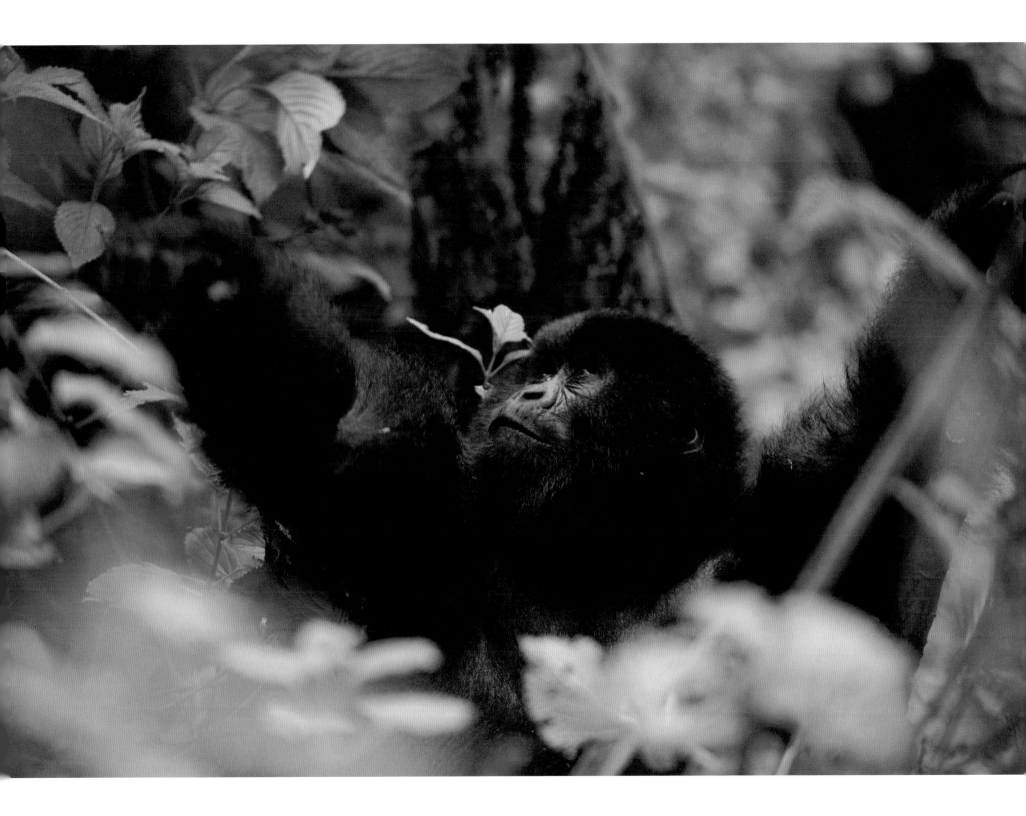

Line of African elephants
Maasai Mara

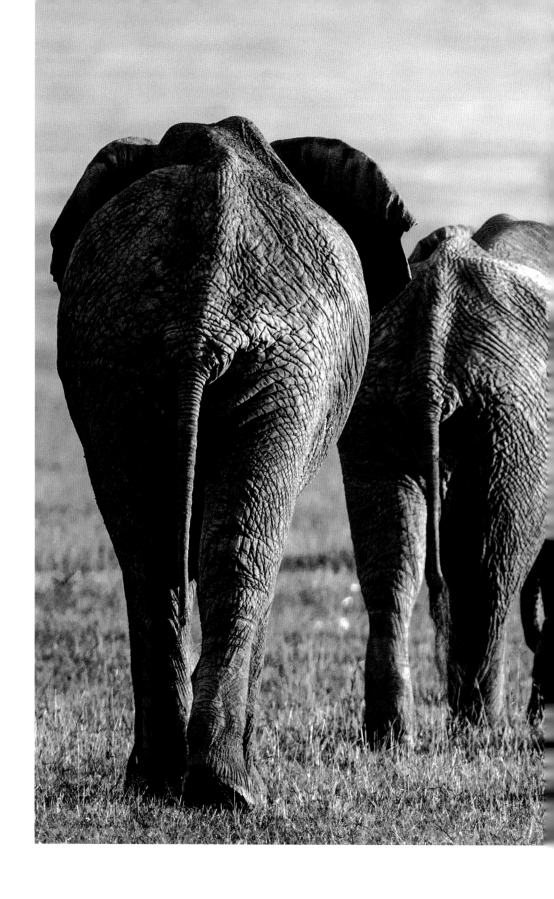

7 YEARS OF CAMERA SHAKE

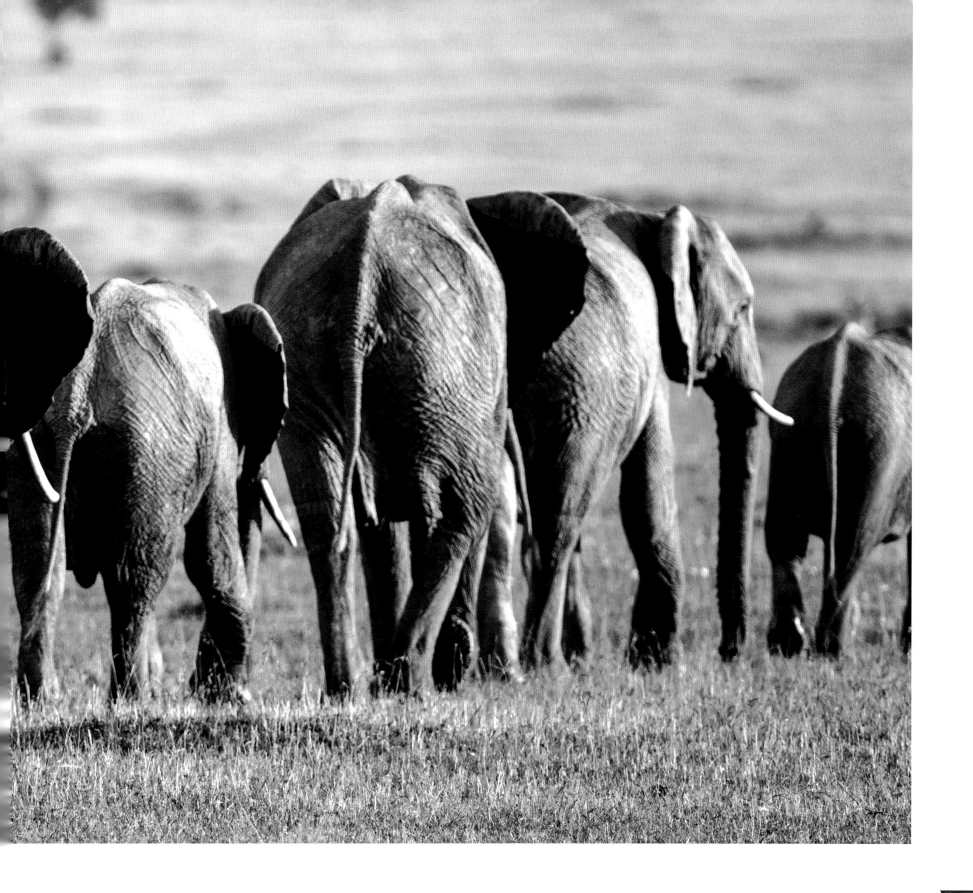

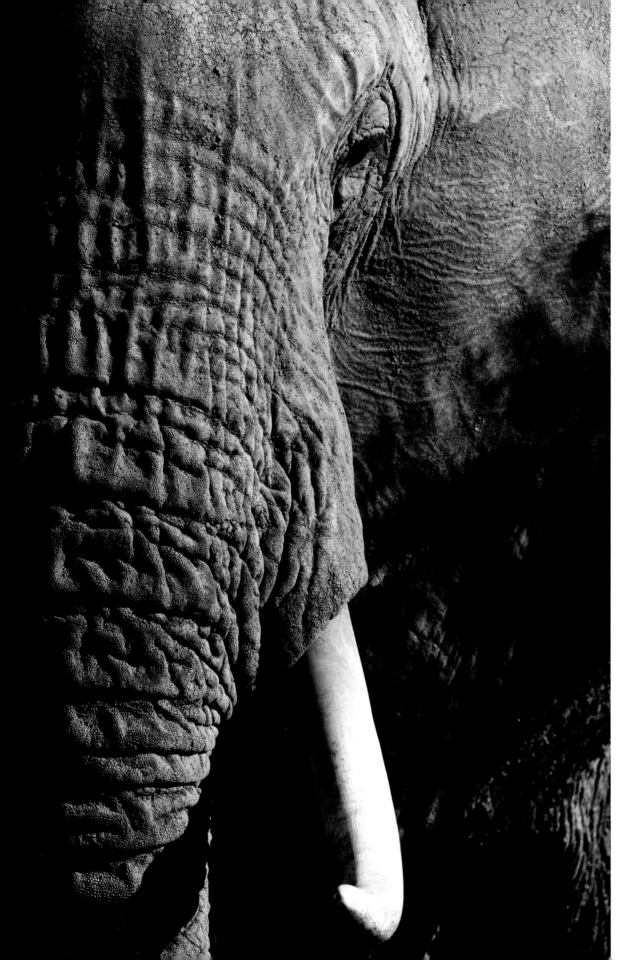

(left) African elephant bull
Maasai Mara

(right) Black-backed jackal
Maasai Mara

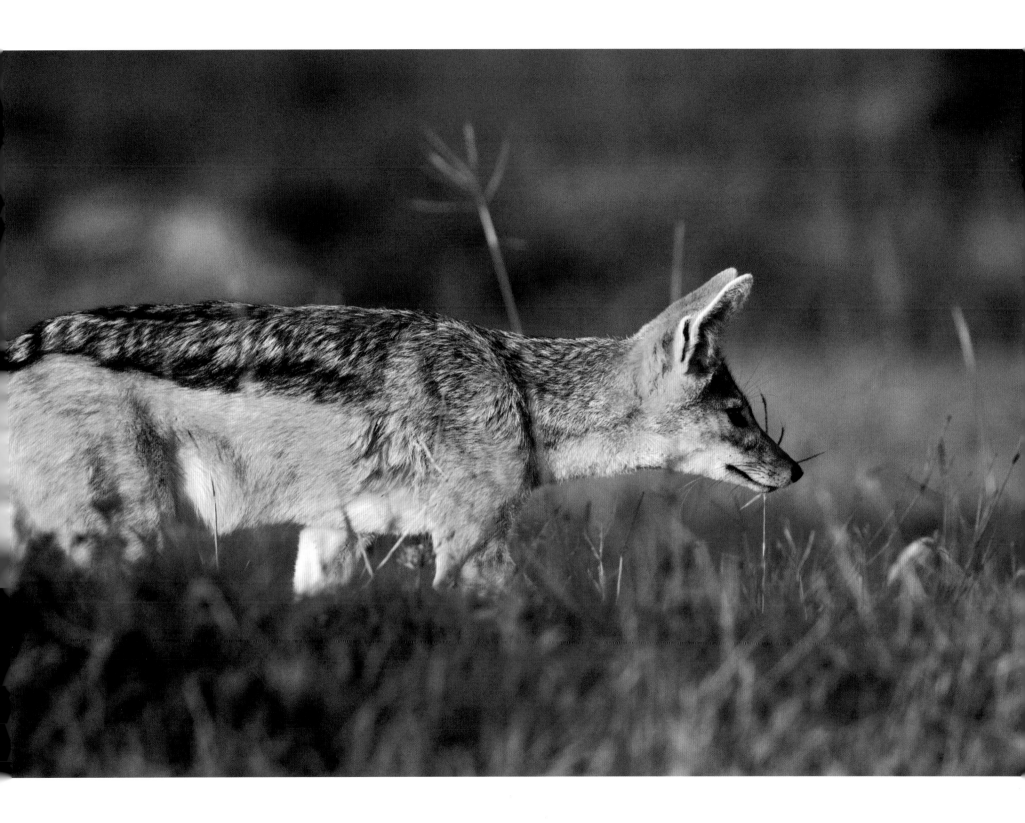

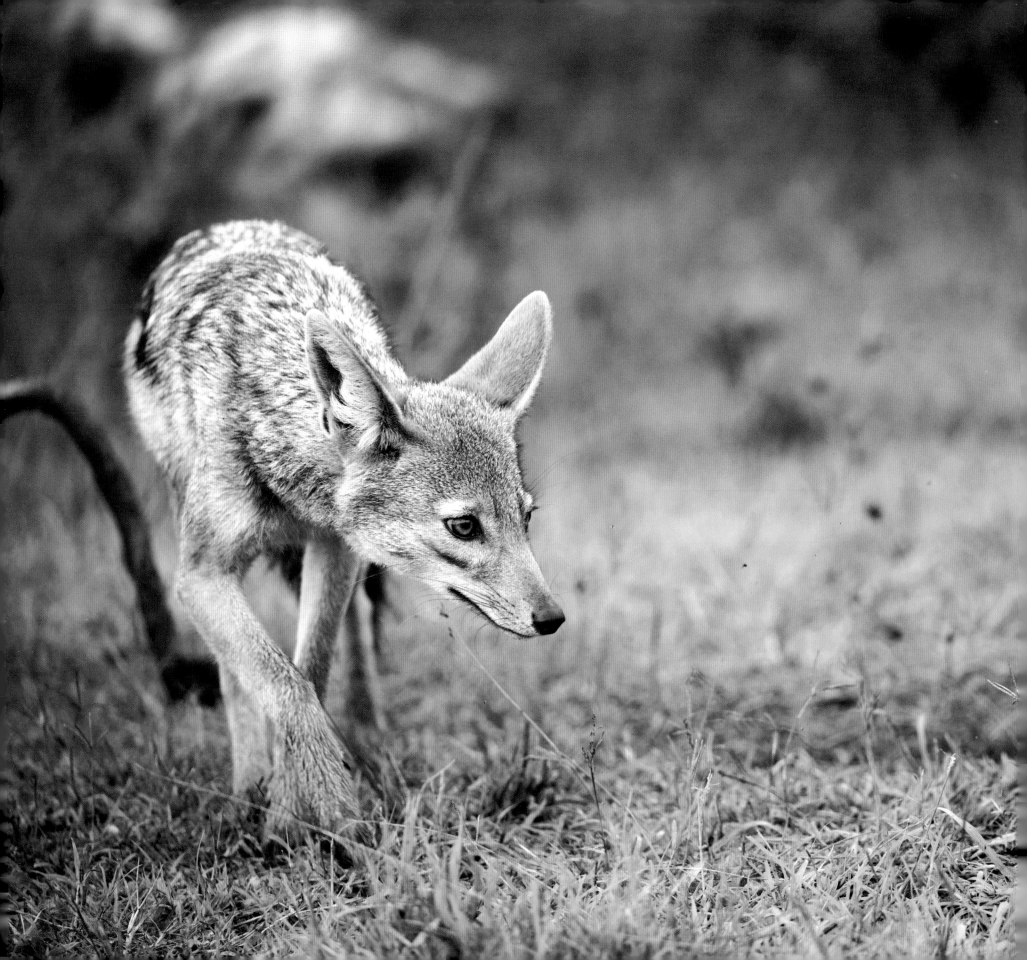

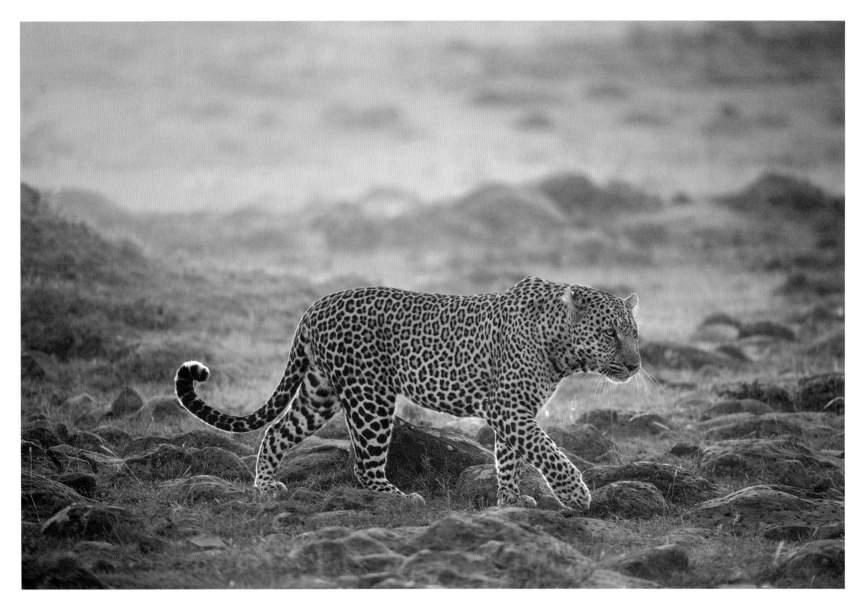

(left) Black-backed jackal, sneaking in to steal meat from a kill

Maasai Mara

(above) Male leopard walking at sunset

Maasai Mara

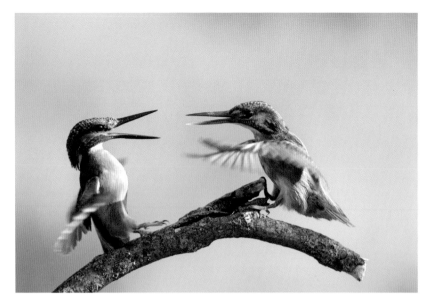
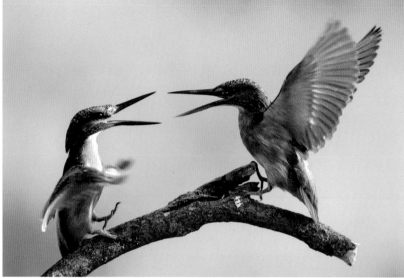
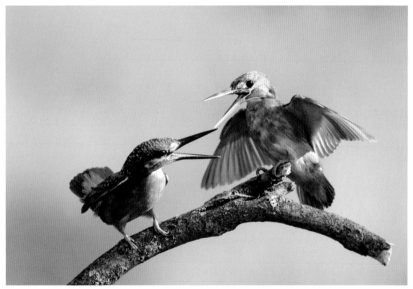
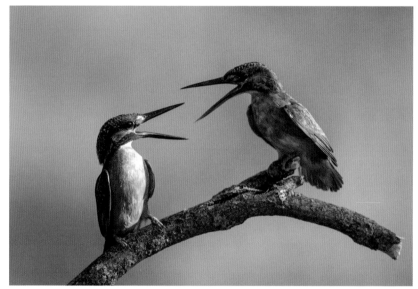

(above) Common kingfishers fighting
Kiskunság National Park

(right) Pair of common kingfishers mating, the result of the fight
Kiskunság National Park

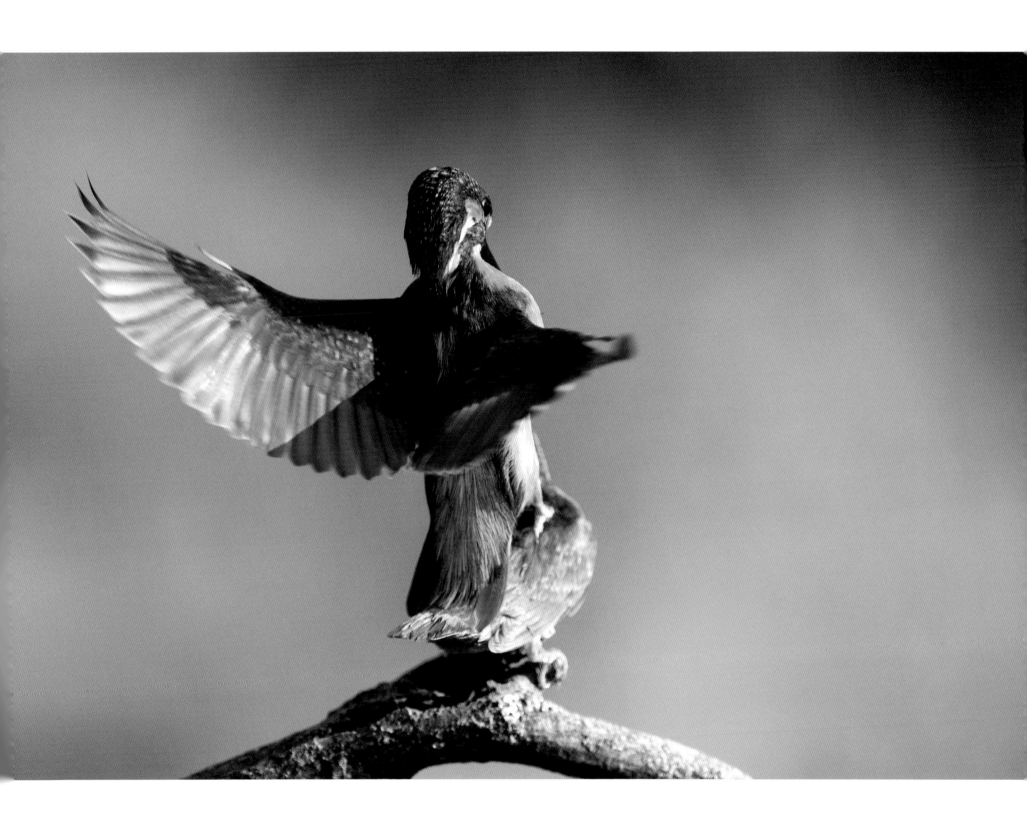

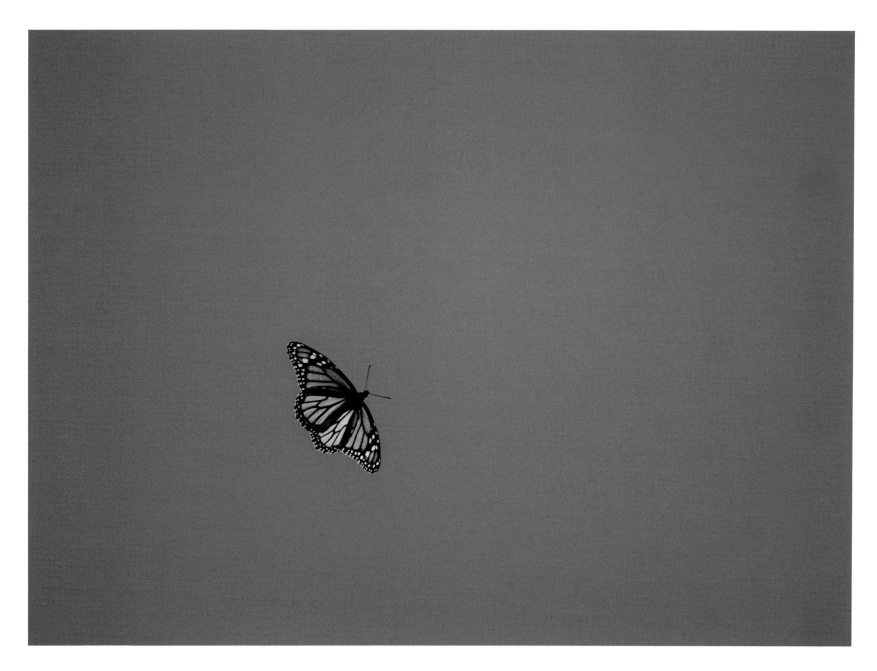

(above) Monarch butterfly on migration
California, USA

(right) Red kite in flight
Mid Wales

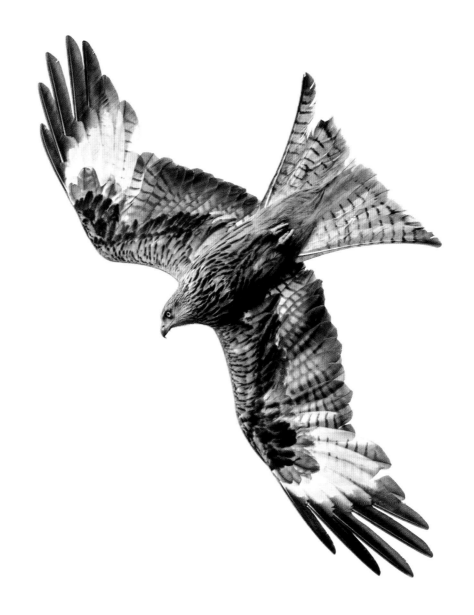

CATS

t is a little clichéd, but I can't deny that I have an inordinate fascination with cats. It's something about their form and function combined with a grace and elegance that other predators don't have. I rarely see this in domestic cats, as the constant human attention keeps them in a kitten-like state. Sometimes though, I do see in my neighbours' domestic cat the same movements I see in a leopard. However, when you see a leopard properly stalking, there's no doubt there is a different kind of eminence from this creature. A maturity and assuredness perhaps. In reality, I think top predators like cats and owls are actually fairly simple computers – food or no food, kill or don't kill, danger or no danger – and that they are just highly adapted and specialised to do what they do, which ultimately is to kill. But the end result of this adaptation and specialisation has produced such beautiful creatures.

We love to watch the young of these top predators with their heads and feet slightly too big, their clumsiness and their touching curiosity. There's nothing better than watching a pride of lions with young cubs, both for the interaction between the lionesses tolerating the clambering and nipping of the cubs, and for the sight of the cubs fighting together. In reality, look at every move they make, every swipe of the paw and leap onto the back of a sibling – it is all just practice, a rehearsal for perfecting the art of becoming what they are – killers.

There is no better place on earth to see big cats in the wild than the Maasai Mara in Kenya, and I am lucky enough to spend four to six weeks there every winter. This has given me the opportunity to get to know individual cats. I don't kid myself – I haven't got any in-depth knowledge of these cats compared to the local drivers and guides. These guys follow the predators day after day, year after year. I like to use the same guides every time. They know what I like, and they certainly know how to find the animals, and predict what they might do, allowing us to get into the perfect position. The prime example of this is when I was with one of my regular guides, Charles Mwangi Wandero.

At dawn, we were following two brother cheetahs. They were walking purposefully and I grabbed the usual walking-cheetah shot, albeit in very good dawn light. I wanted something more though, and, as Charles suspected they were gearing up for a hunt, we left them and drove at least half a mile away to the opposite side of a line of walking wildebeest. We both agreed that this was a likely attraction for the cheetahs, but Charles went even further and pointed to the individual wildebeest that they would go for. Within a couple of seconds, the wildebeest herd panicked and scattered as one of the cheetahs sprinted towards them. And the cheetah was going directly for the animal Charles had predicted. We were perfectly positioned, and in the two seconds or so that the

chase lasted, the cheetah and the targeted animal came directly towards us before the brothers put the victim down in a cloud of dust just thirty metres or so from the vehicle. We simply rolled forward and I watched the panicked eyes of the wildebeest begin to lose energy and then glaze as the jaws of the cheetah clamped around its throat and suffocated it.

Witnessing this can be challenging, but as this action unfolds I am relatively unmoved by what I see; I tend to experience the true impact of what I've witnessed retrospectively. Once I had met the eyes of the wildebeest, I acknowledged the significance of the kill, but at the time it is all about capturing the shot. Sometimes people have had problems with this: I'm not saying it does not affect me, I am saying it does not affect me at the time. People are often upset by the brutality of what they've witnessed, but this is life-and-death and it is going on everywhere, even in your own backyard. We may not see it quite as bloody and raw as it appears in the Maasai Mara, but the same predator-prey relationships occur everywhere. It is sometimes worth remembering that not many organisms on Earth die of old age.

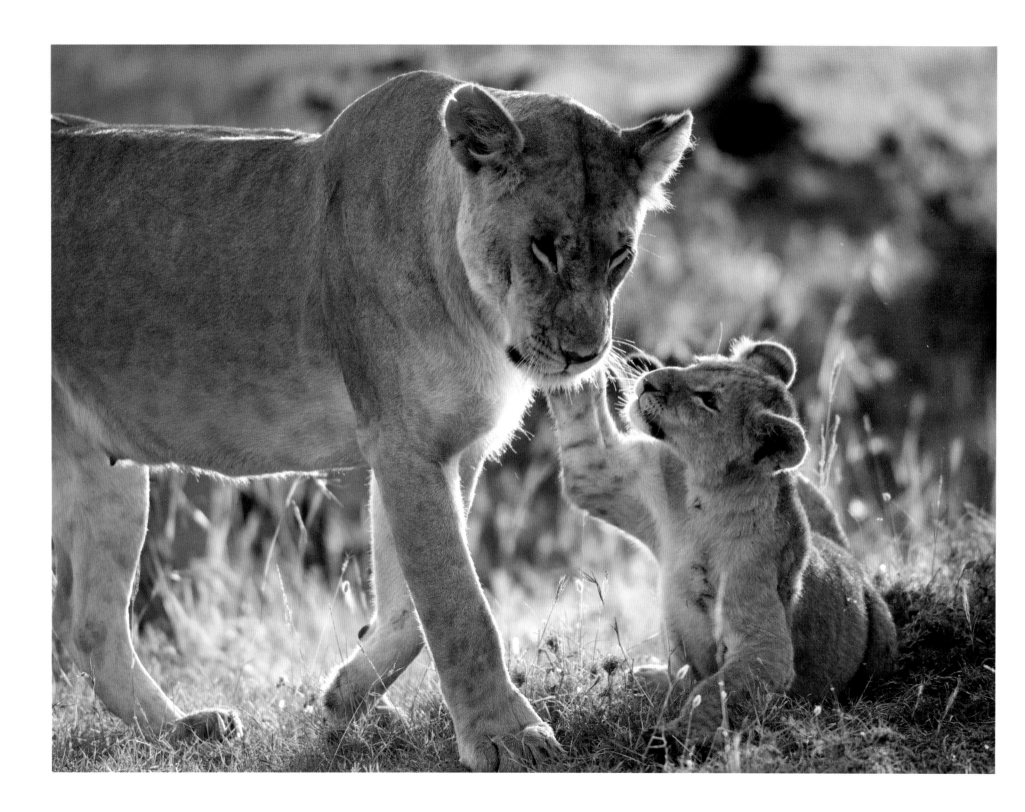

(left) **Interaction between cub and lioness**
Maasai Mara, Kenya

(right) **Young lion caked in mud**
Maasai Mara

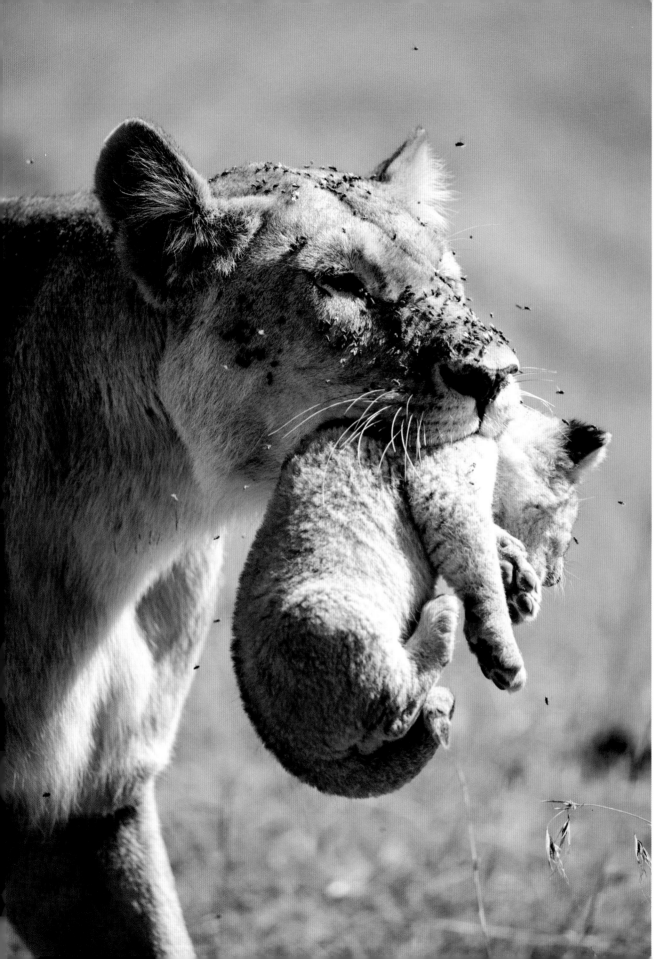

(left) Lioness carrying cub
Maasai Mara

(right) Lion cub playing with vegetation
Maasai Mara

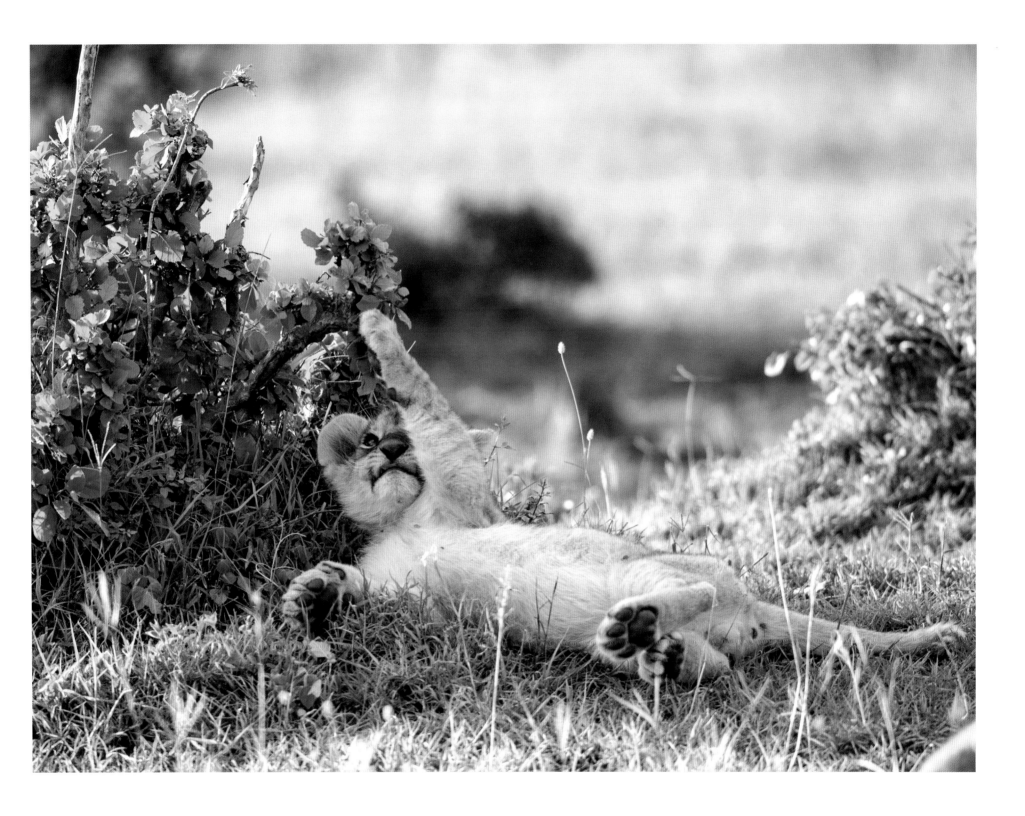

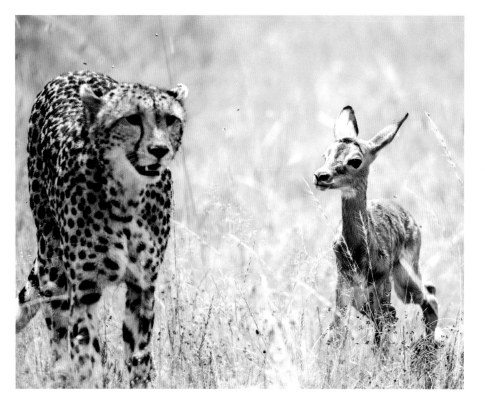

(left) Young cheetah closing in on impala fawn
Maasai Mara

A prolonged wait and observation of a female cheetah with four nearly full-grown cubs. And another situation where Charles Mwangi Wandero, my regular guide, identified a likely prey – a newly born impala fawn. After a chase, the mother cheetah caught the struggling fawn and dumped it in front of her confused cubs. To survive they need to learn to kill. What ensued was a forty-minute learning experience as all four cubs repeatedly chased and knocked down the dazed fawn. On occasion, cub and fawn would sit together, unsure of the situation, and at one stage one of the cubs even began to lick the fawn. In the end, it was as if a switch was activated collectively within the cheetahs and their behaviour just totally changed as they surrounded, killed and rapidly consumed the fawn.

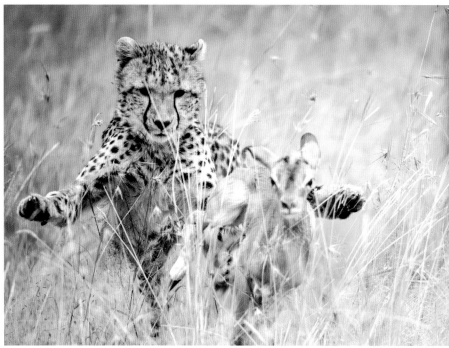

(left) Cheetah chasing impala
Maasai Mara

(right) Leopard
Maasai Mara

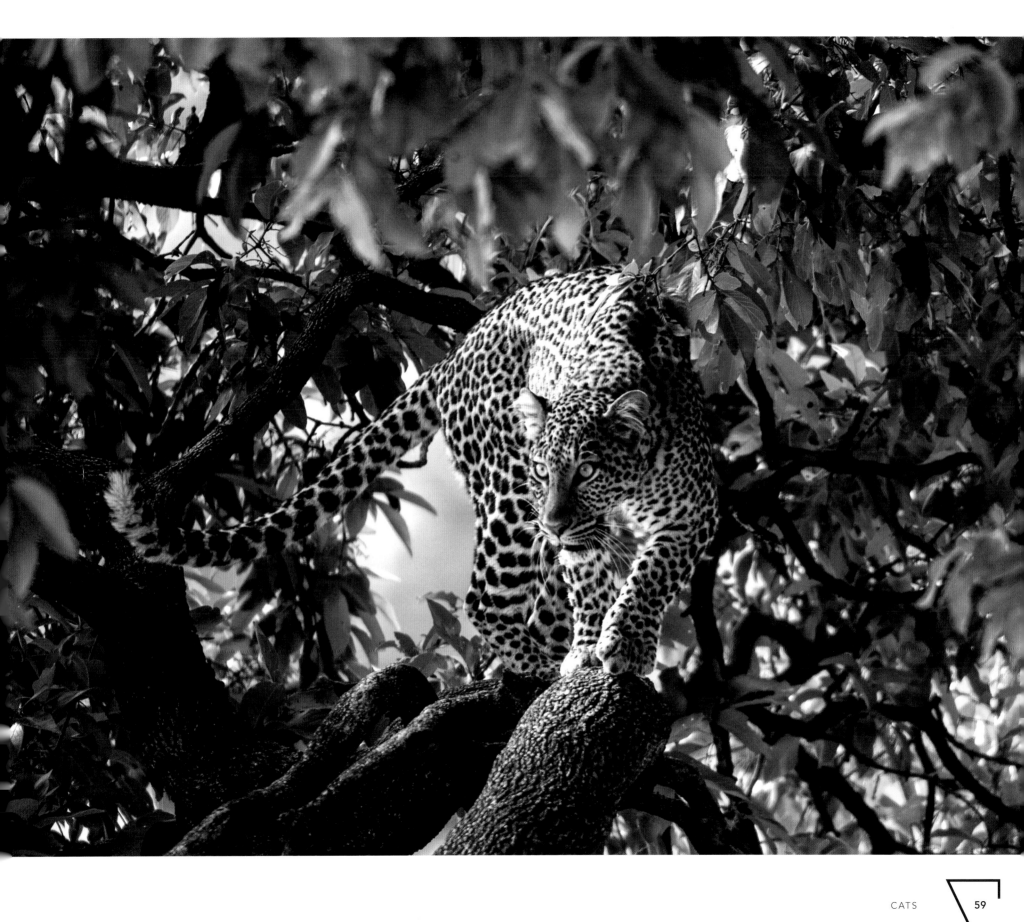

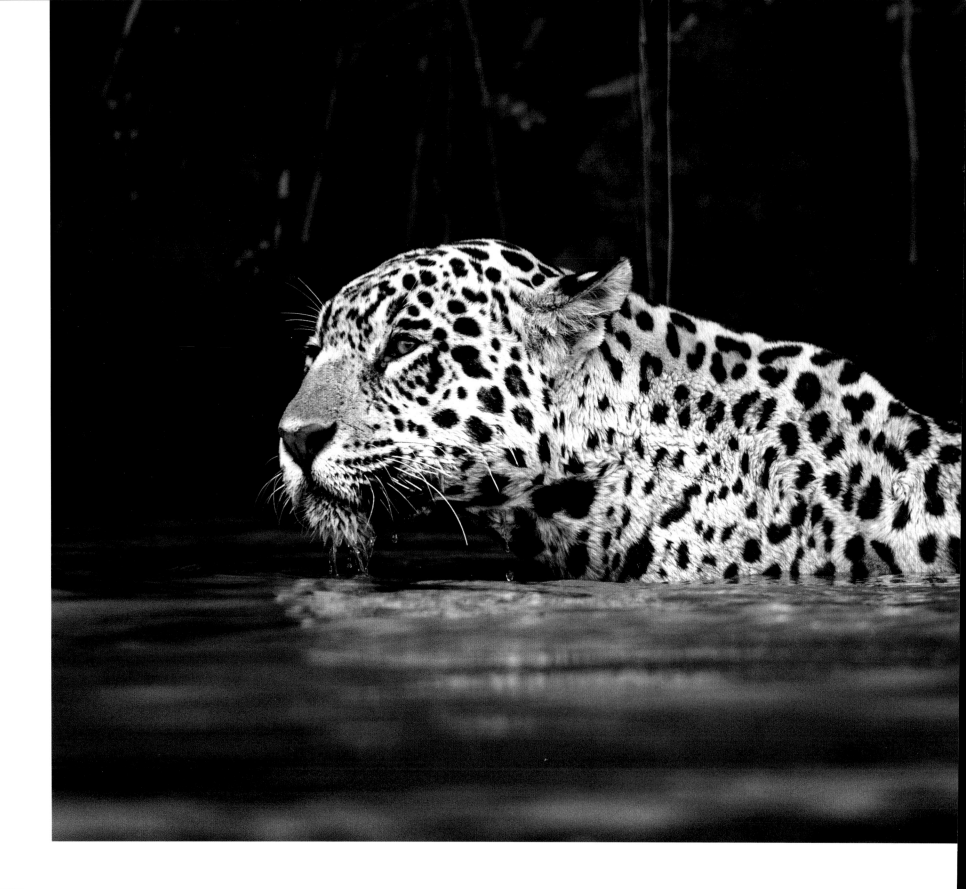

7 YEARS OF CAMERA SHAKE

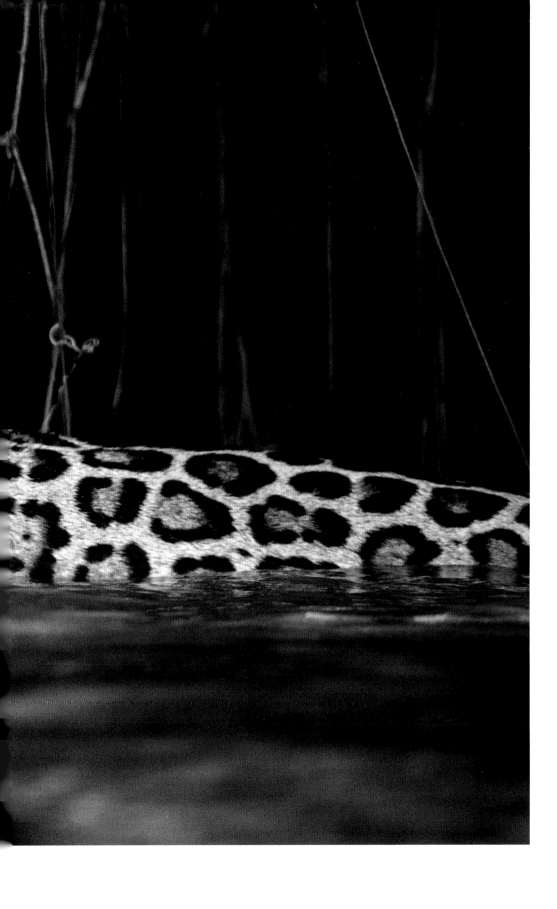

Jaguar in water
Pantanal, Brazil

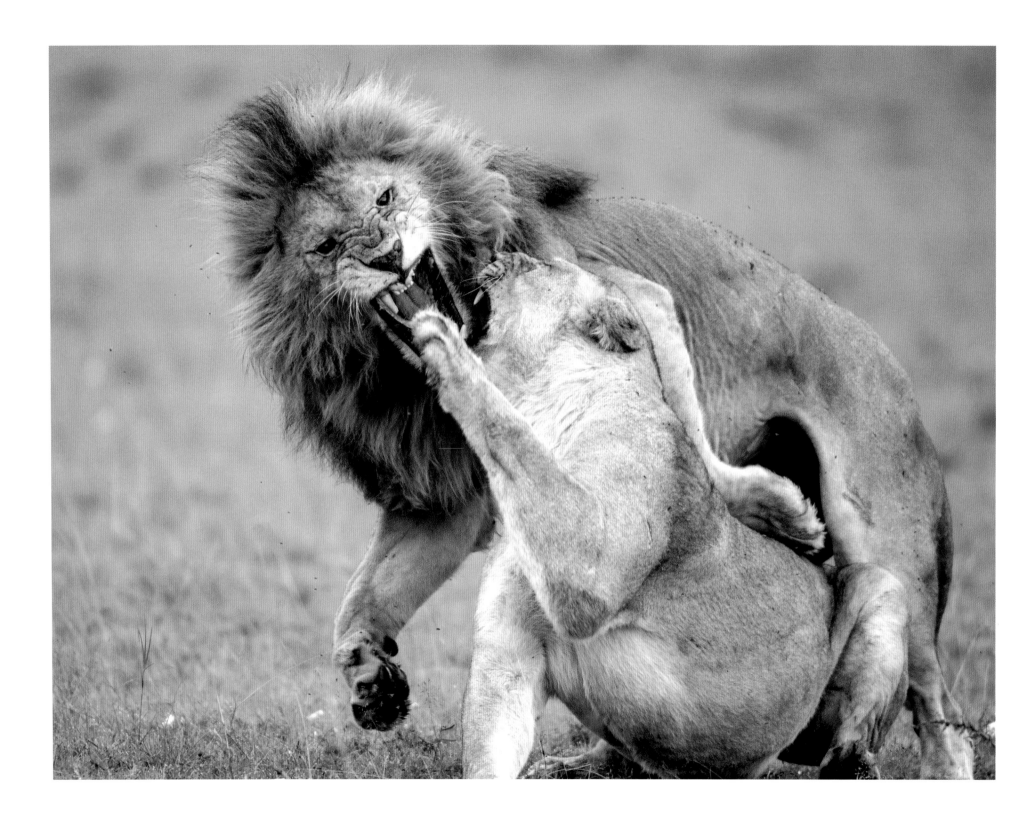

(left) Lions separating after mating

Maasai Mara

(right) Lions mating

Maasai Mara

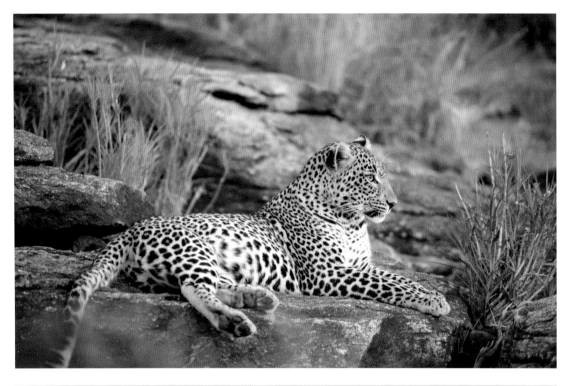

(top left and right)
Nalangu

Maasai Mara

This leopard has become one of my favourites in the Maasai Mara. For about a week she drifted through the camp at night because she had a cub stashed locally, probably at the top of the ridge behind the camp. I think she's the most beautiful leopard I've seen – she has spectacular lines, which is probably a strange thing to say, but some of these cats look more striking than others and Nalangu has a certain quality about her. Maybe it was her initial mystery combined with the fact that she is a very elegant female leopard. Sadly, that first cub died, and Nalangu was not seen for a while; but I was thrilled in 2016 when she had another cub, which is now several months old and appears to be doing very well. The father of the cub is believed to be the shy male leopard pictured on page 74 in black and white, with just his eyes looking through the undergrowth. He is another favourite leopard of mine, definitely because of his habit of remaining aloof. This would appear to be a good match indeed, which bodes well for this cub.

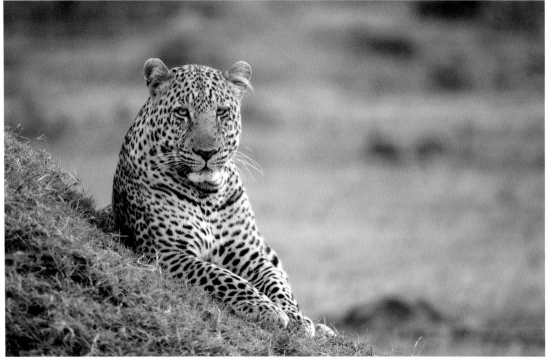

(left) Male leopard
Maasai Mara

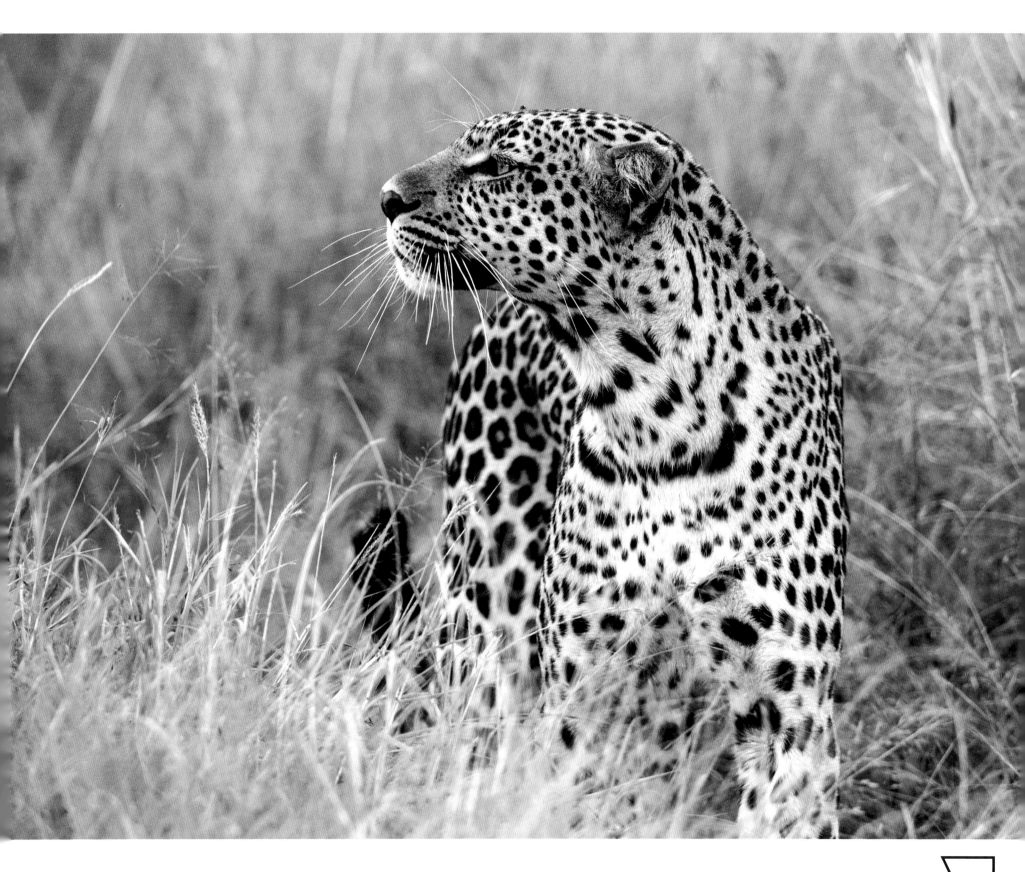

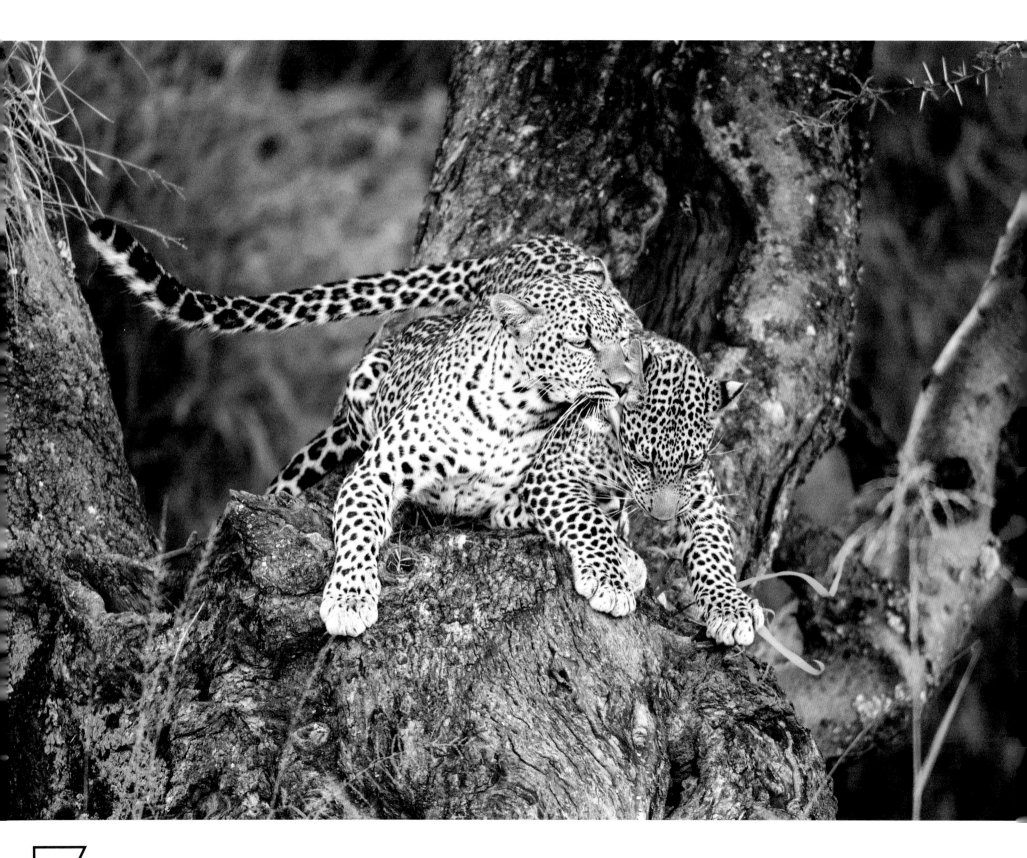

7 YEARS OF CAMERA SHAKE

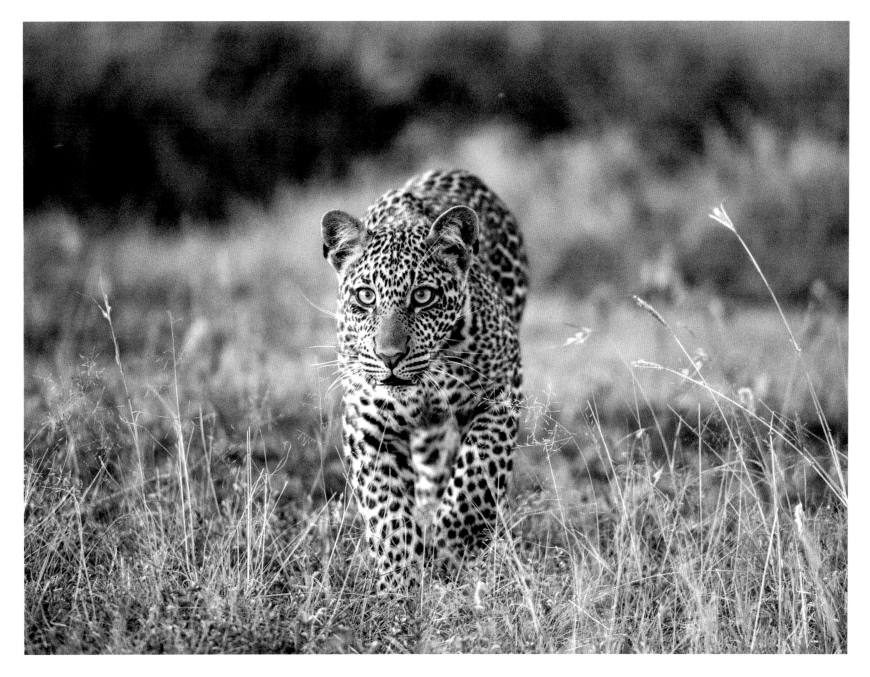

(left) Nalangu and her cub
Maasai Mara

(above) Nalangu's young cub
Maasai Mara

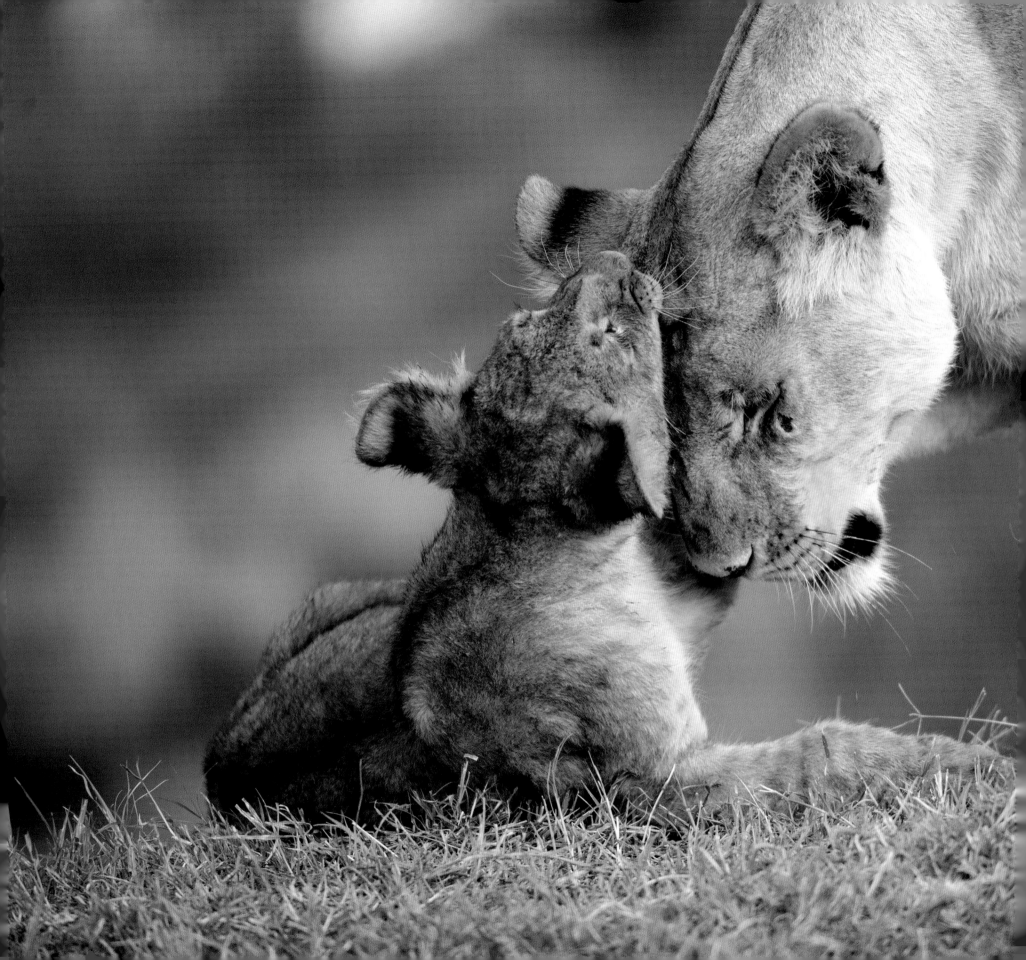

Lioness greeted by cub
Maasai Mara

Cheetah at sunset
Maasai Mara

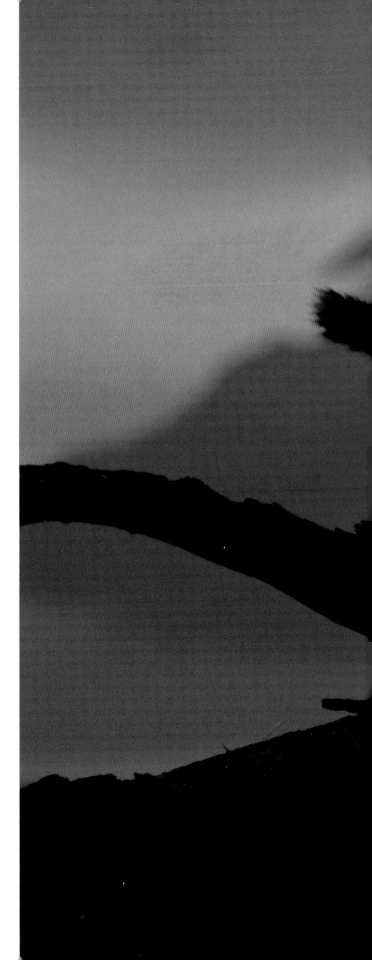

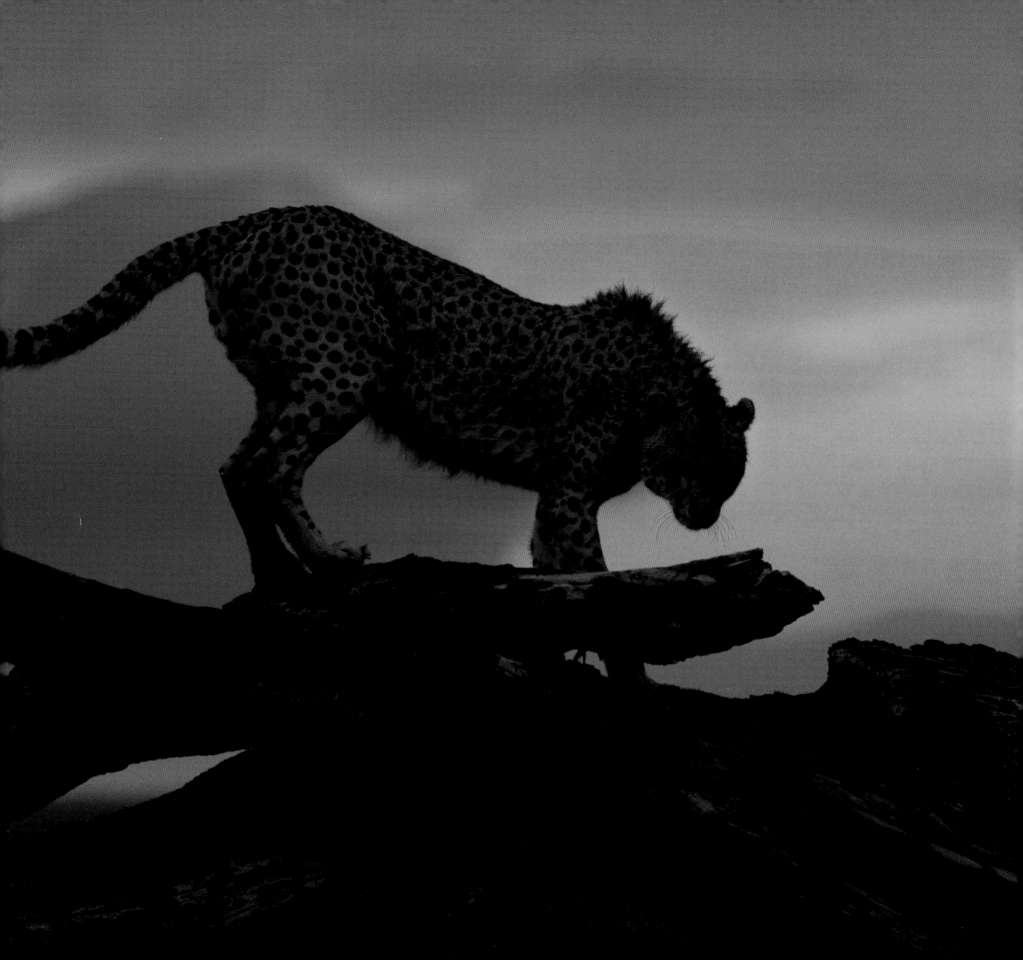

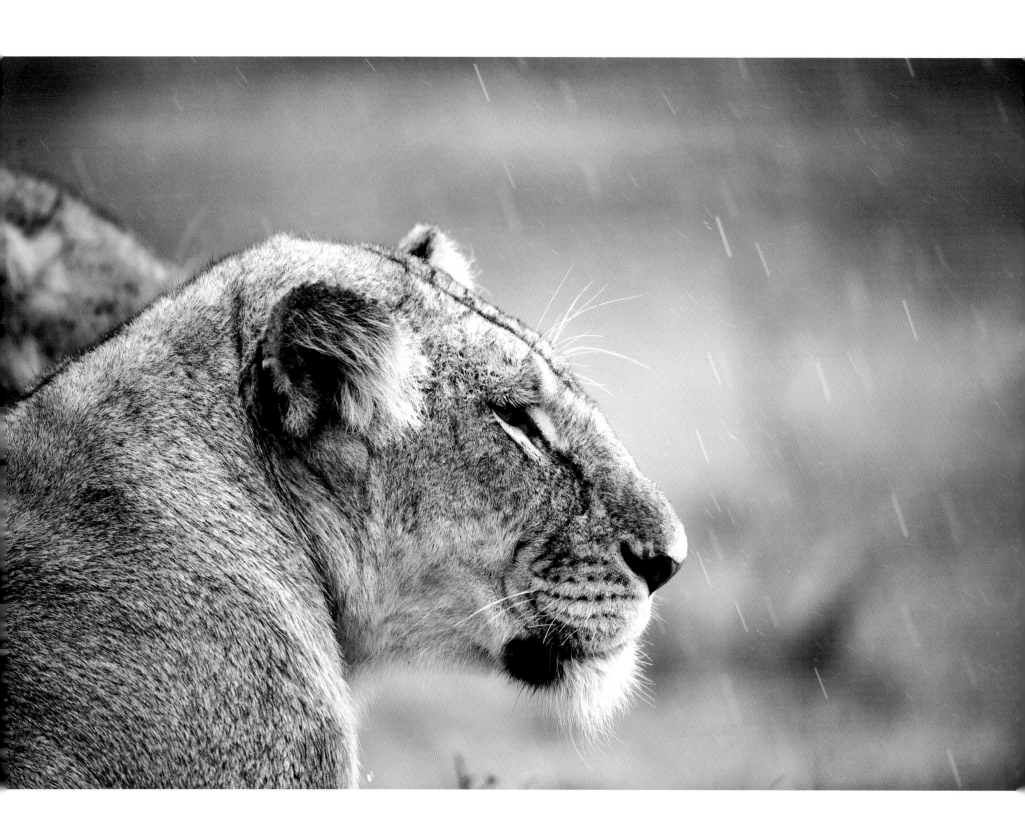

7 YEARS OF CAMERA SHAKE

(right) Male lion looking down at cub
Maasai Mara

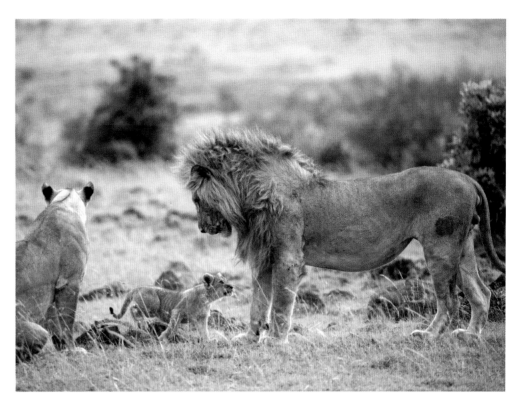

(right) Affection between lioness and cubs
Maasai Mara

(left) Lioness in rainstorm

Maasai Mara

Lions can look a bit grumpy at the best of times;
they look positively glum in a rainstorm.

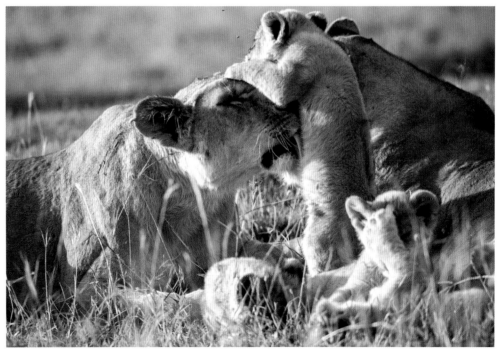

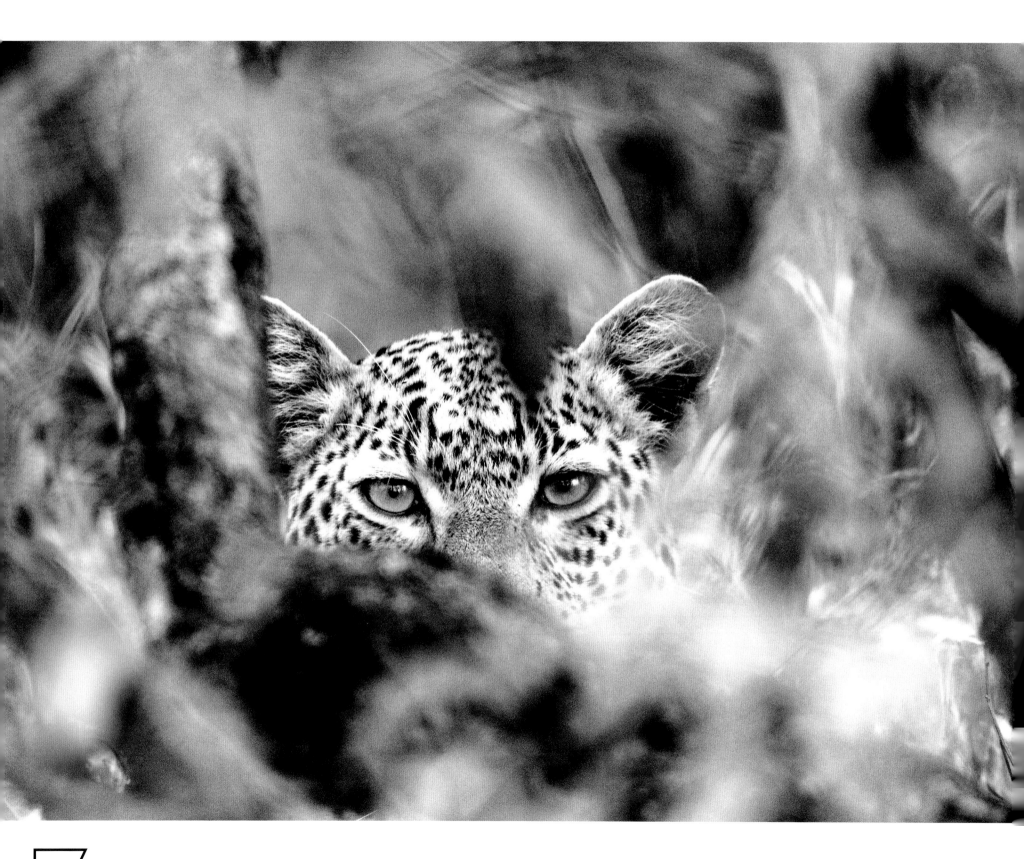

7 YEARS OF CAMERA SHAKE

Male leopard
Maasai Mara

This leopard is known as being shy in the Mara and on this occasion he certainly lived up to his reputation. After seeing him hurriedly drag a kill into the bush, it took a lot of manoeuvring of the 4x4 by the driver, Joseph Sengeny, to get anywhere near where he was. A long wait ensued. After at least an hour, I noticed that he would occasionally look up and stare at the vehicle through a small window in the vegetation. I hung my camera and long lens on a sling I've developed: it gives reasonable stability and freedom of movement. Crucially, it also takes the full weight of the camera. It took a bit of contorting to get into position, then I waited until the next time he appeared. I managed just three or four frames as he next looked up. Ironically, it has become one of my favourite leopard shots. This might be the last view many prey animals see.

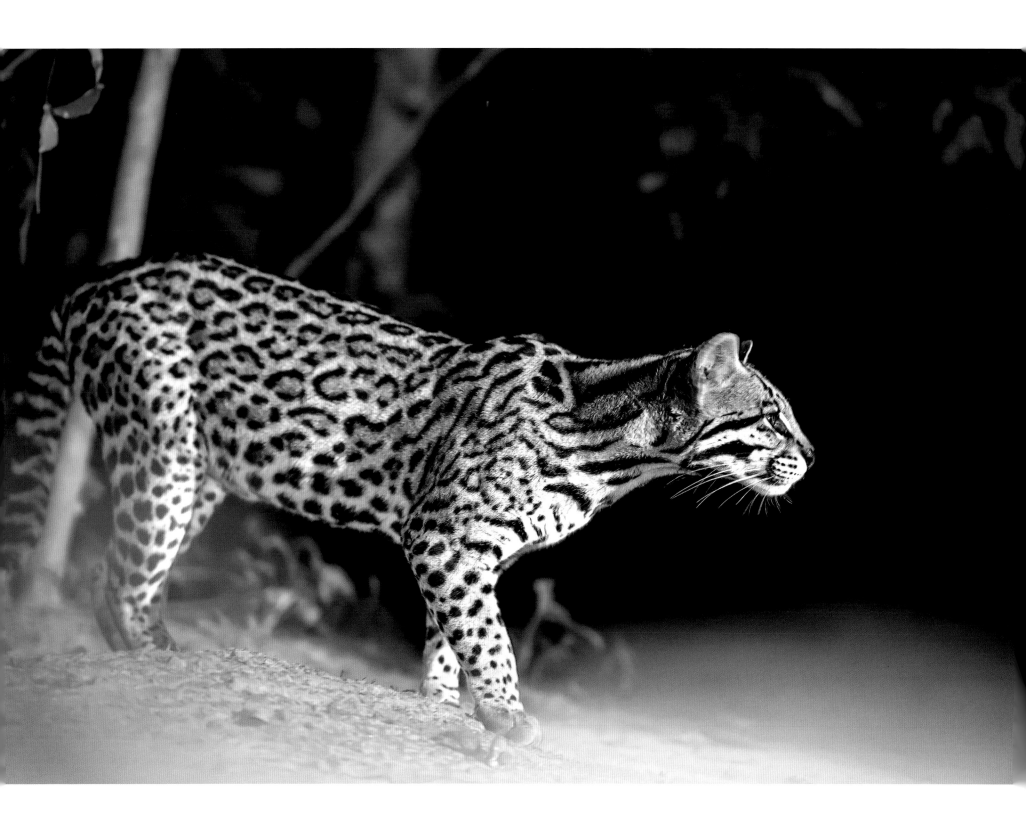

7 YEARS OF CAMERA SHAKE

Ocelot

Pantanal

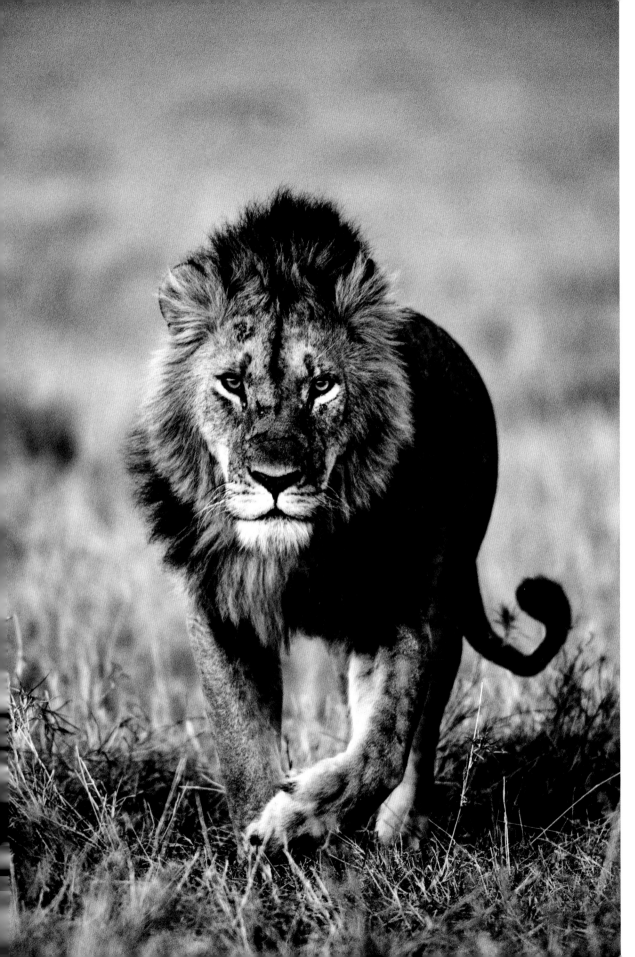

Male lion
Maasai Mara

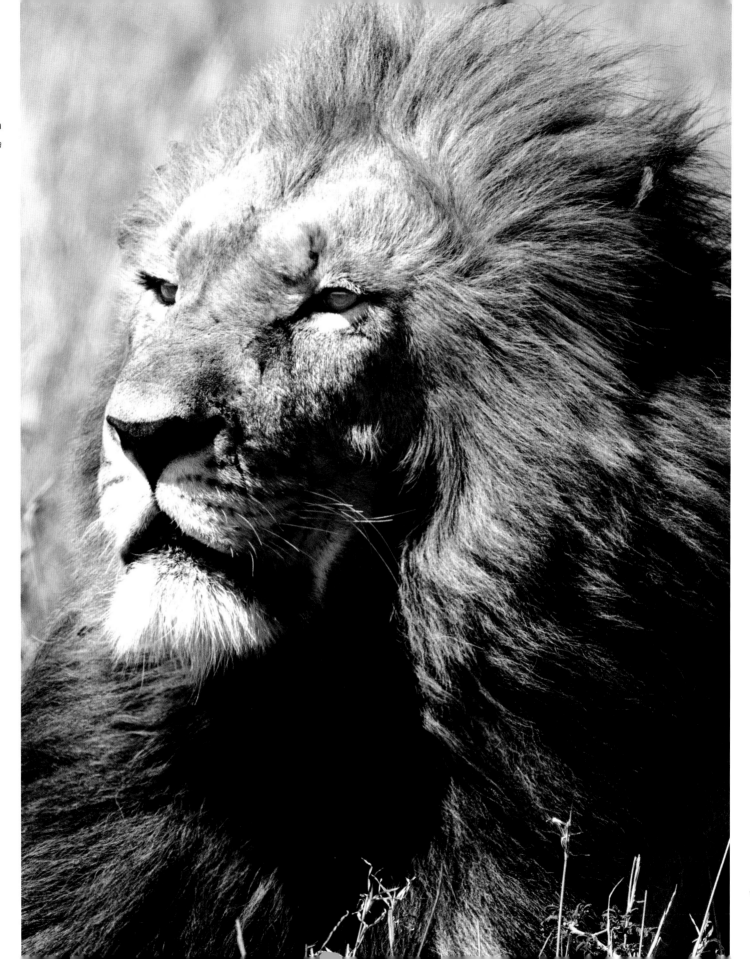

Lion
Maasai Mara

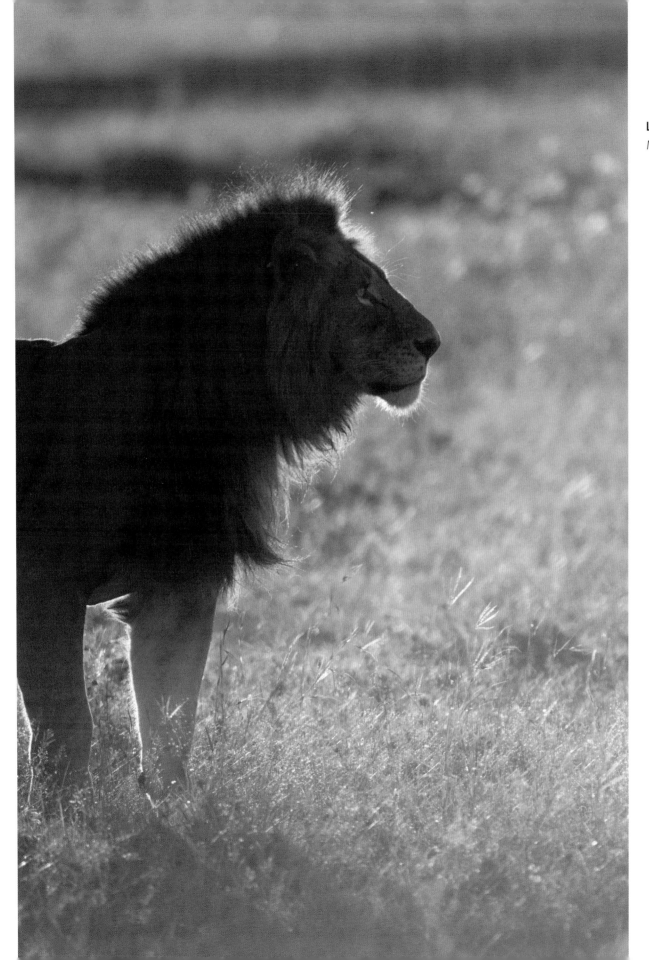

Lion at dawn
Maasai Mara

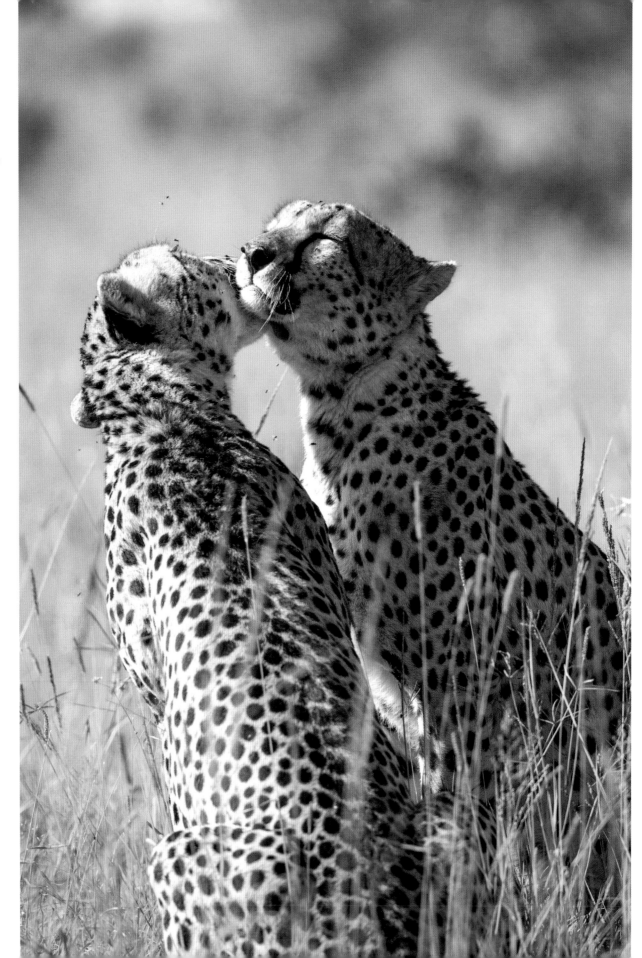

**Male cheetahs groom
each other after a kill**
Maasai Mara

SPEED

In recent years I've become fixated on speed. Capturing animals mid-action adds real grit and drama to an image. Despite the higher capability of cameras now, a lot of my in-flight shots are surprisingly low-tech. I do not use autofocus for many of these shots; instead, the key is to predict or manipulate the exact spot into which a bird is going to fly or, perhaps more importantly, where it will land. The only high-tech aspect I use in that circumstance is the high frames-per-second capability of modern professional-level DSLR cameras. On my Nikon D4 I currently shoot eleven per second. These additional frames often provide the winning shot instead of a frustrating sequence of bird half-in then bird half-out shots with nothing in the middle. Once again, it comes down to the knowledge of the wildlife and the particular species, followed by prolonged observation and coupled, of course, with a refusal to give up.

The image of the swallow in flight was actually easy. On Skomer, off the Pembrokeshire coast, some of the footpaths across the beautiful island are cut through high bracken. This in effect creates a trench about seventy centimetres wide, and I noticed that swallows were repeatedly flying about twenty centimetres above the ground straight down these trenches. It reminded me of the X-wing fighters in the first *Star Wars* film trying to blow up the Death Star.

So, they were flying in a predictable path at a more or less predictable height and at great frequency to catch lots of insects for their young. I lay down by the side of the path and embedded myself into the bracken a little bit so as not to put the swallows off. The camera was lying on a beanbag just off the ground. I simply pre-focused to a point where the swallow would occupy sufficient space in the frame. Then I turned autofocus off. Each time a swallow flew down the trench approaching my predetermined point, I pressed the shutter and held it down for a second or two. Obviously, many of the pictures were out of focus, out of frame or simply empty, but some, as I hope these images show, came out pretty well.

The same technique was used for Agrippa the little owl. To get the shot of Agrippa, I focused my camera where I predicted he was going to land. Again, autofocus was switched off. Then, as he approached, I pressed and held the shutter. All pretty low-tech, but effective.

Some images, however, require more technology. I often use an infrared trigger system to fire the camera and flash units as the animal crosses the trigger line. My garden in Sussex is visited nightly by badgers and foxes, and like most animals they use favoured paths, especially badgers

who actually create their own. Their whole navigation system is based on smell, which is about 700–800 times the power of our own; they literally smell their way along a network of paths to various points in their home territory. By utilising the same line repeatedly, they eventually create a distinctive narrow path. Foxes, deer and even humans will also subsequently use these paths.

The concept, therefore, is simple – set up an infrared 'tripwire' and, as the animal crosses, it fires the pre-focused camera and flash units and in effect takes a 'selfie'. It sounds easy, but in practice it invariably requires a lot of setting up, tweaking and re-tweaking to work well, and frequently one of the flashes will fail to trigger.

When it works it can be very effective and I especially enjoy this set-up in the garden; as I sip my wine in the conservatory, I watch the animals do the work for me.

Another advancement in camera development is improved ISO capability, or the ability to operate in low light. In the past, taking an image in low light with a very high ISO setting normally resulted in what is known as noise, which is essentially a very grainy image. Now, however, the top digital SLRs can take acceptable images at high ISO. I effectively gain an additional couple of hours in the day to get shots, which means I can be more active at dawn and dusk when you often find the best animal behaviour. The leopard shots would just not have been achievable without this capability.

I have chosen to embrace camera capabilities and advancements, using whatever technique, whether low-tech or high, to get the job done. It's certainly not cheating as some people claim – this type of photography requires a lot of time, patience and persistence.

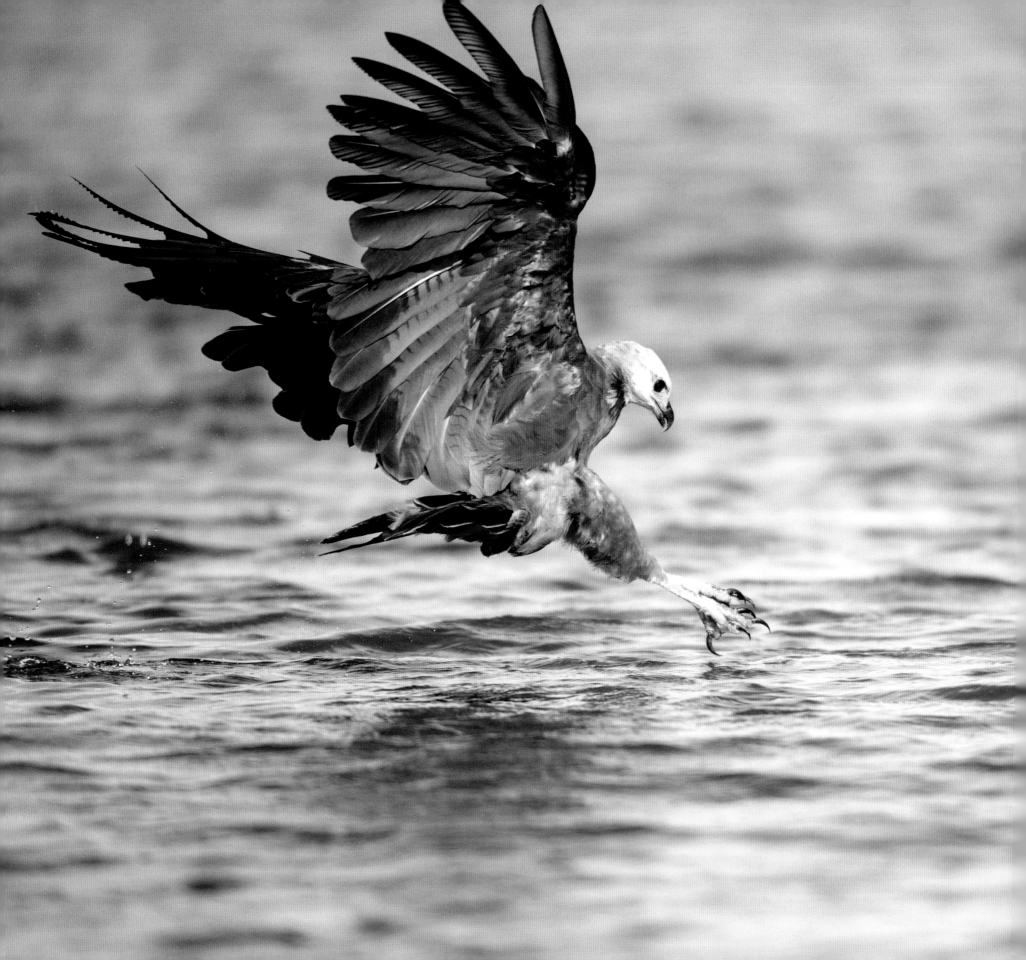

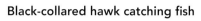

Black-collared hawk catching fish
Pantanal, Brazil

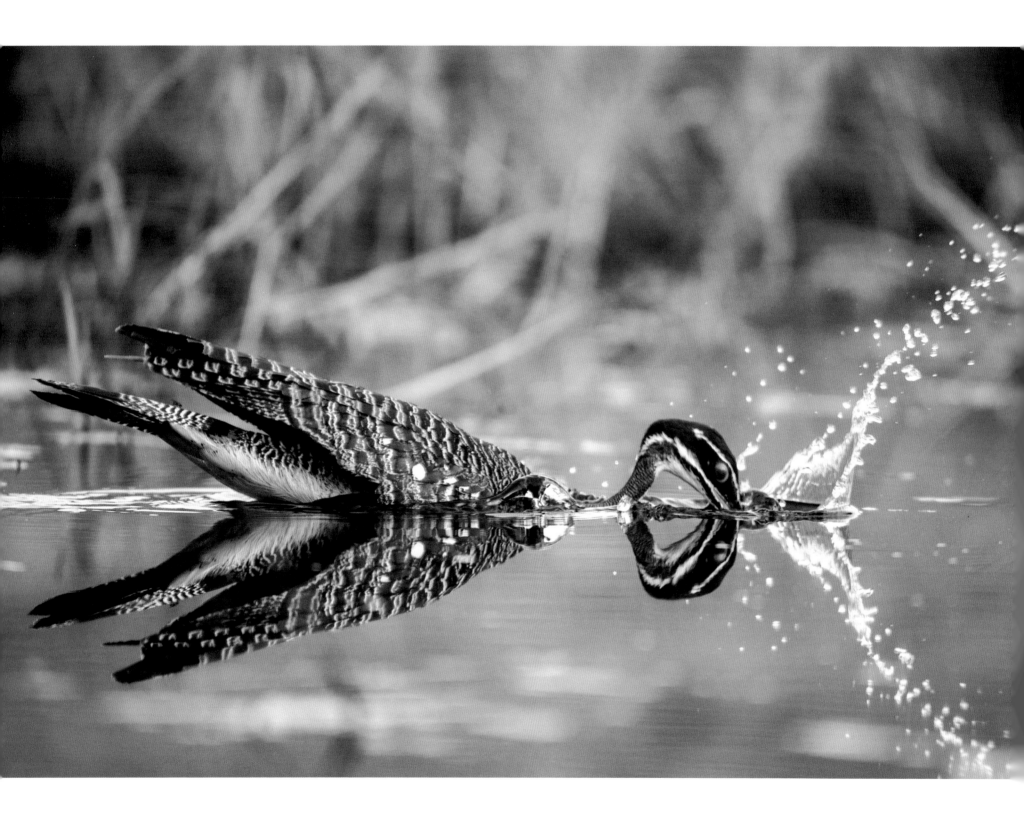

7 YEARS OF CAMERA SHAKE

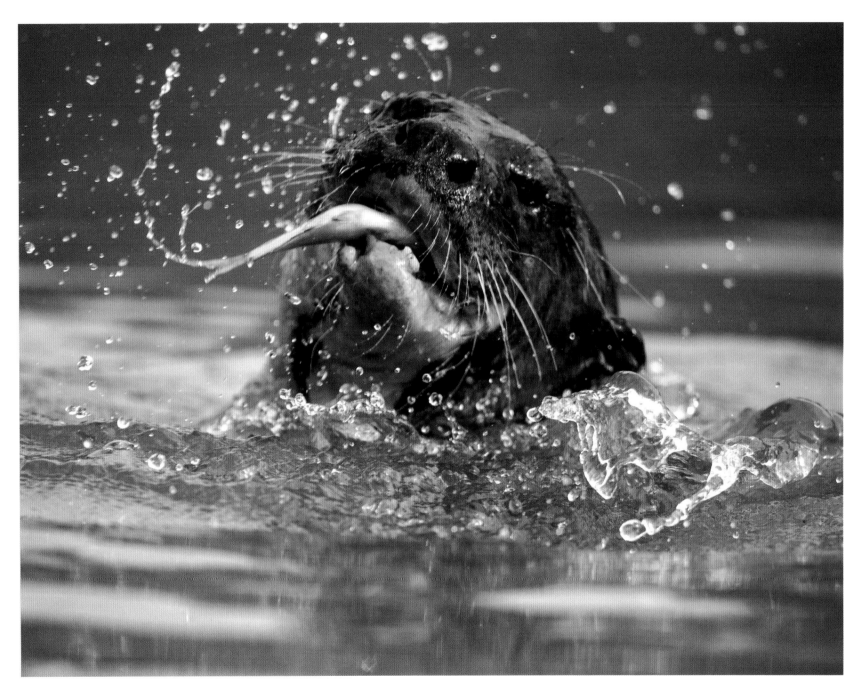

(left) Sunbittern striking for fish

Pantanal

(above) Giant river otter catching fish

Pantanal

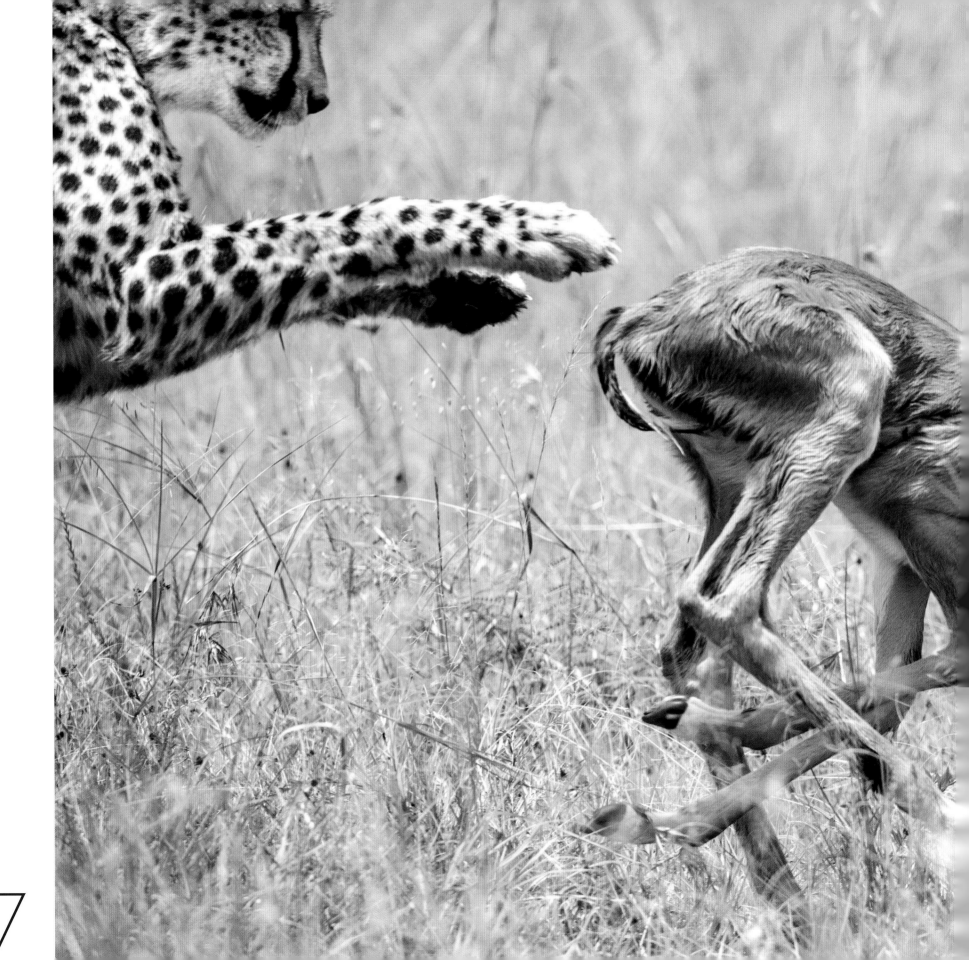

Cheetah chasing impala fawn
Maasai Mara, Kenya

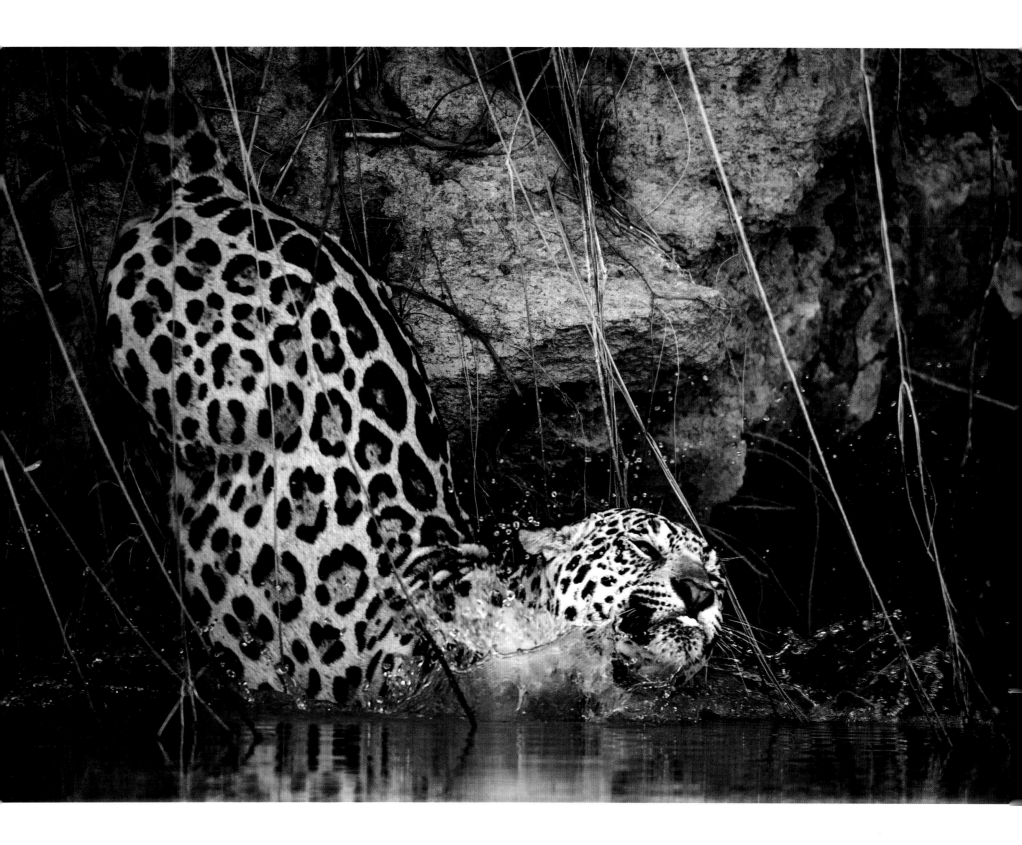

7 YEARS OF CAMERA SHAKE

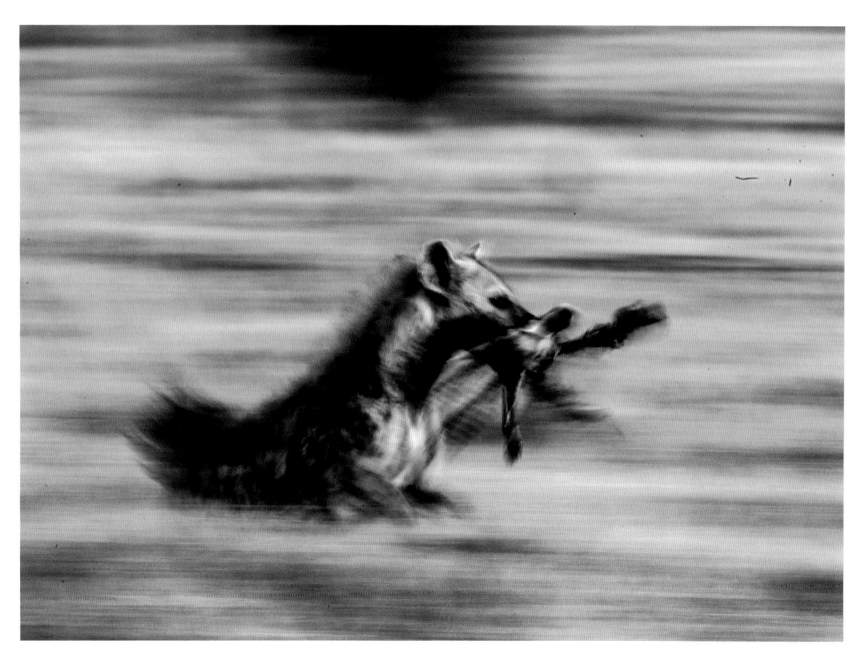

(left) Jaguar landing in water
Pantanal

(above) Hyena running with head of prey
Maasai Mara

Sometimes panning with the subject, creating a blurred effect, can convey speed and motion more effectively than freezing it.

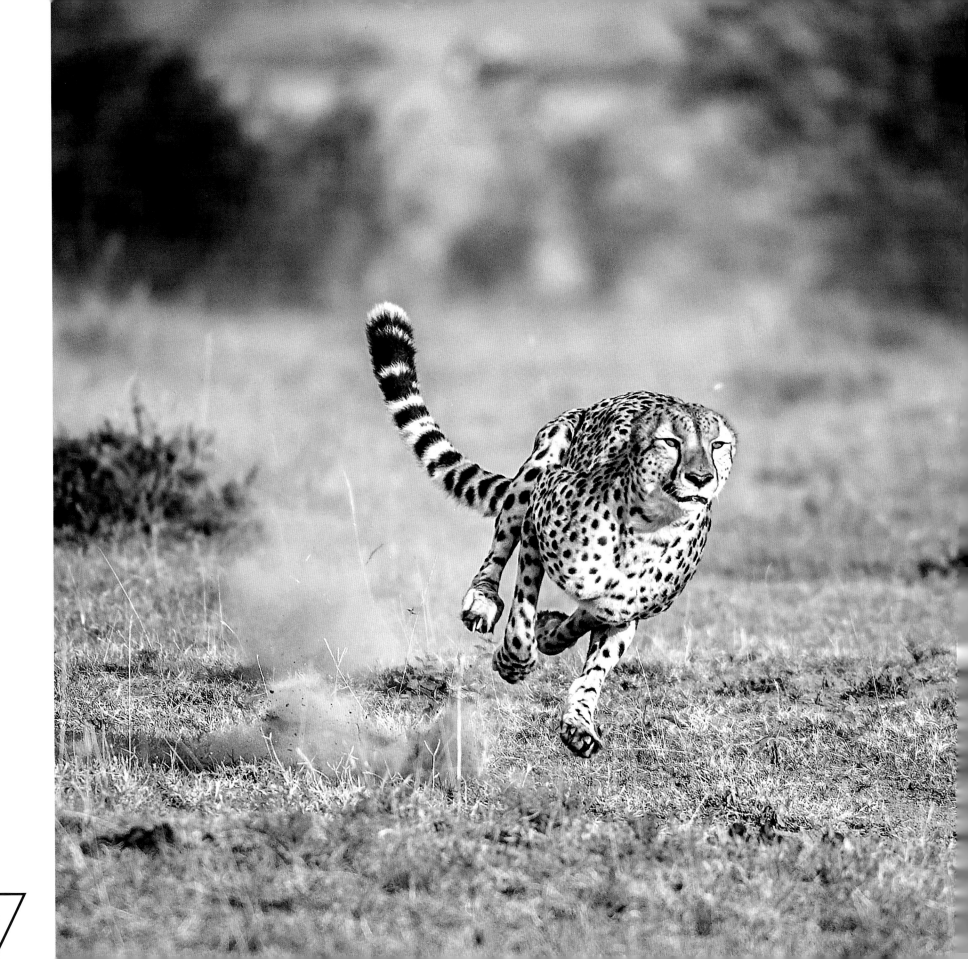

Cheetah during the chase
Maasai Mara

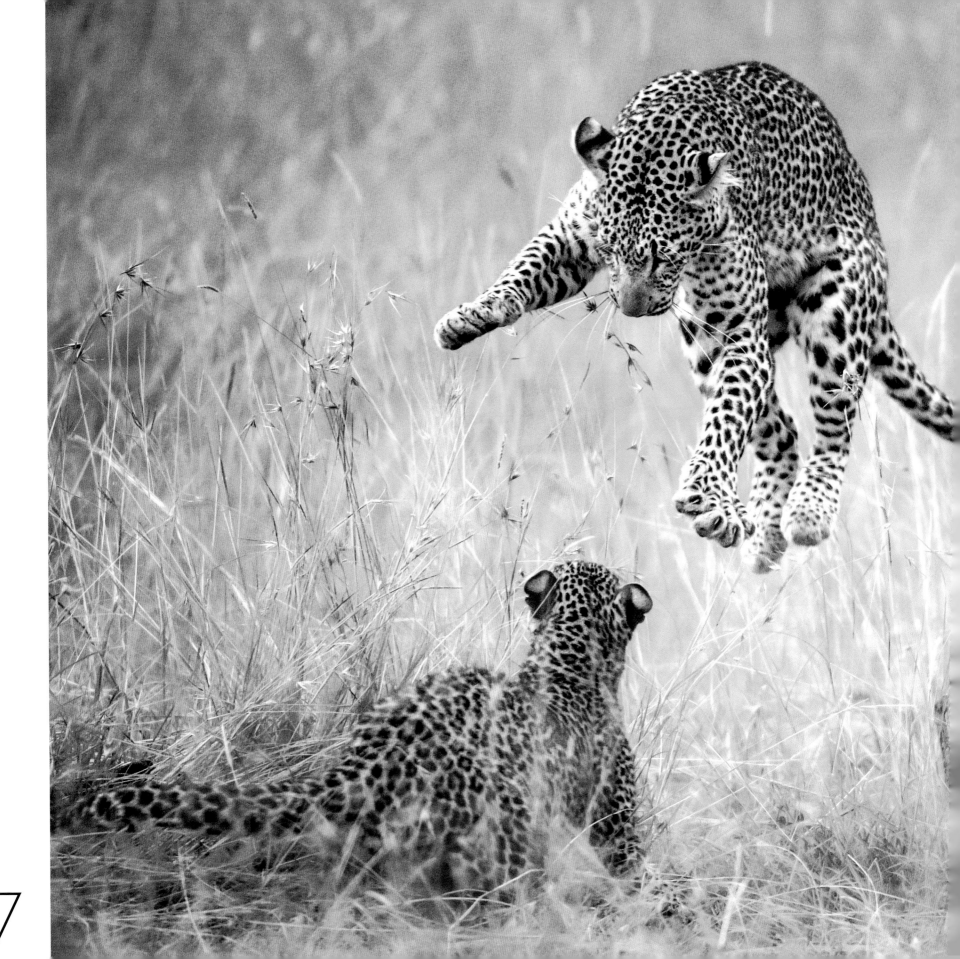

Female leopard leaping over cub
Maasai Mara

Fig must be one of the most well-known leopards in the Olare Orok conservancy, and she's so relaxed around vehicles. On this occasion we found her in a tree with her cub and their kill. We were faced with a three-hour wait, but it was worth it as the two cats started chasing and playing like domestic kittens. I must thank modern camera design with its rapid focus, and exceptional low-light capabilities for capturing this image. It was, however, a case of just focusing, shooting and trying to stay with the action, only looking to see what I had later on. Luckily I got this one.

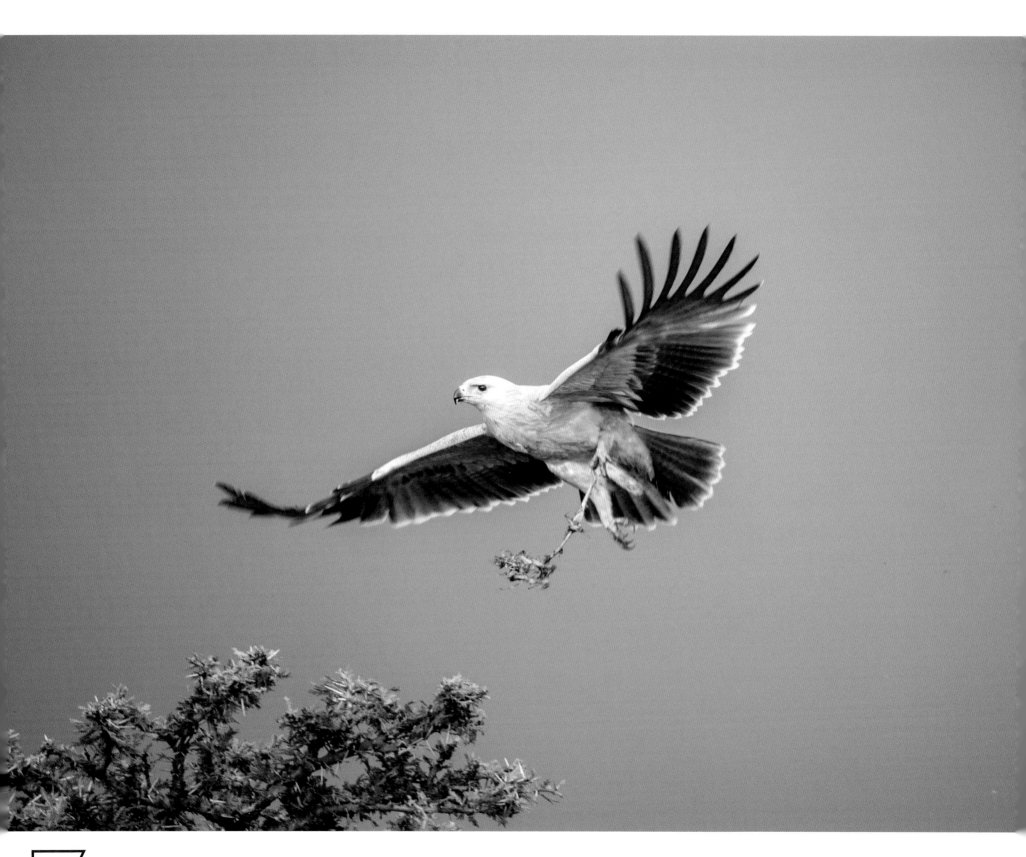

7 YEARS OF CAMERA SHAKE

(left) Immature tawny eagle

Maasai Mara

(above) A shot of the author getting the correct line of flight for high-speed shots

Sussex, UK

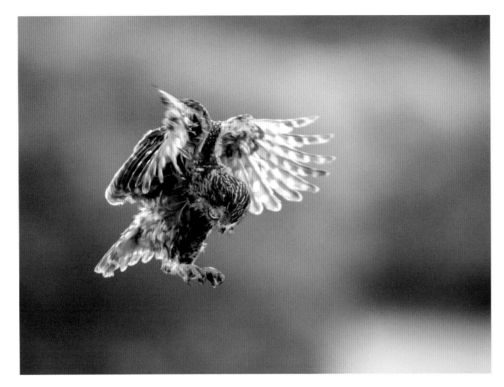

(left) Little owl in flight
Sussex

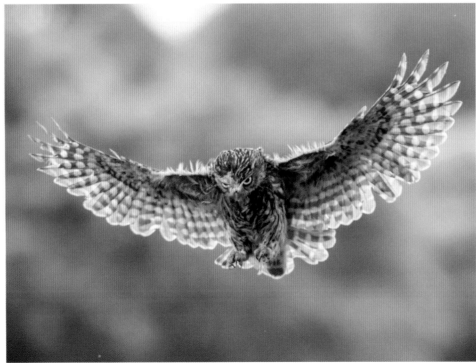

(right) Little owl just about to land
Sussex

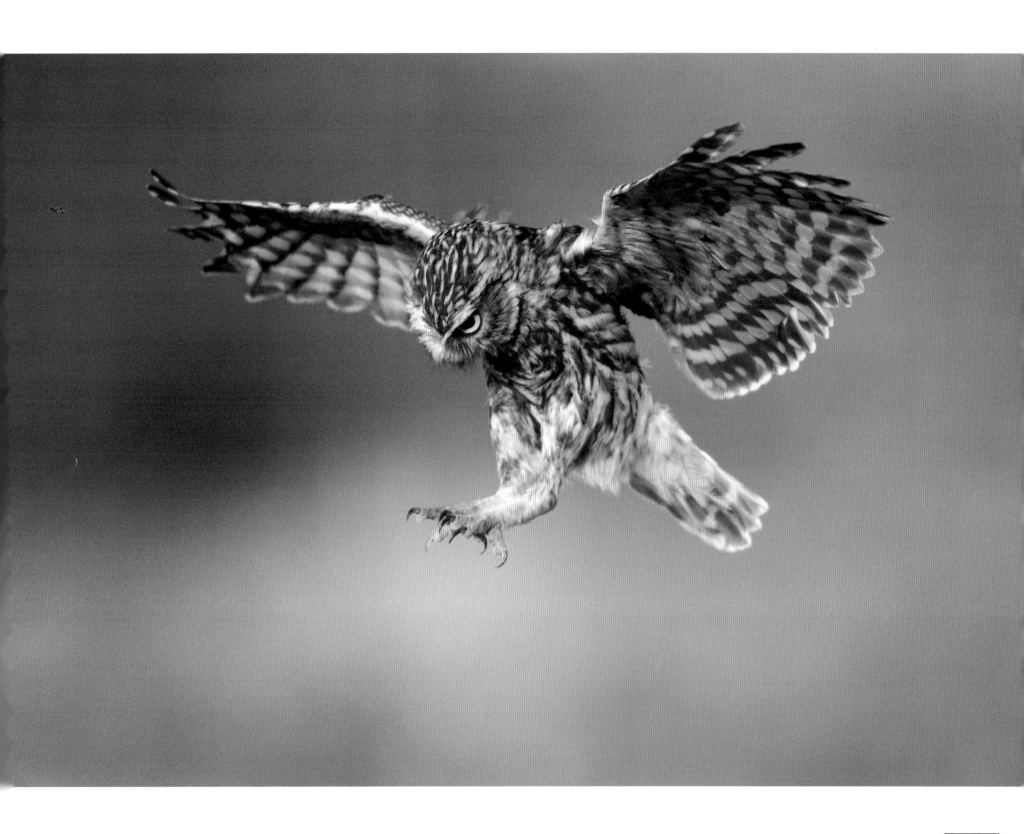

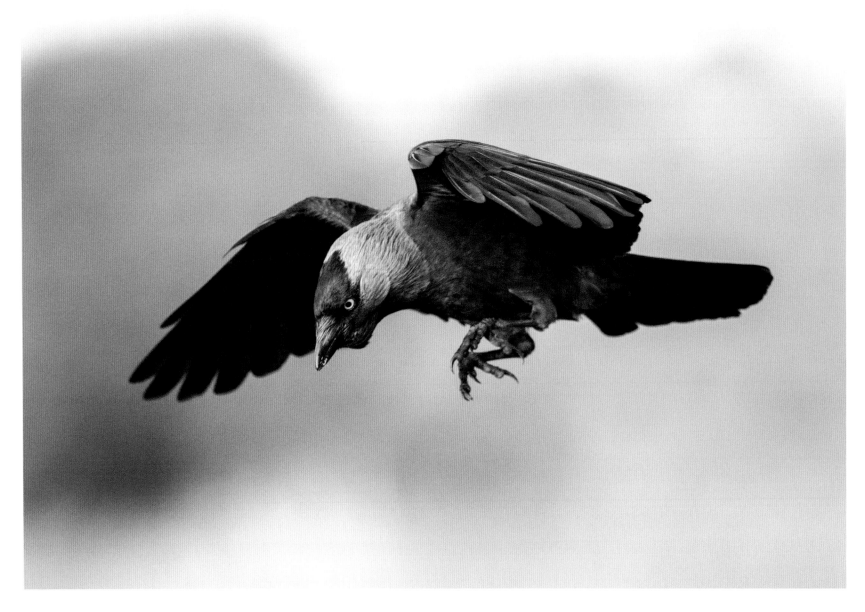

(above) Jackdaw in flight

Sussex

(right) Hoopoe landing at nest hole

Kiskunság National Park, Hungary

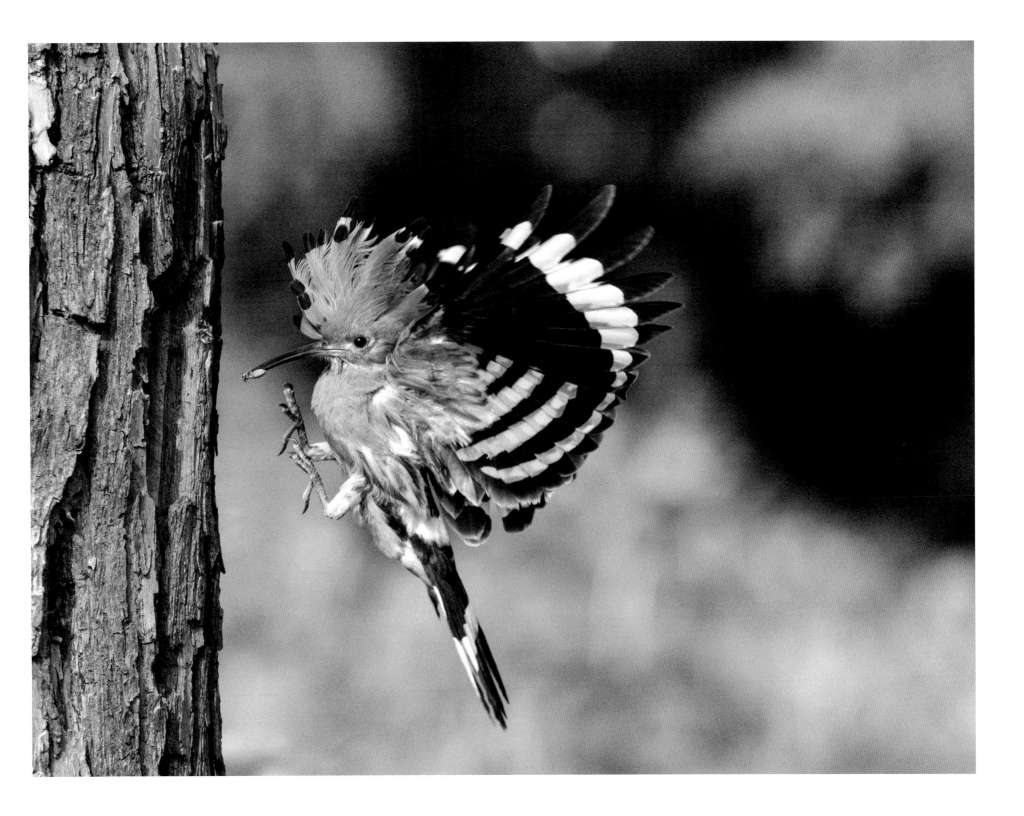

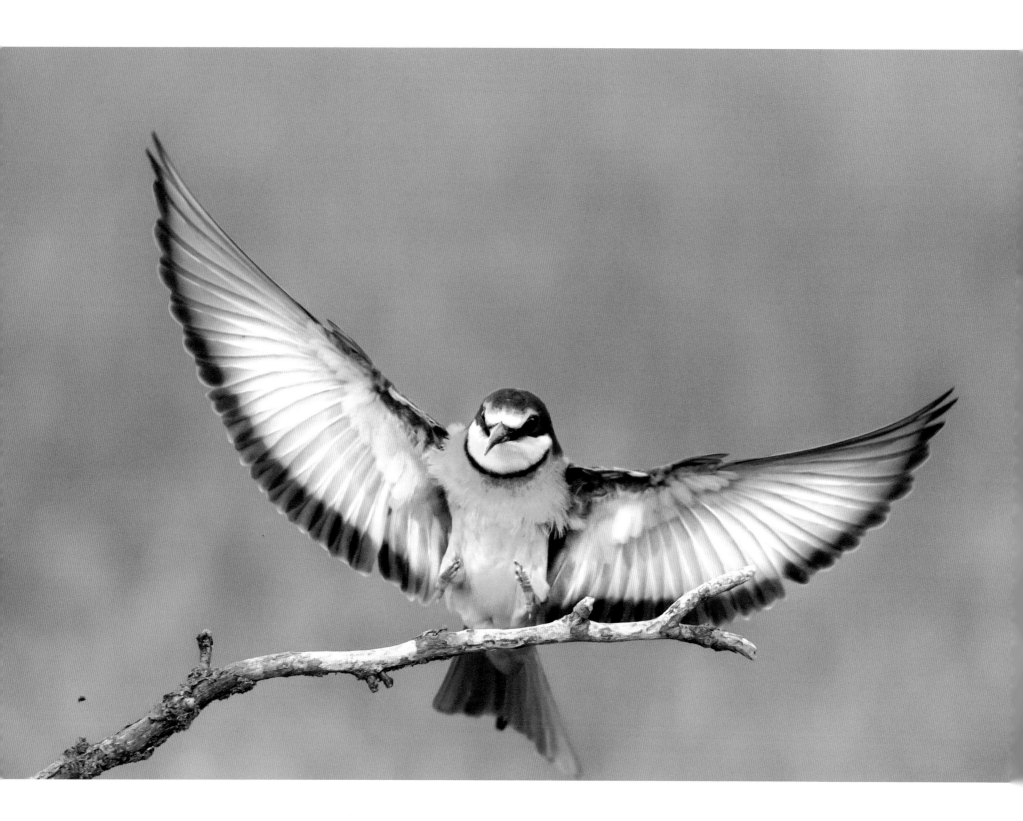

7 YEARS OF CAMERA SHAKE

Bee-eater landing

Kiskunság National Park

Bee-eaters make frequent insect-catching sallies before returning to their regular perch outside the colony. Sometimes these colonies are not situated in the most convenient places; this one drifted across a sandy track on a piece of farmland in Hungary, and while I was in the hide I heard the sound of a fast-approaching vehicle – my hide was camouflaged just a metre or so to the left of the track. As the vehicle bounced past, I did wonder if they even knew the hide was there!

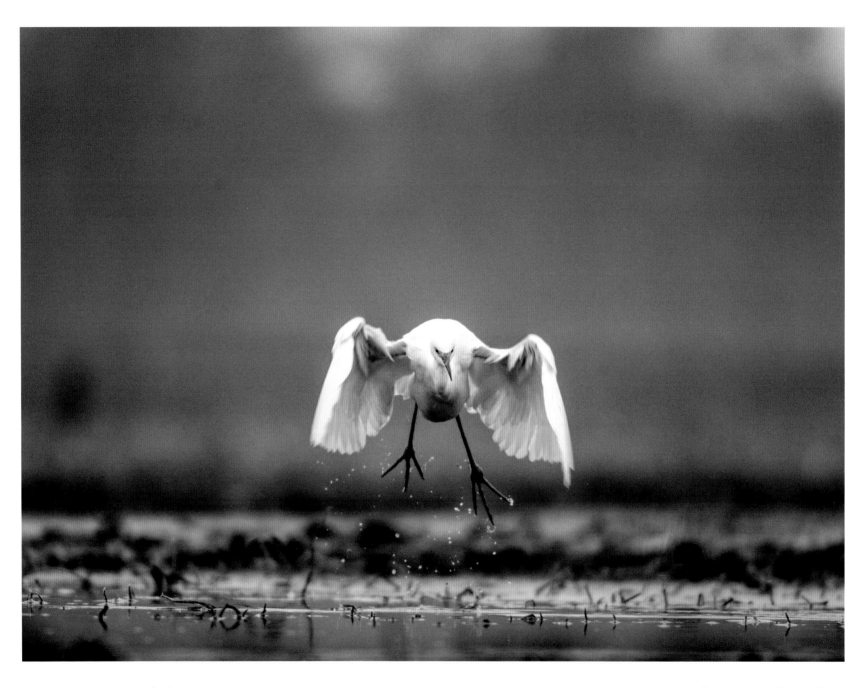

(above) Little egret in flight
Kiskunság National Park

(right) Barn swallow in flight
Skomer Island

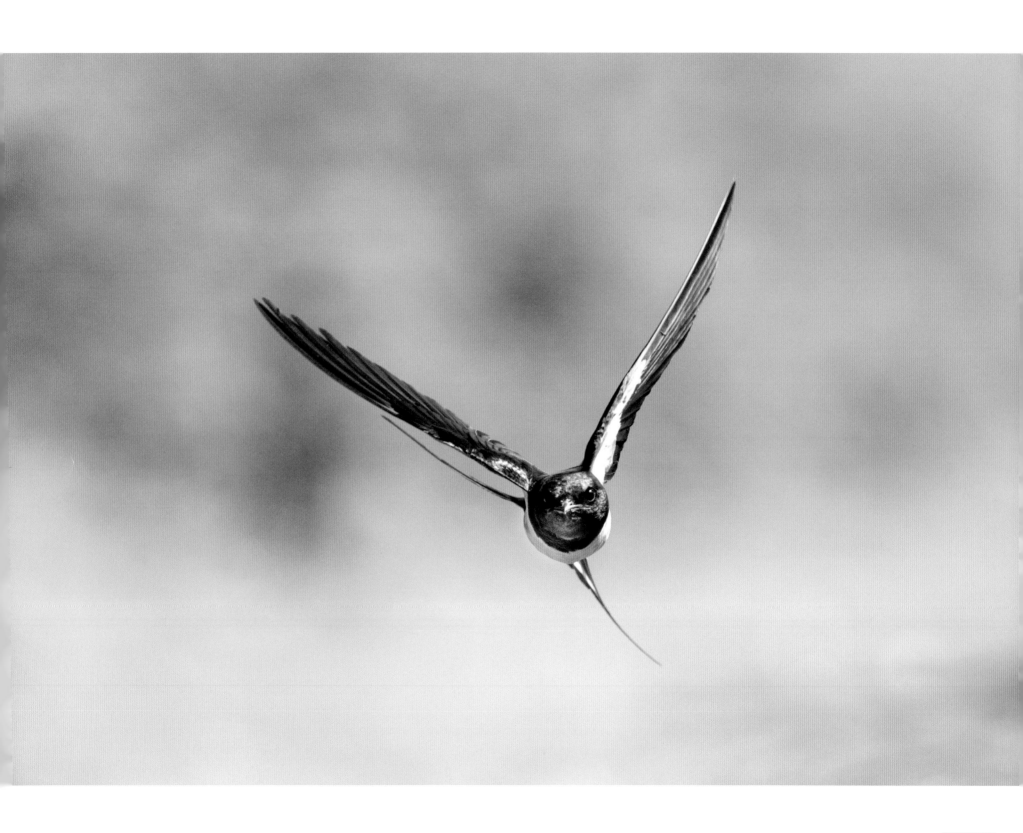

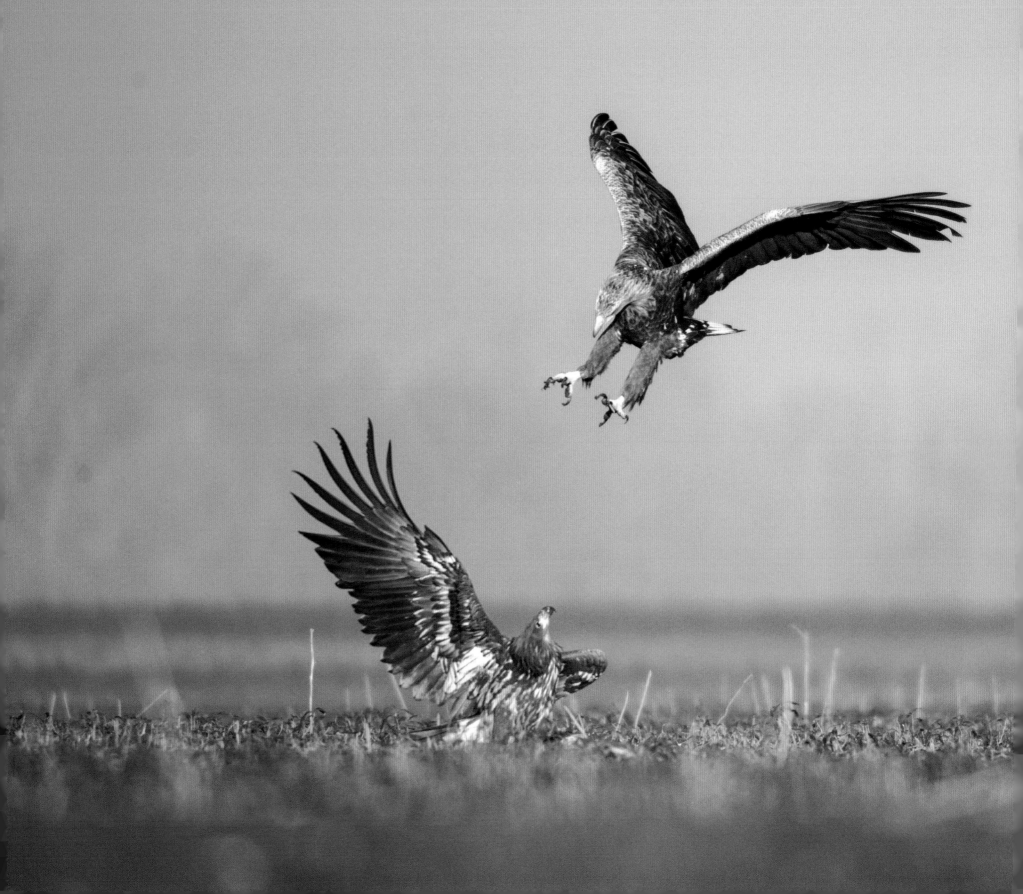

White-tailed eagles fighting
Kiskunság National Park

LIFE IN A HIDE

Most wildlife photography of shy species takes place from a hide. The first hide I used was a simple canvas sheet hung up next to an oak tree that housed a blue tit nest. This was using my first camera, the Prinzflex, with a 135 mm lens; obviously poor equipment and by far inferior to what I use now – my extensive Nikon system. However, growing up on a budget in photography is potentially the best way to learn, especially with wildlife. You learn shortcuts, workarounds, and how to get the best out of very limited kit. From the wildlife perspective, you learn a huge amount about fieldcraft and how to get close to your subject or, as we call it, being within the fear circle.

Now, I use any number of hides in different designs, some still incredibly simple, and some more elaborate. More elaborate does not necessarily mean more successful. It is observing the species' habits and placing the hide that ensures success.

Either way, no matter what you use as a hide system, your goal is to get within the fear circle of the animal in order to get perfectly composed shots, in the right light, of natural behaviour without – and this is crucial to me – any detriment whatsoever to the animal's welfare.

Most small bird photography involves a technique known as bait and perch. In effect, the photographer sets up a food source for the bird and an approach perch, which is in the correct position to get the shot you want. Some people say this is cheating and that we should stalk birds in the wild, but I do not feel this is the case. Indeed, bait and perch, as a technique, is a win-win situation for both bird and photographer, causing much less disturbance to birds in their natural environment than people trying to chase them through a piece of woodland or across an open marsh.

Working in a hide is certainly not for everyone. It often involves long hours in uncomfortable conditions, with a very limited view of what's around you. Photographic hides are not the big, open affairs normally found on bird reserves; instead they tend to be small and cramped with just one viewing port directed at the perch where your target species is expected to land. The more sensitive the species, the tighter the hide discipline needs to be.

I usually find the first hour is one of the slowest; it takes a while to settle down and get into the zone. Once there, being in a hide can be magical; your senses, especially sound and vision, become heightened to the environment you're in. I have witnessed many rare spectacles, and have certainly tuned in to some vocalisations of birds that you just don't read or hear about in bird guides. This total immersion in the wild environment for hours at a time hones your field skills and observation further.

Don't get me wrong, I don't sit in a cramped hide in freezing cold conditions for masochistic pleasure; rather, it's a necessary part of the job and I try to make it as comfortable, enjoyable and productive as possible.

My floating hides have become quite well known, even featuring on the BBC. I've always liked the low-level, intimate shots of wetland bird life, and shooting from the bank or riverside always resulted in the perspective being too high. I needed to get the camera just above water level and the only way to do that was to develop a platform that meant that the camera was three or four centimetres above the waterline, with a surrounding covering system to hide me. I then get in the water behind the platform – within, effectively, a short camouflaged tunnel or low dome – and move the whole strucutre, following or approaching the subject without disturbance. The resulting images are some of my favourites.

Using a floating hide can be a little bit extreme. The water can be very cold, especially if you're in for over an hour, so I use a wetsuit or even a drysuit to prolong my time. In Hungary there was the added pleasure of leeches about the size my finger! I have looked down at my chest waders at times and seen twenty or thirty leeches marching up the neoprene to get to my skin. Although I can reason that they will not do me any harm, they are still horrible! And once it starts happening, my time is limited in the water. The shot of the great crested grebe was achieved by waiting in these conditions and just repeatedly knocking leeches off. I can get them off my arms, but when they're on my back I can't reach them. So, once I'm out the water, I virtually strip off and violently rub my back against the undergrowth or grass to get rid of them.

On a more positive note, in 2014 I followed a pair of little grebes who raised two broods of chicks on the pond of Sussex Wildlife Trust's headquarters, which just happens to be a quarter of a mile from my house. Almost every morning, at about 4 or 5 a.m., I would put my wetsuit on, normally still wet and cold from the previous day, and slide into the water to follow the birds; it became addictive and I grew very attached to the pair, following their trials as they raised their two broods. The floating hide was so successful that I could get within one or two metres of the nest site with absolutely no disturbance. Many of the birds in this situation do not see the hide as any threat at all, allowing very close, intimate photography. On one occasion, I also noticed that the pair of adults I had been following was aggressively swimming towards an area at the pond's edge. I moved a little closer and realised there was a large grass snake catching some sun, which then alarmingly swam across the water and tried to get onto the floating hide, or rather into it. Now, I have no great fear of snakes, but there was something alarming about it trying to get inside the floating hide and effectively around my head! I had to reverse rapidly and push the snake away.

Sometimes, as when photographing barn owls, a little more flexibility is required, so I wear camouflage clothing. In this scenario, you never exactly know where the barn owl is going to hunt, so a little freedom of movement is beneficial. However, if you just sit there in normal clothes with pale hands and pale skin showing on your face, the barn owl will inevitably see you and fly off. Therefore, camouflage, or disruptive pattern material (DPM) as it is known, just gets you that little bit closer.

Another example is a freshly cut hay meadow; it tends to act as a magnet to predators. With the top layer of grass removed, the small rodents below are much more exposed. The evening after a meadow has been cut, I have watched red kites, buzzards, kestrels and foxes all honing in on the area. I think foxes actually smell the freshly cut vegetation from the surrounding countryside. Either way this acts as a great opportunity for me, so setting up in cover, while camouflaged within the hedge, can produce great results.

When using camouflage, I do go the extra mile to break up the human outline. It's true that in full camouflage you can feel a bit of an idiot – however every additional feature of camouflage can gain you additional proximity, and if I'm going to invest the time to go to a location and sit waiting for a subject, I always intend to maximise my chances of success.

A camouflage jacket will only achieve so much; the human head, especially with pale skin, is the beacon of the ultimate predator for some of these animals, such as true rural foxes, persecuted for centuries by humans. I have seen foxes watching me from about 500 metres away, and even if I just turn and look at them directly, they often turn around and slope off; it is just not worth the risk to them.

So, wearing a bush hat will break the outline of the head and shade a pale face. In this situation, I've watched barn owls quartering closer and closer, although they will eventually see the face or hands and do their distinctive 'double-take' and bear off, normally just before they are within the perfect camera range. So the addition of camouflage gloves and scrim netting or a balaclava across the face can really do the trick. Add to this a little bit of camouflage for the camera and tripod and you will really be getting somewhere. I have had barn owls glide right past my head and perch just two metres away. This, for the photographer, is really frustrating, as they are too close to focus. On a personal level, however, it's incredible to have a barn owl perched so close yet oblivious to your presence. I am certain that one day a barn owl will perch on my head.

If animals don't see it, humans definitely don't, and I have had many people walk within a metre or so of me. I have to make the decision: do I say something? When I have done so in the past, people have jumped out of their skin! Now, I just let the person walk on by.

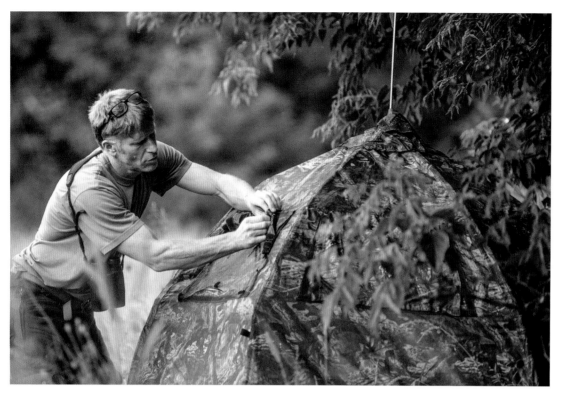
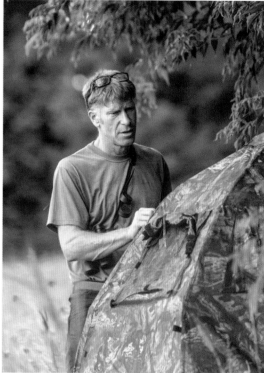

Setting up a hide

7 YEARS OF CAMERA SHAKE

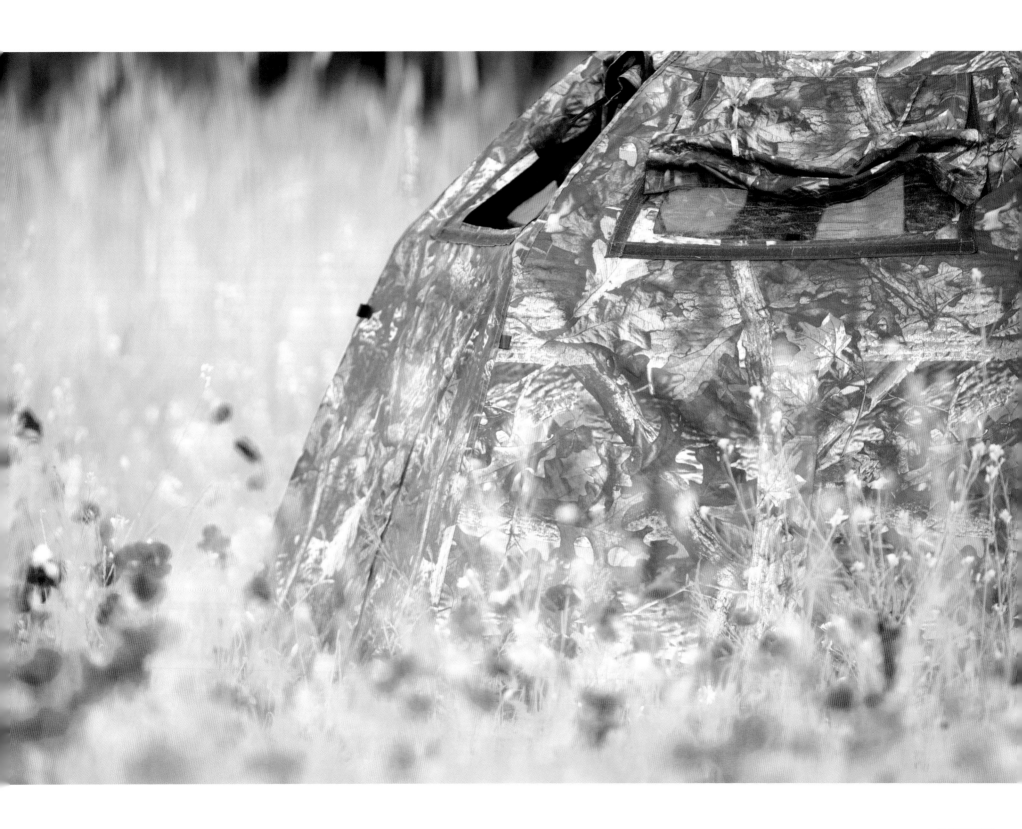

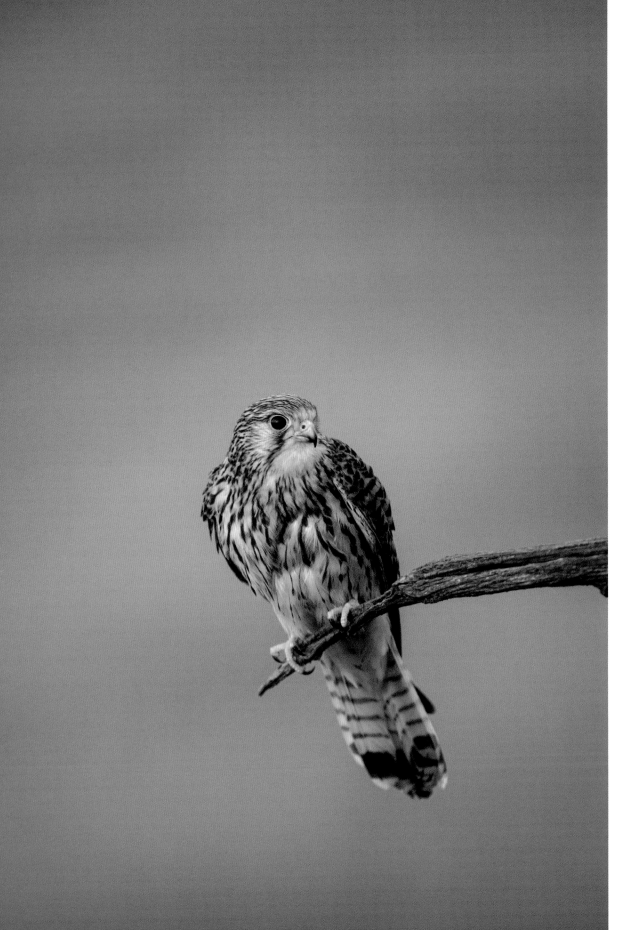

(left) Kestrel
Kiskunság National Park, Hungary

The kestrel was the first bird of prey I ever saw as a child.
It was hovering above a cliff in Cornwall and I was told it was
a kite. Ironically, the red kite was then almost extinct in the
UK and the kestrel was a common sight especially along the
sides of motorways. Nowadays though, the red kite is in the
ascendant and the common kestrel is the only declining bird
of prey in the UK.

(right) Mating red-footed falcons
Kiskunság National Park

I have a great friend, Istvan Bartol, who is director of
Kiskunság National Park. We have worked together for six
years, running photographic tours in the National Park, and
we always swap ideas about setting up hides. However, his
tower hide in the middle of a red-footed falcon colony is
elaborate to say the least; the main advantage being that it
is at the exact height of the falcons going to and from the
nest sites. Unfortunately, to reduce disturbance to the
birds during breeding season, we have to arrive
before dawn, which is about 3:30 a.m.

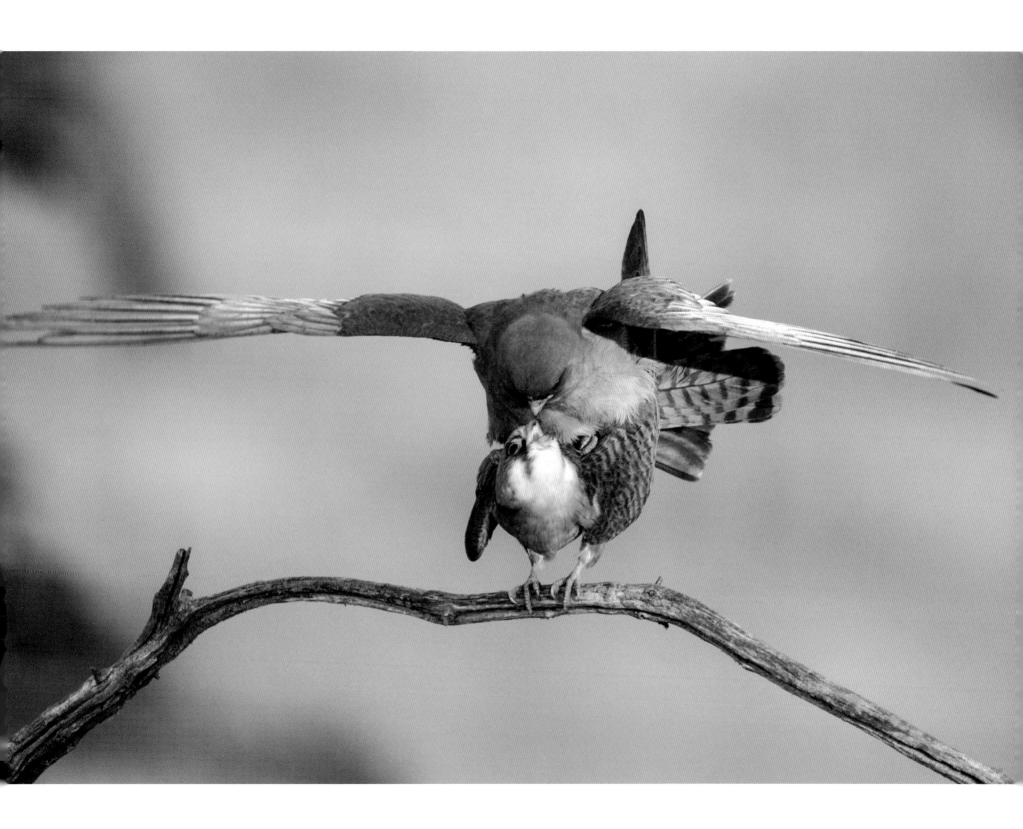

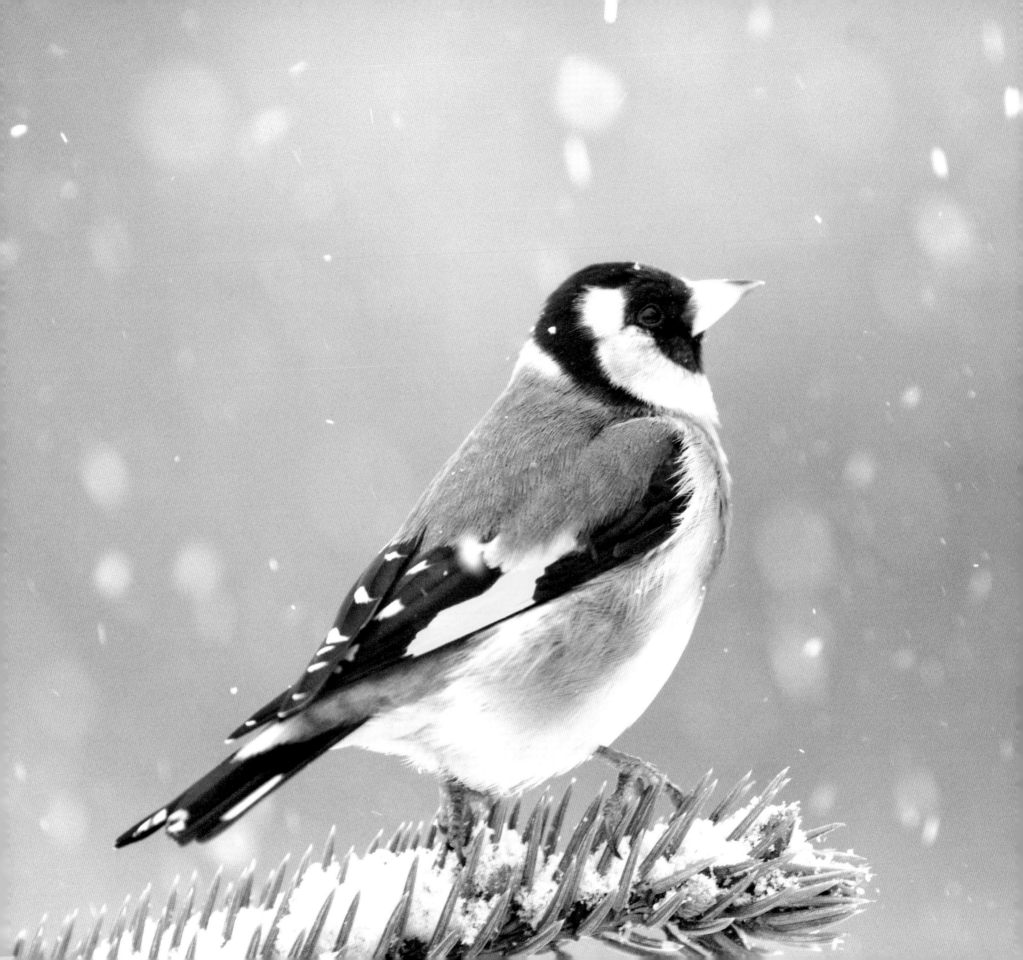

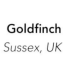

Goldfinch
Sussex, UK

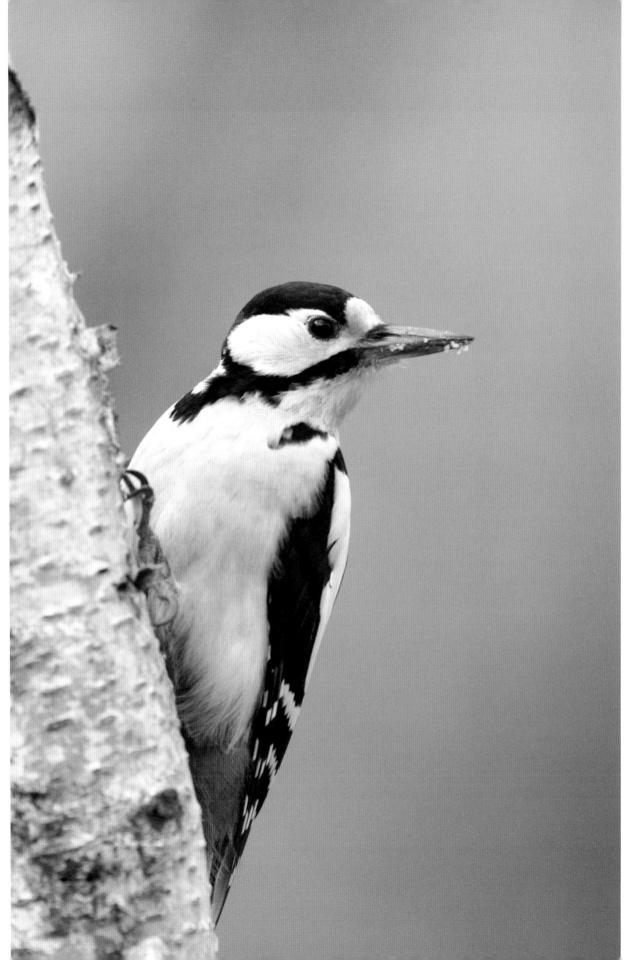

Great spotted woodpecker
Sussex

Tawny owl
Sussex

When tawny owls fledge and leave the nest, they are unable to fly and clamber through the branches, squeaking to encourage the parent birds to bring food. They are pretty useless at this stage and it's hard to believe that if they survive to adulthood they will become one of the most efficient killers of the woodland.

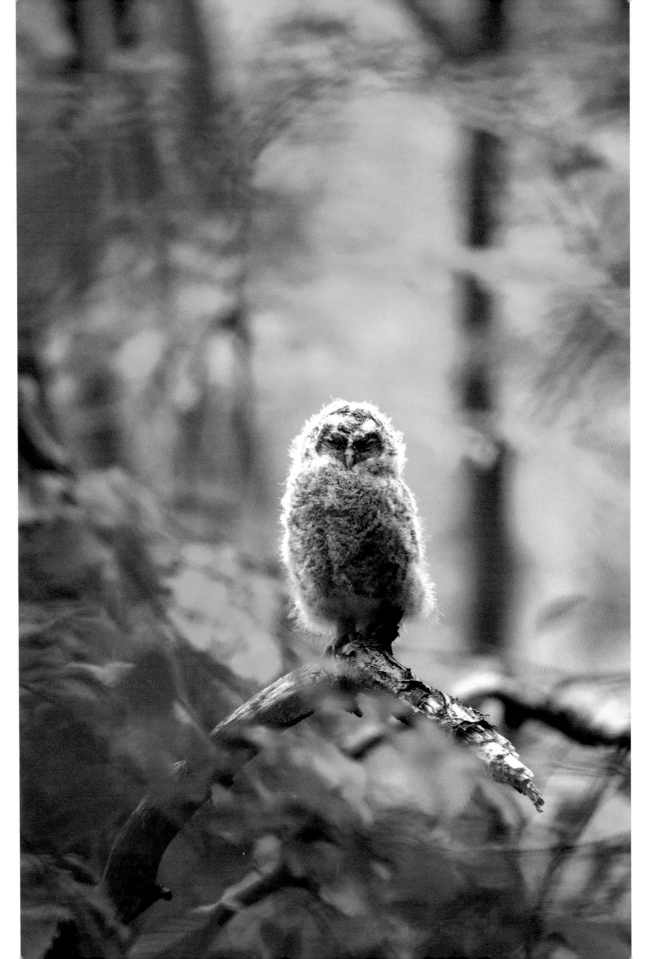

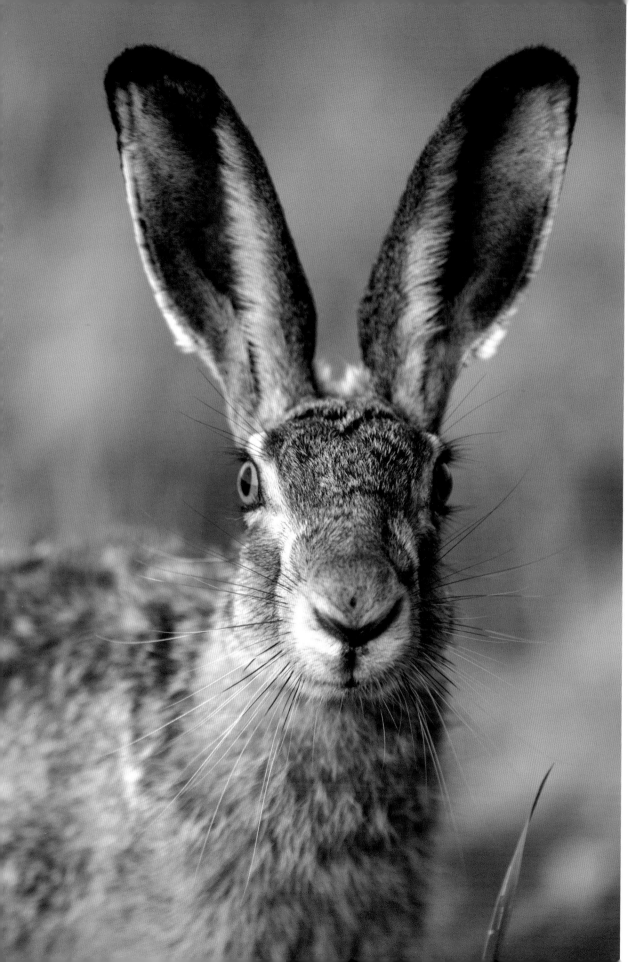

(left) Brown hare
Kiskunság National Park

Brown hares are tricky to photograph in the UK; they tend to utilise huge, open fields, are very difficult to approach, and are often suspicious of hides. In Hungary, however, they are much less timid and much more common. An evening set-up with a hide wedged into a hedge can be a lovely experience as well as a productive one. Sometimes the hares approach so close that I can't fit them all into the frame, and they will even stare towards the hide at the sound of the shutter firing.

(right) Brown hare at sunset
Kiskunság National Park

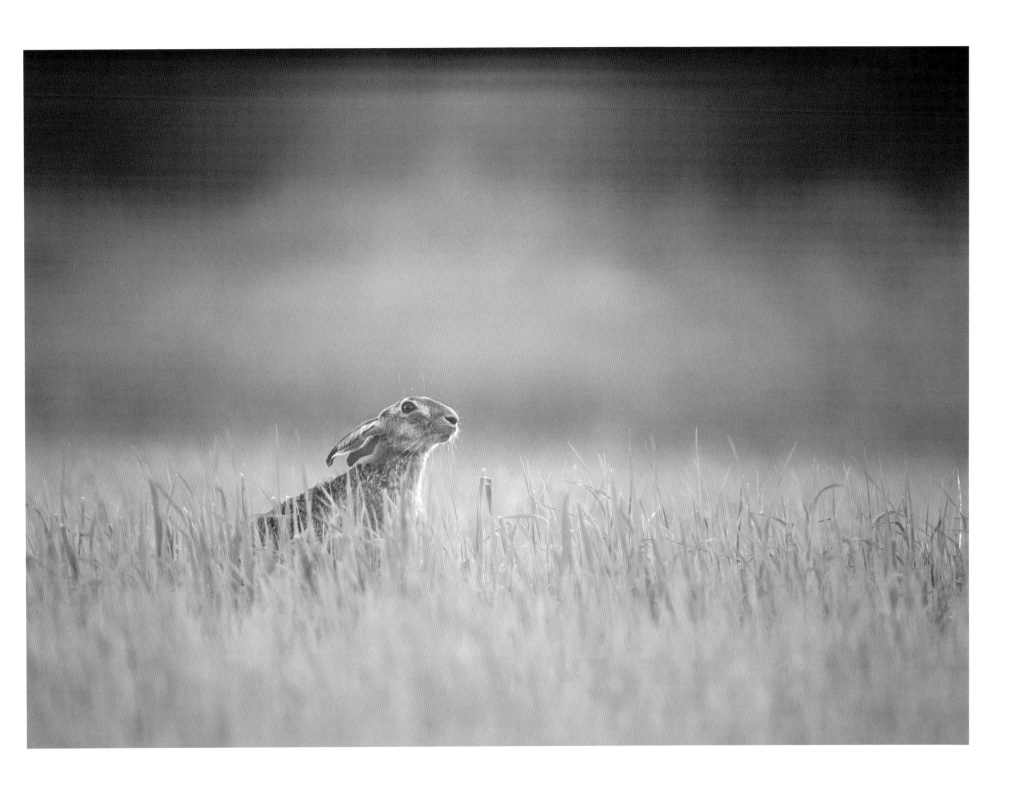

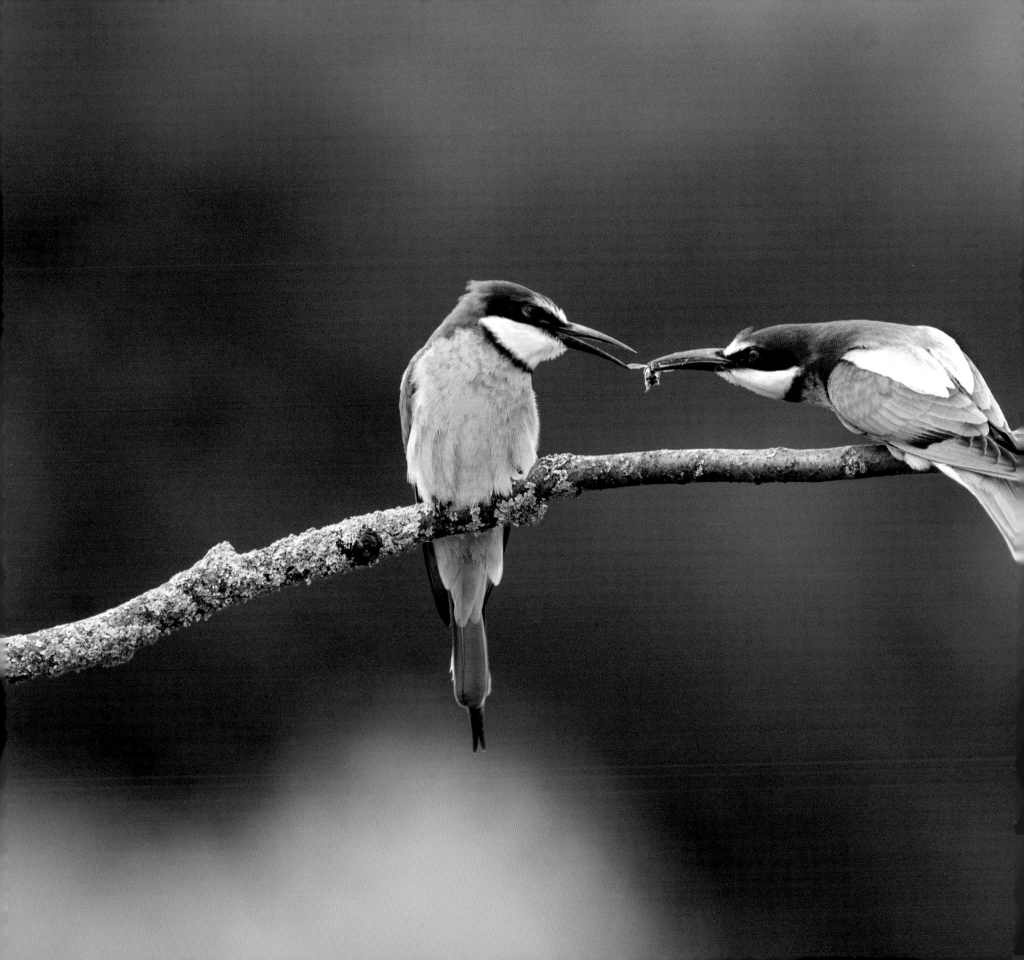

Bee-eater passing food to mate
Kiskunság National Park

(left) **Working in a hide in harsh weather**

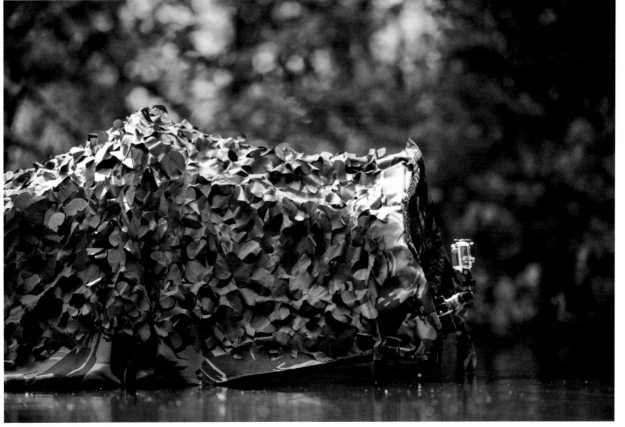

(left) **Floating hide**
Surrey, UK

The well-known floating hide that was even featured on the BBC can seem rather extreme in its usage but is highly effective.

(right) **Great crested grebe**
Kiskunság National Park

I had to endure many leeches to get this shot.

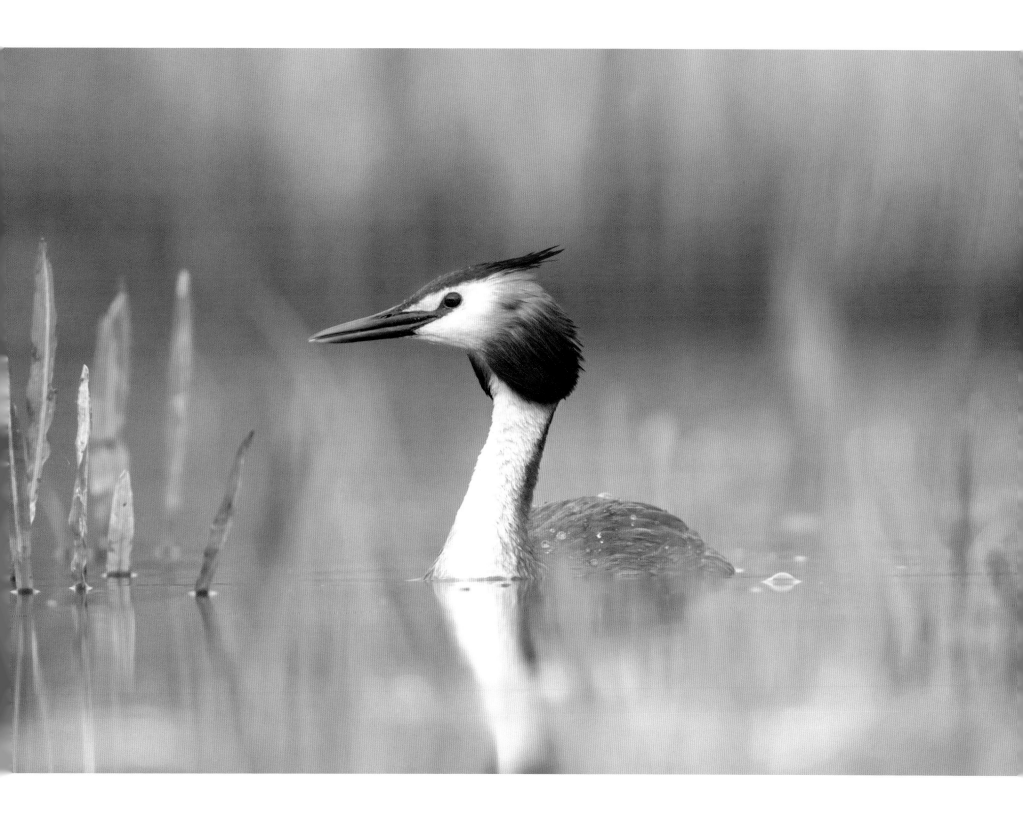

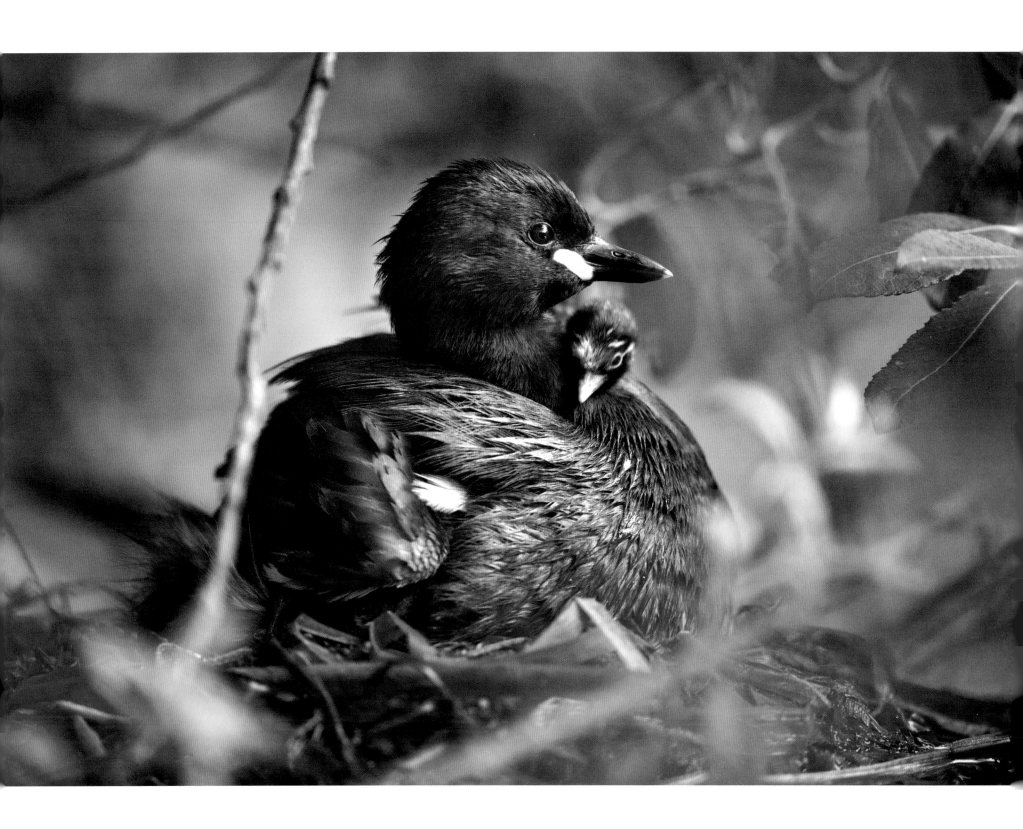

7 YEARS OF CAMERA SHAKE

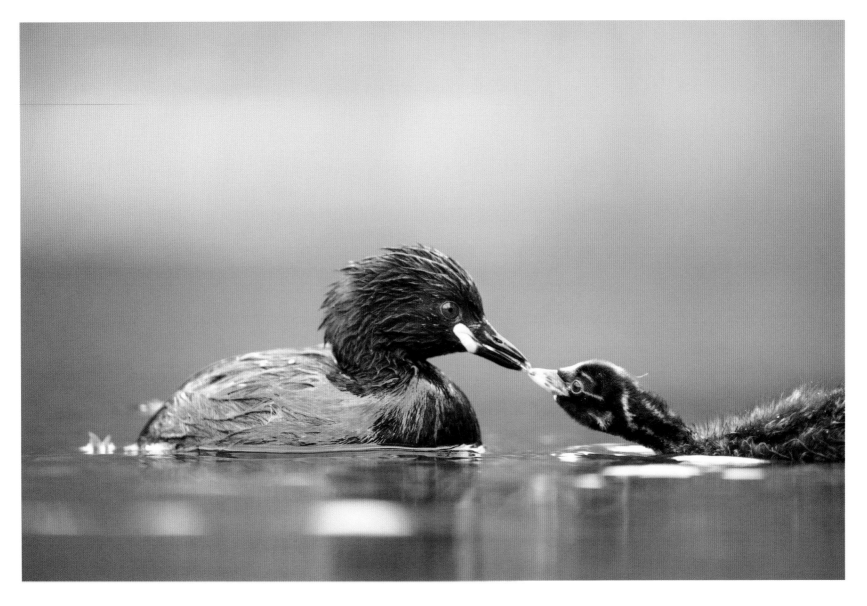

(left) Little grebe at nest

Sussex

(above) Adult little grebes passing food to young

Sussex

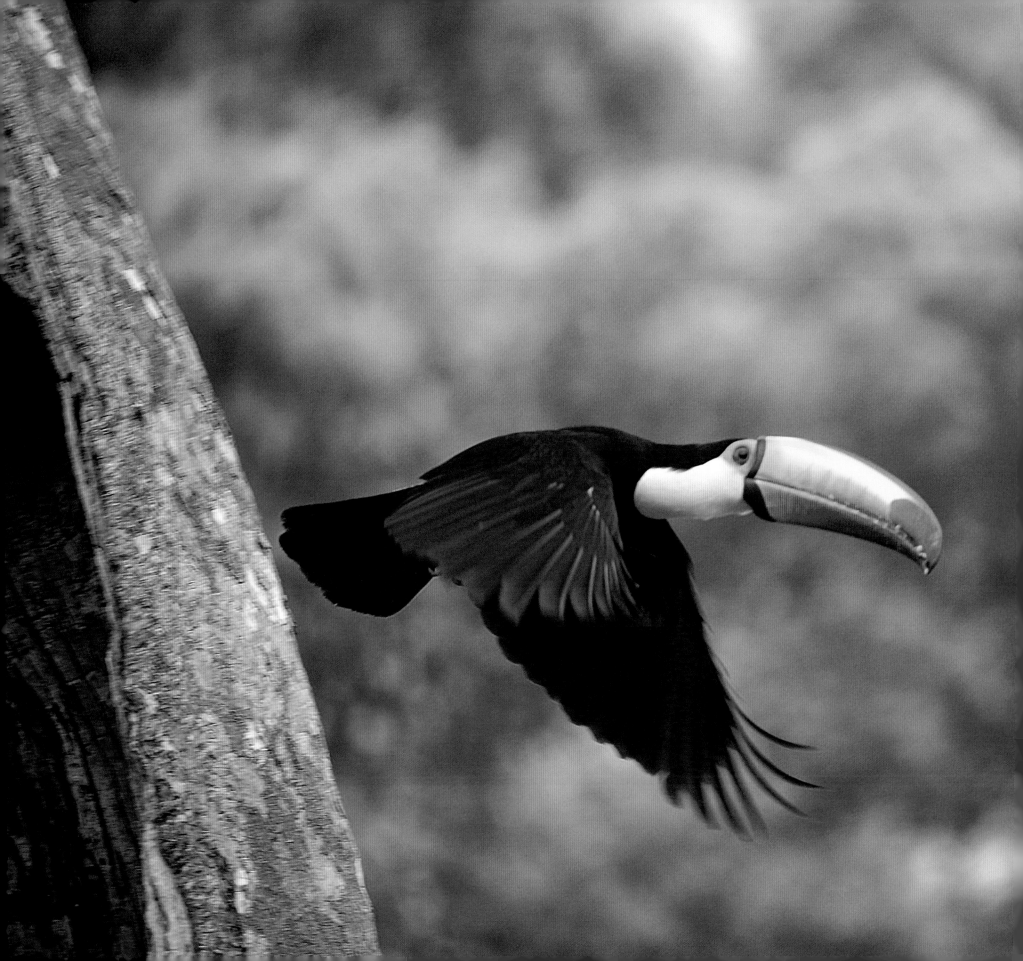

Toco toucan

Pantanal, Brazil

This bird is incredibly shy at the nest, which meant I had to get to the hide at 4 a.m. before the adult birds woke up to begin foraging for their young. Good hide discipline, in incredibly hot conditions, was required for these birds to make return visits. The hide was tiny and cramped and I had to kick around it in the pre-dawn darkness to check for any unwanted visitors.

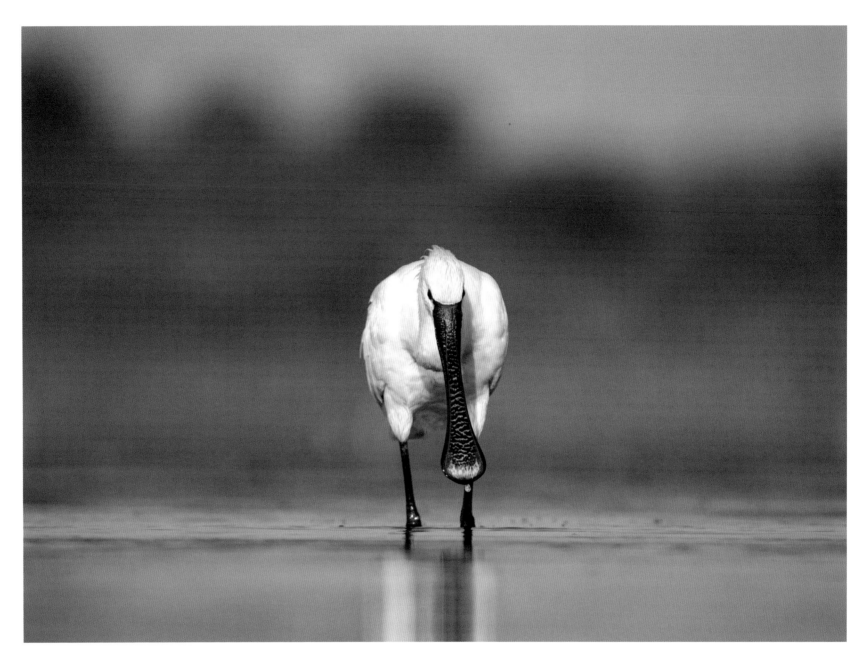

(above) Spoonbill
Kiskunság National Park

(right) Spoonbill feeding
Kiskunság National Park

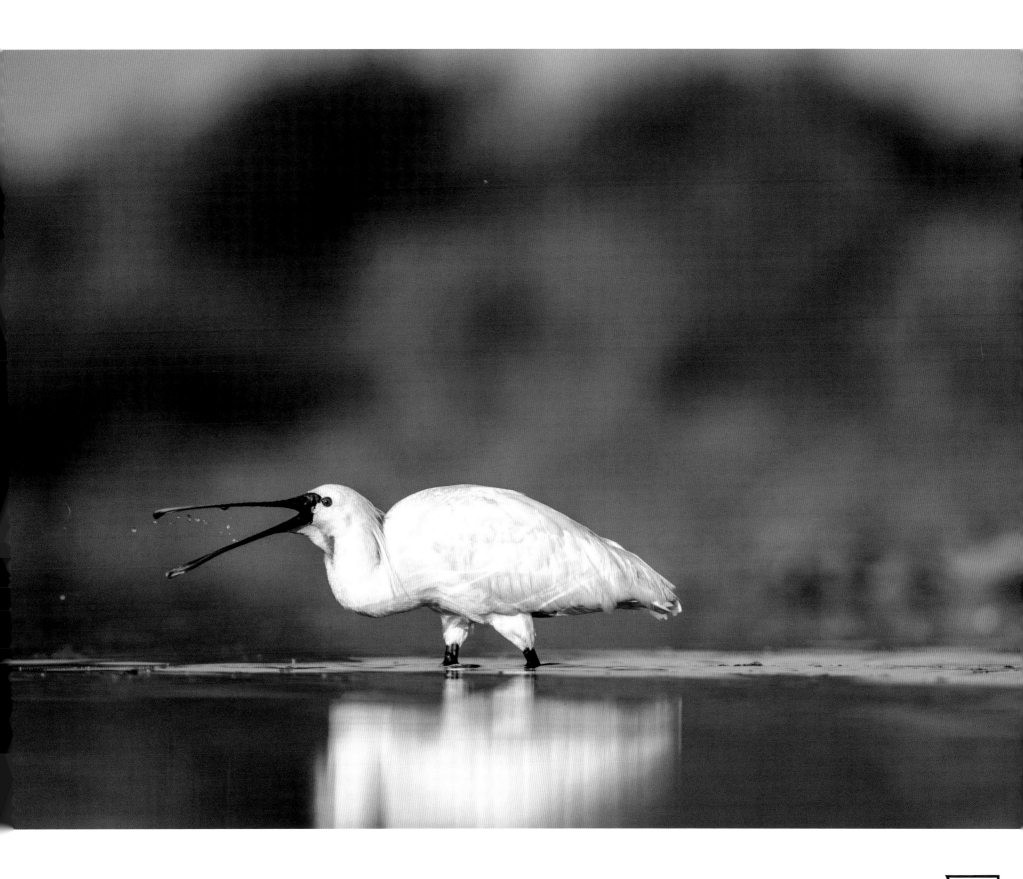

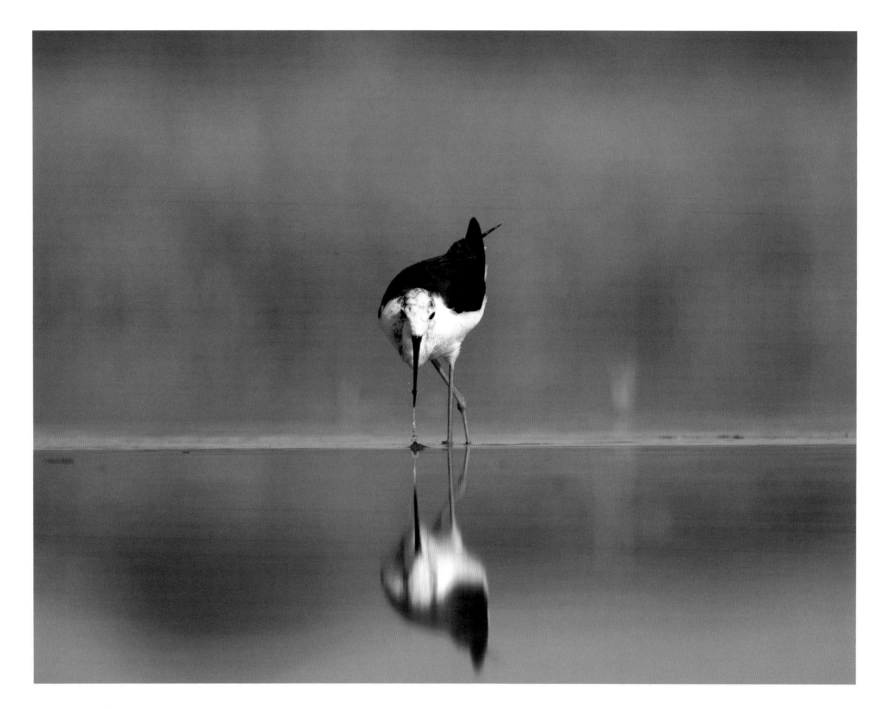

Black-winged stilt

Kiskunság National Park

Little owl
Kiskunság National Park

This was my first full-framed shot of a little owl from a bait and perch set-up in Hungary. On the first day, I waited three hours in a roasting hot hide for the owl to choose to perch on an unsightly concrete well, next to the perch I had selected. Some tweaking on day two and another three-hour baking-hot wait resulted in nine frames being fired of this beautiful owl at the last moment of light, but fortunately on the correct perch this time.

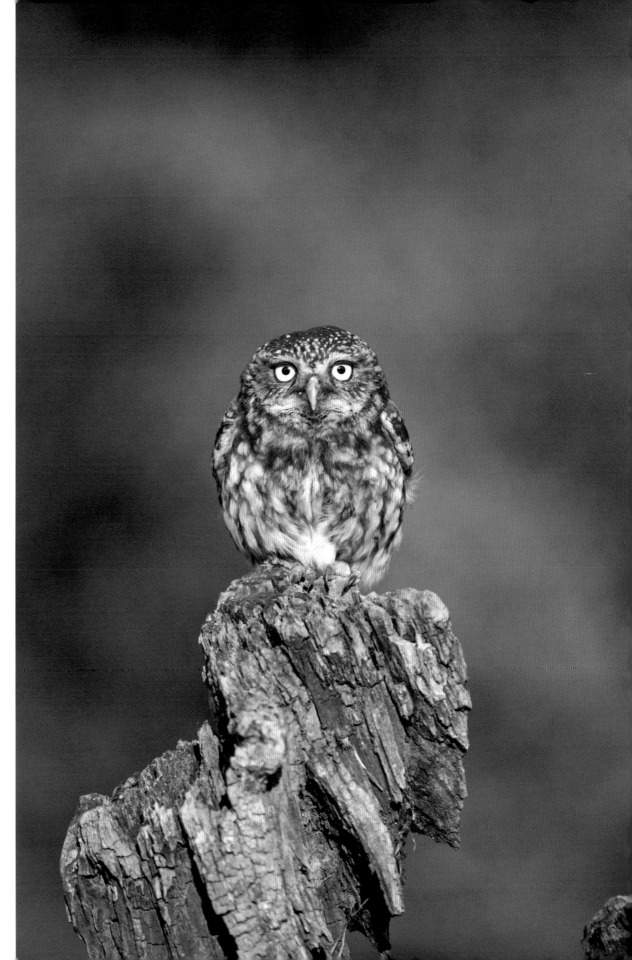

Fox hunting in freshly cut hay meadow

Sussex

Wearing full camouflage clothing, including face net and camouflage gloves, can make all the difference with shy mammals like rural foxes.

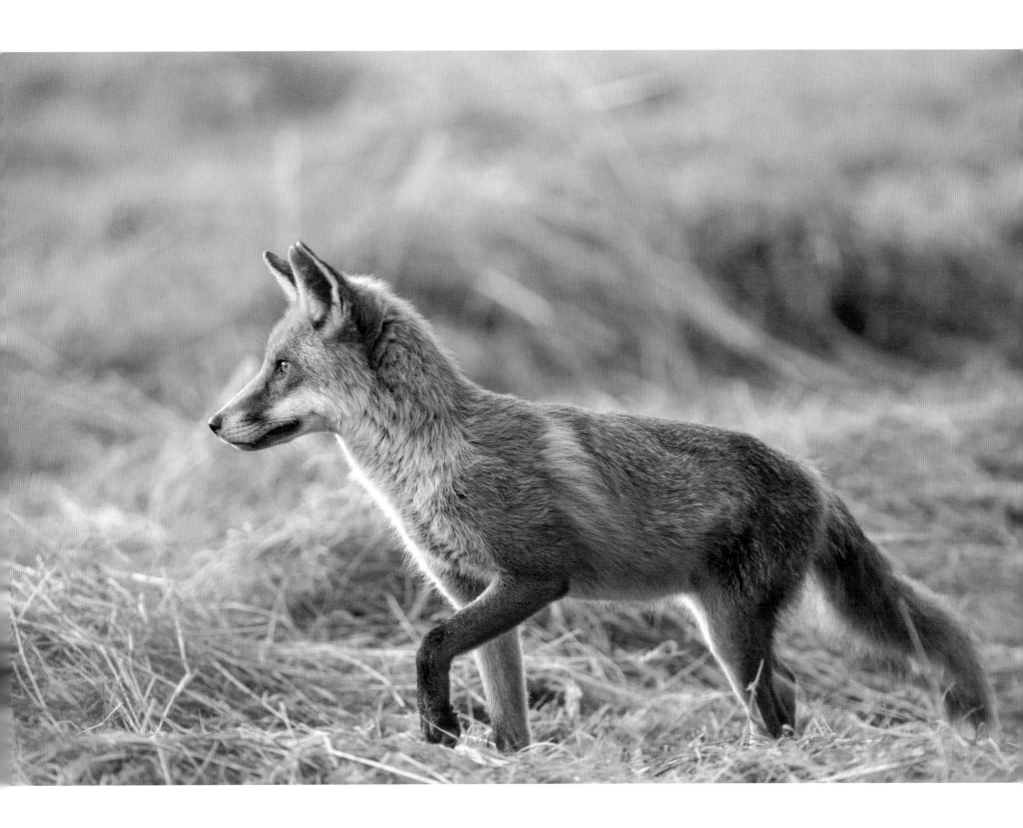

THE BEAUTIFUL KILL

Witnessing a chase or kill in Kenya's Maasai Mara is adrenaline-pumping stuff. A cheetah might just be lazily shading itself under a small bush with game dotted around, apparently unconcerned – both the predator and prey have calculated the distance, speed and energy requirements. There is a kind of status quo and uneasy understanding; if the predator starts to run, the prey is too far ahead and too fast for the predator to catch, so why bother?

So, the cheetah will glance up and scan every now and then for potential prey or, importantly, possible dangers – lions, elephants, buffalo – anything that would easily kill or trample a delicate cheetah. Then, on one casual glance, she sees something – a chance, an opportunity, a weakness. The odds shift and a certain intensity overcomes her being. She switches on.

The opportunity may be a newborn fawn, an old, injured or sick adult, or even just an advantage in the geography as the herd of gazelles have shifted their positioning slightly, or maybe lost their concentration. She's up and starts trotting, eyes on target. There is purpose to her movements, rigidity in her upper body to reduce her visibility as she pushes through the grasses. She closes the distance, increasing the odds all the time, with precious metres gained. Yet the advantage still invariably lies with the prey, after all, who will always be more motivated – the predator is running for its dinner; the prey is running for its life.

All hell breaks loose as alarm snorts scatter the gazelles and she goes from a trot to a full-on sprint in astonishing time. This is where wildlife documentaries switch to slow motion whereas in reality the speed is astonishing and confusing. Sometimes the target is not obvious to a human observer. Often she misses and then a new target pops up in the chaos for her to acquire.

The impact is a tumble, dust, a bleat as jaws clamp around the throat of the victim. Legs kick frantically. And then I have seen what I can only describe as resignation in the victim's eyes. Maybe I am attaching too much emotion to this but it does actually appear as if the victim knows it is finally over. This resigned look of prey has transfixed me for years.

Once the dust has settled, and if you're close enough, all you can hear is the hard panting of the cat as it repays the oxygen debt incurred during the chase. This heavy breathing lasts many minutes.

It is certainly brutal, disturbing, thought-provoking. It is also a true death, honest and beautiful in a way. Although not as obviously bloody as a kill in the Mara, this dynamic of killing occurs at the same level on every square metre of the planet – even in the carpet at your feet. Predator and prey.

Once the kill itself is made, nothing is wasted; again this is most obvious in a kill on the plains of Africa. The cheetah will try to drag its prize to

shade and cover before consuming as much as possible – her tenure over the kill will be short as other consumers become aware: hyenas, lions – certainly dangerous to a cheetah – but also vultures, jackals and storks will try to steal their share. Knowing the brevity of her hold, her stomach bulges impossibly as she consumes as much meat as she can in one go before she is usurped.

It is common for human observers to feel sympathy for the beautiful, spotted cat, graceful in her perfect form and function, being pushed off by an ugly, bullying hyena. Yet this food source is as valuable to a hyena as it is to a cheetah. Both animals have just adapted different strategies to achieve the same end. The hyena therefore is no less perfect or beautiful than the cheetah, except to our subjective judgement.

So however violent, shocking, moving a kill of this nature is, it is truly beautiful in its totality; it is just the perfect example, strongly visual, of this thing we call nature. And nature doesn't care or have feelings. It is merely an indifferent process and each protagonist within it is just struggling and doing whatever is required to survive.

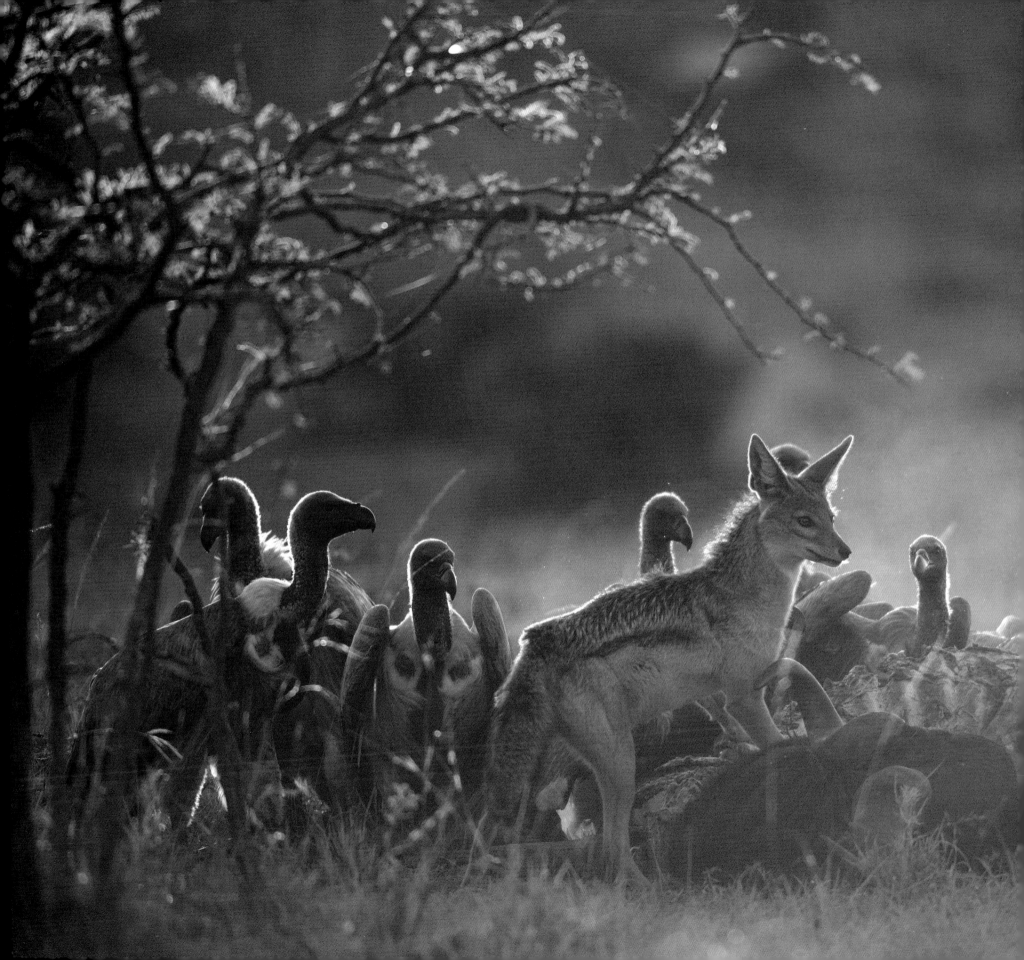

The beautiful kill
Maasai Mara, Kenya

It's surprising what you can make look beautiful with a dose of backlight.

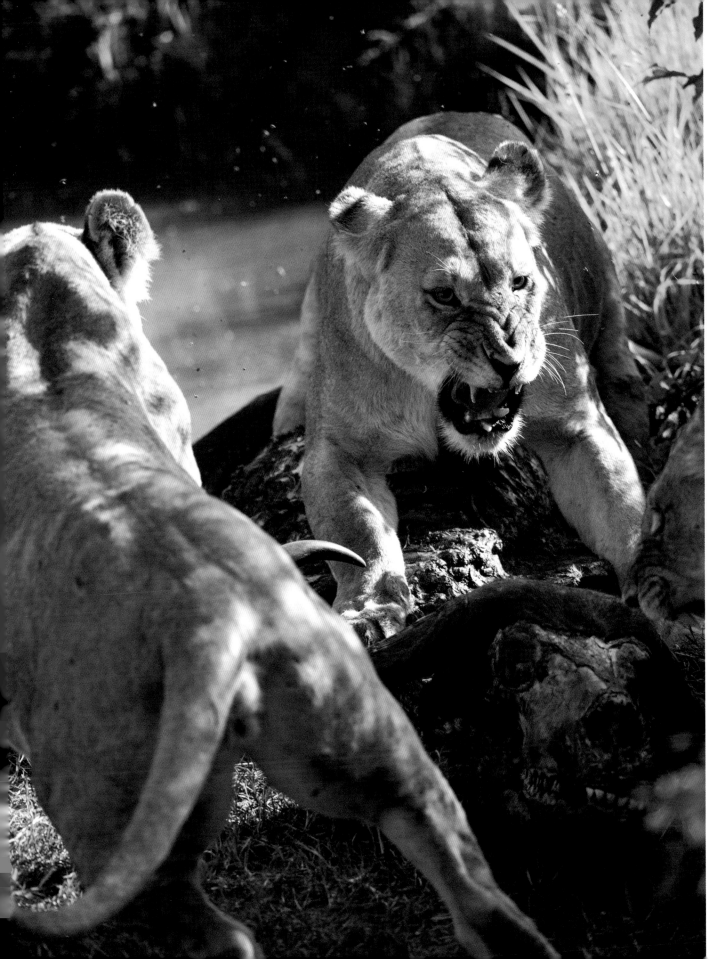

(left) Lions fight over the kill
Maasai Mara

(right) Lion cub with the remains
Maasai Mara

Lion kills can be grisly affairs. However, they can also be one of the most interesting places to view lion behaviour, as well as the pecking order within the pride. You can get very contrasting images of cute cubs amongst the bloody remains.

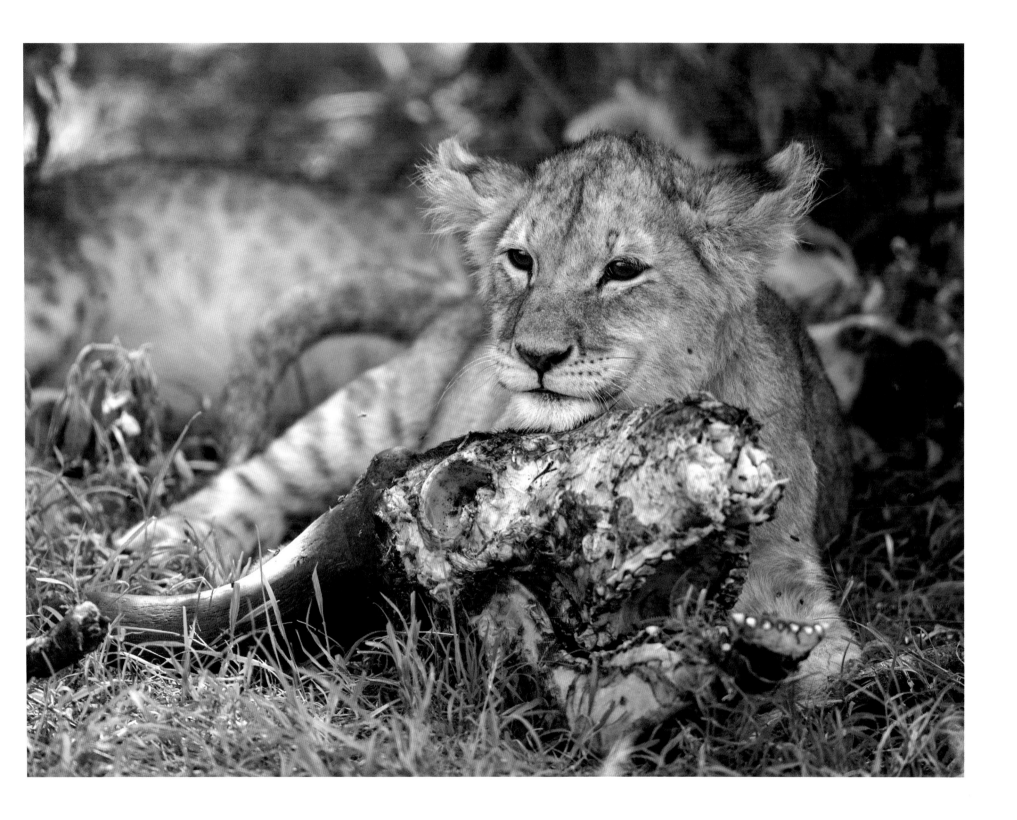

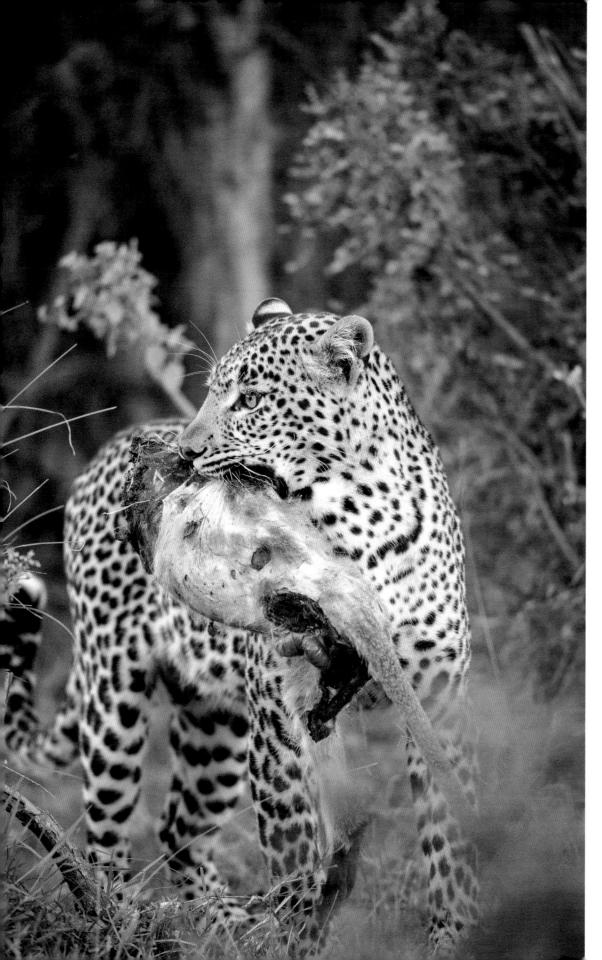

(left) Female leopard with a monkey as prey

Maasai Mara

(right) Hyena tearing at a dead zebra

Maasai Mara

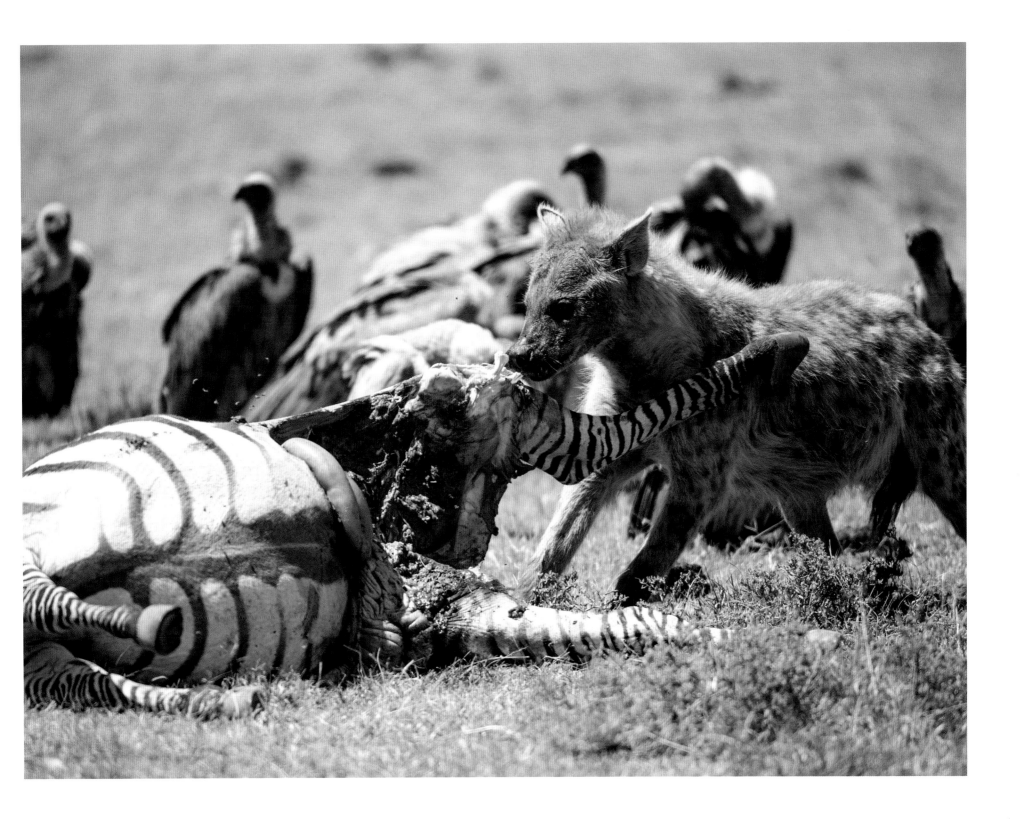

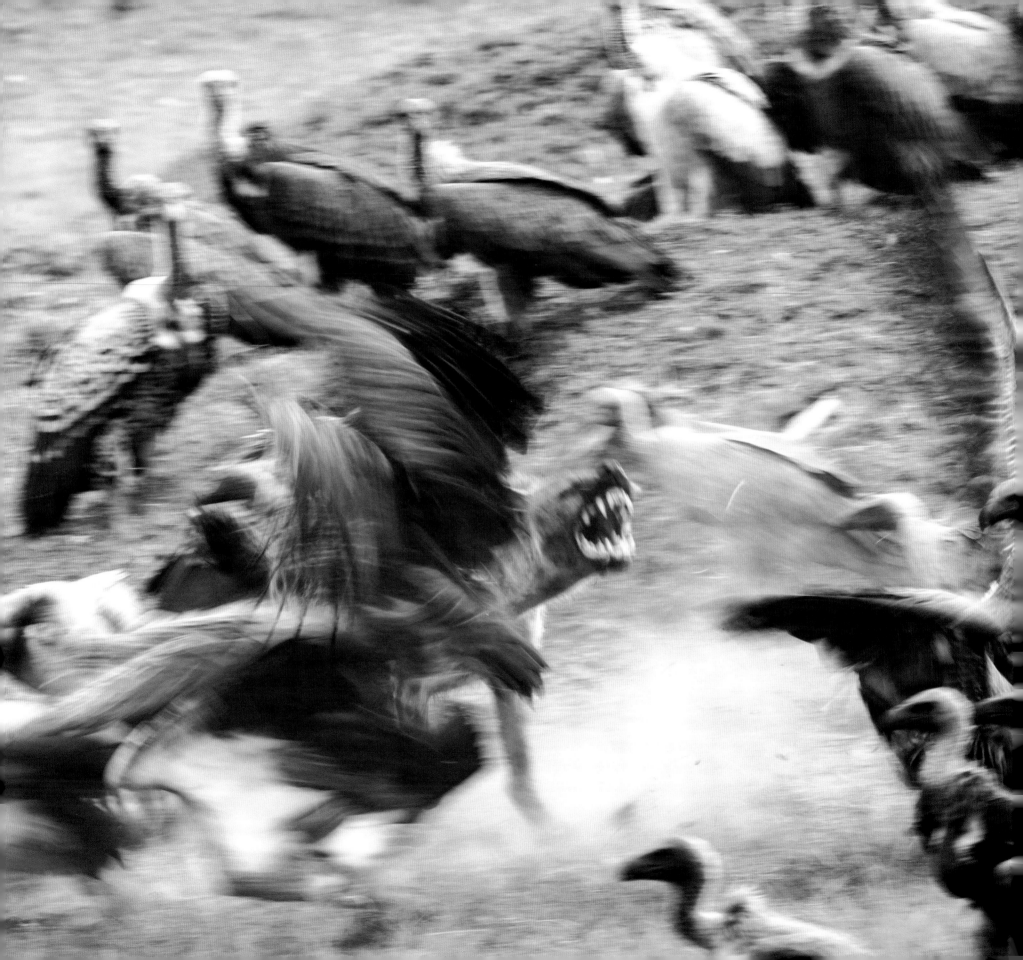

Spotted hyena
Maasai Mara

Kill sites can be challenging: not only is there the smell and the sight of the carnage, but things can change fast as soon as one animal leaves and is invariably replaced by voracious vultures. Occasionally, the main stakeholder has not finished and charges back to scatter the vultures.

Black-backed jackal

Maasai Mara

The consumption of large kills can be prolonged affairs and lead to repeated return visits by individual lions whilst the pride holds tenure over the carcass. This will only last as long as there are sufficient numbers of adult lions, before other consumers – such as hyenas – come in for their share. Around the kill though, regardless of whoever holds tenure, there will be other visitors sneaking in to snatch a morsel. I have nothing but respect for these animals, coming in below the radar amongst a group of predators that could easily kill them. One of my favourite mammals in Africa is the black-backed jackal. I love the look of them, as well as their fearless cunning, speed and agility. They are perfect predators in their own right and I have witnessed many kills by jackals, but I can only watch in disbelief sometimes as they dart in front of a pack of hyenas, staying just out of reach of the bigger animals.

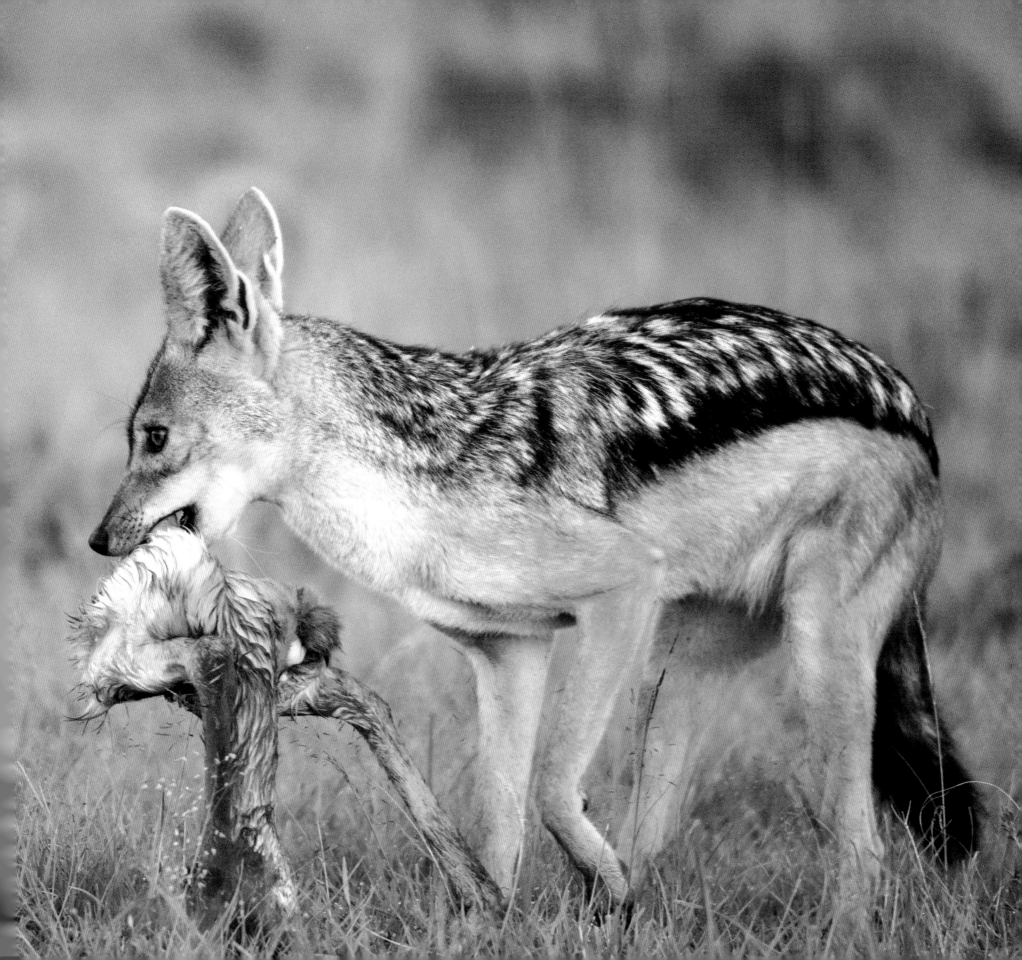

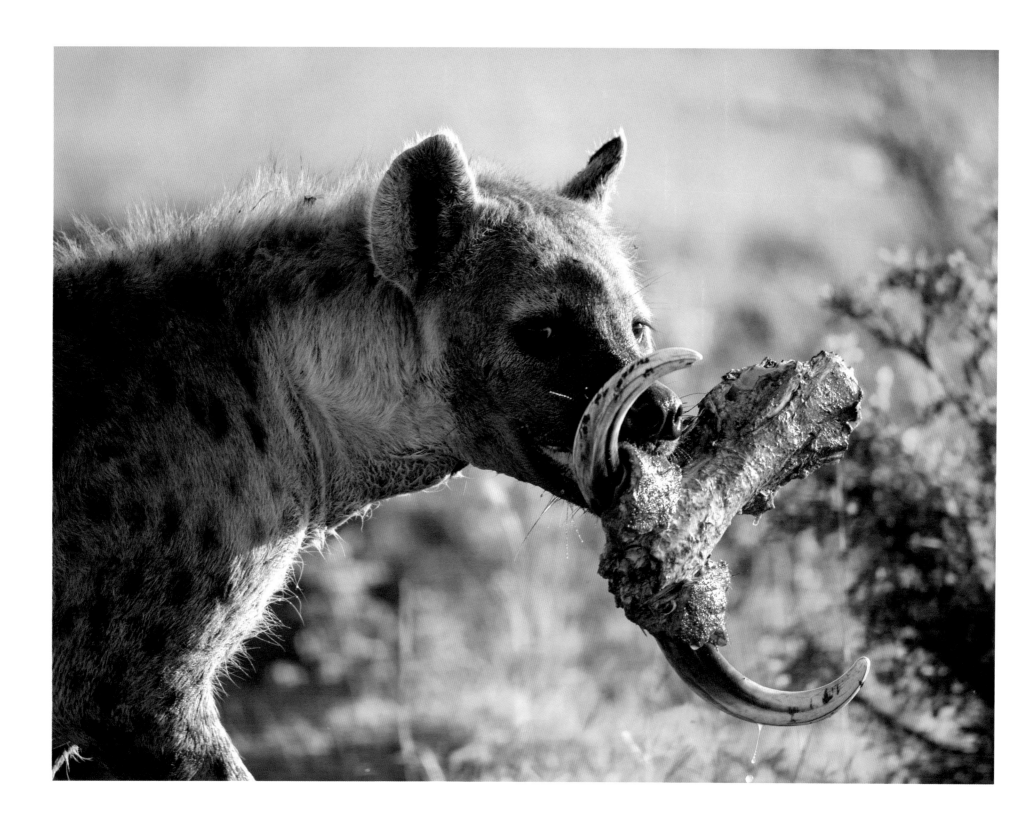

7 YEARS OF CAMERA SHAKE

(left) Spotted hyena with warthog skull
Maasai Mara

(right) Spotted hyena and prey
Maasai Mara

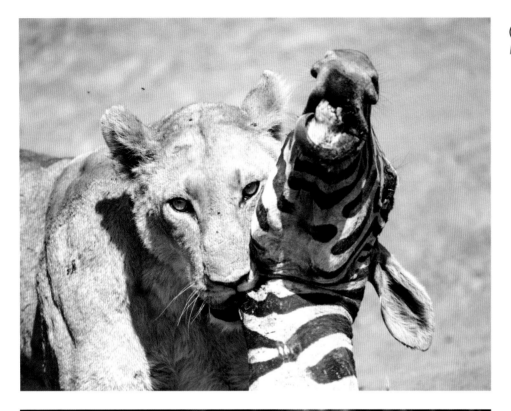

(left) Lioness throttling a zebra
Maasai Mara

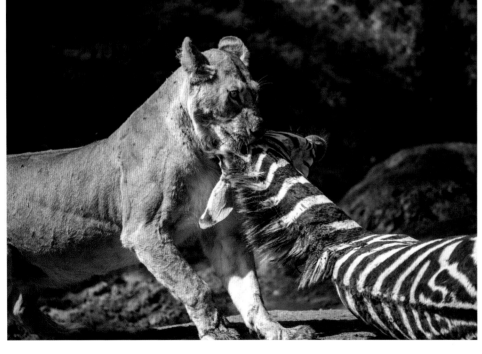

(left) Lioness dragging zebra
Maasai Mara

(right) Lionesses devour a zebra
Maasai Mara

The speed of consumption can be alarming after a kill, but as a photographer I feel detached from what is occurring in front of me and focus completely on recording the event. It is a strange mindset that could perhaps be criticised, but it is what it is; my role is to capture the image.

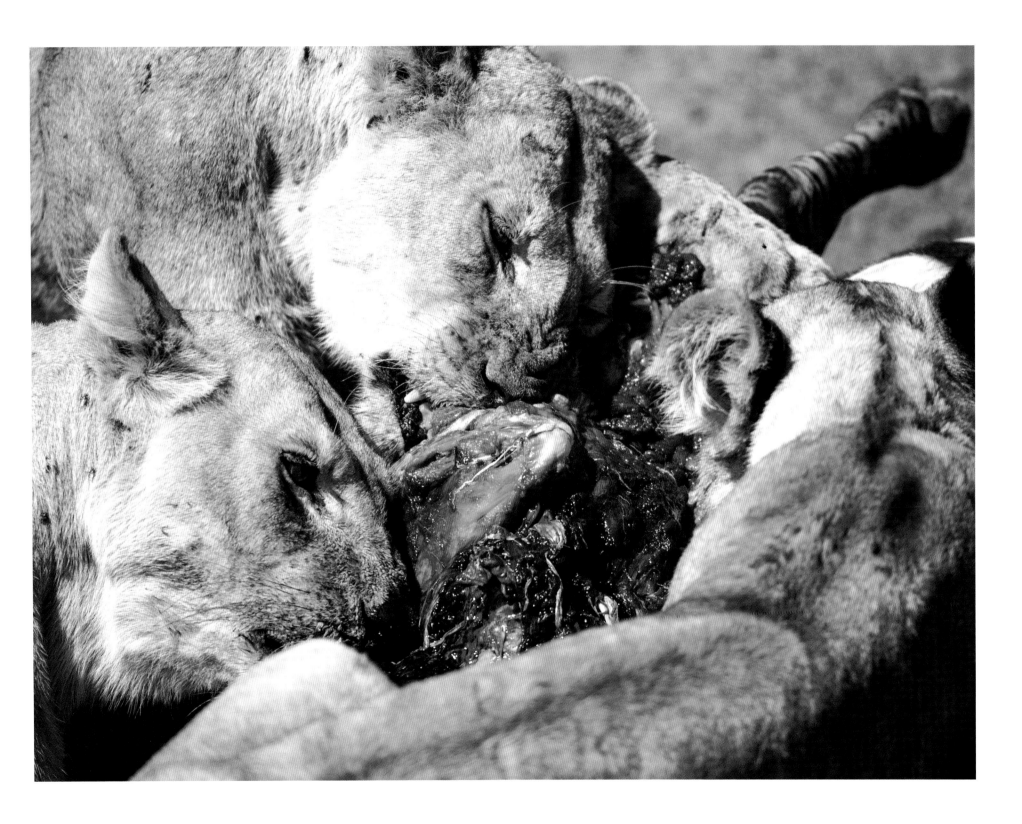

Lioness and zebra
Maasai Mara

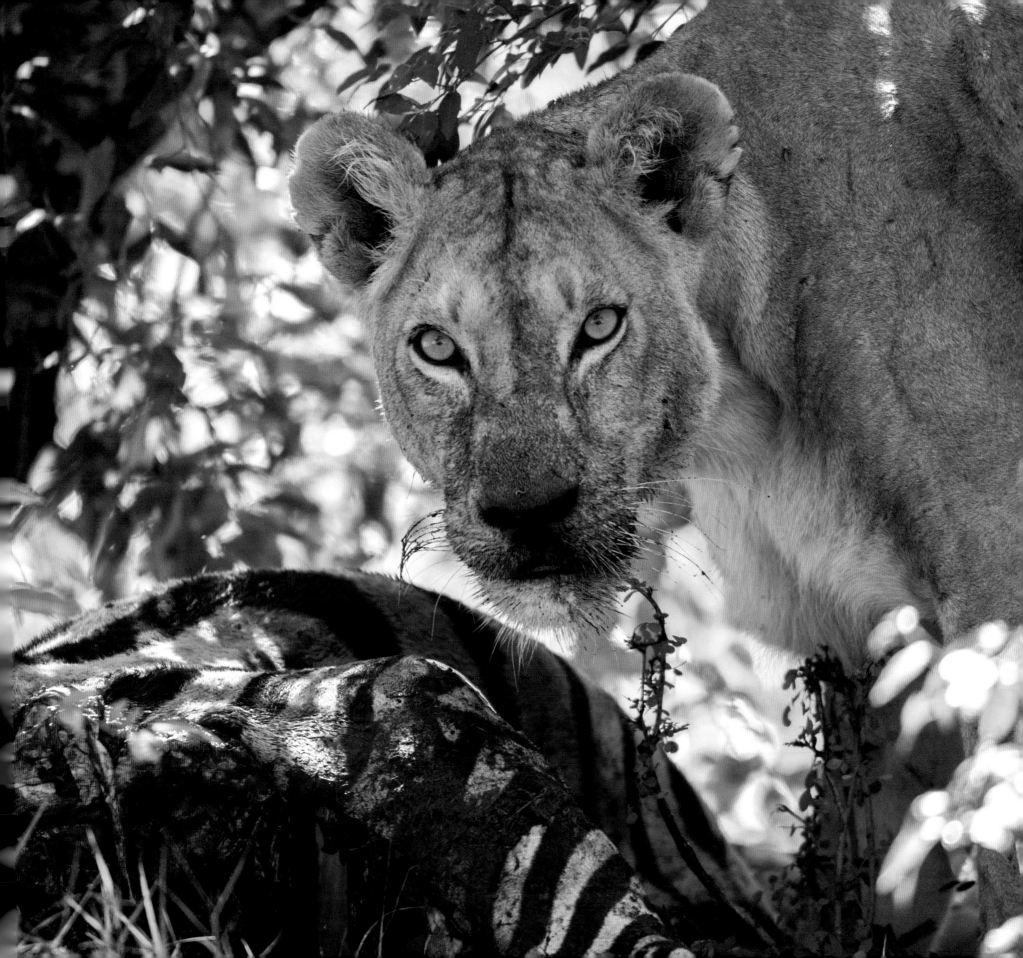

Female leopard dragging prey

Maasai Mara

7 YEARS OF CAMERA SHAKE

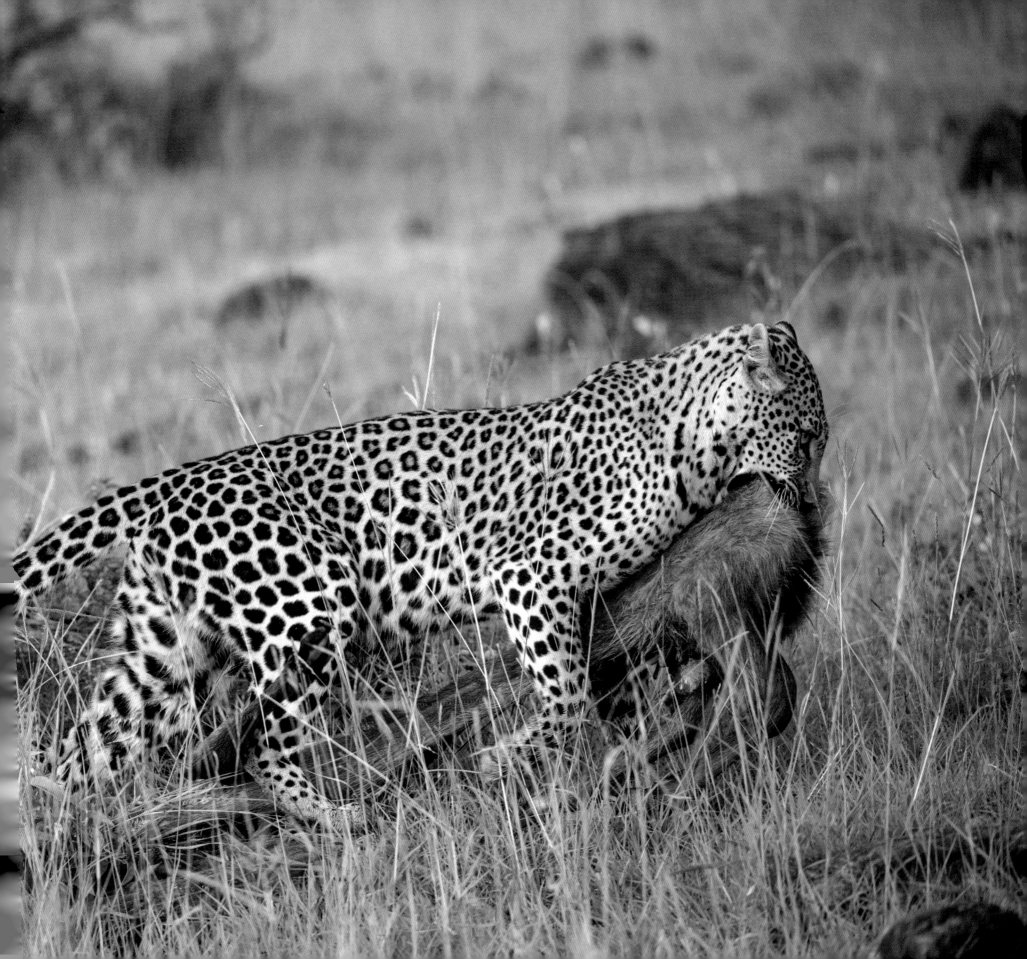

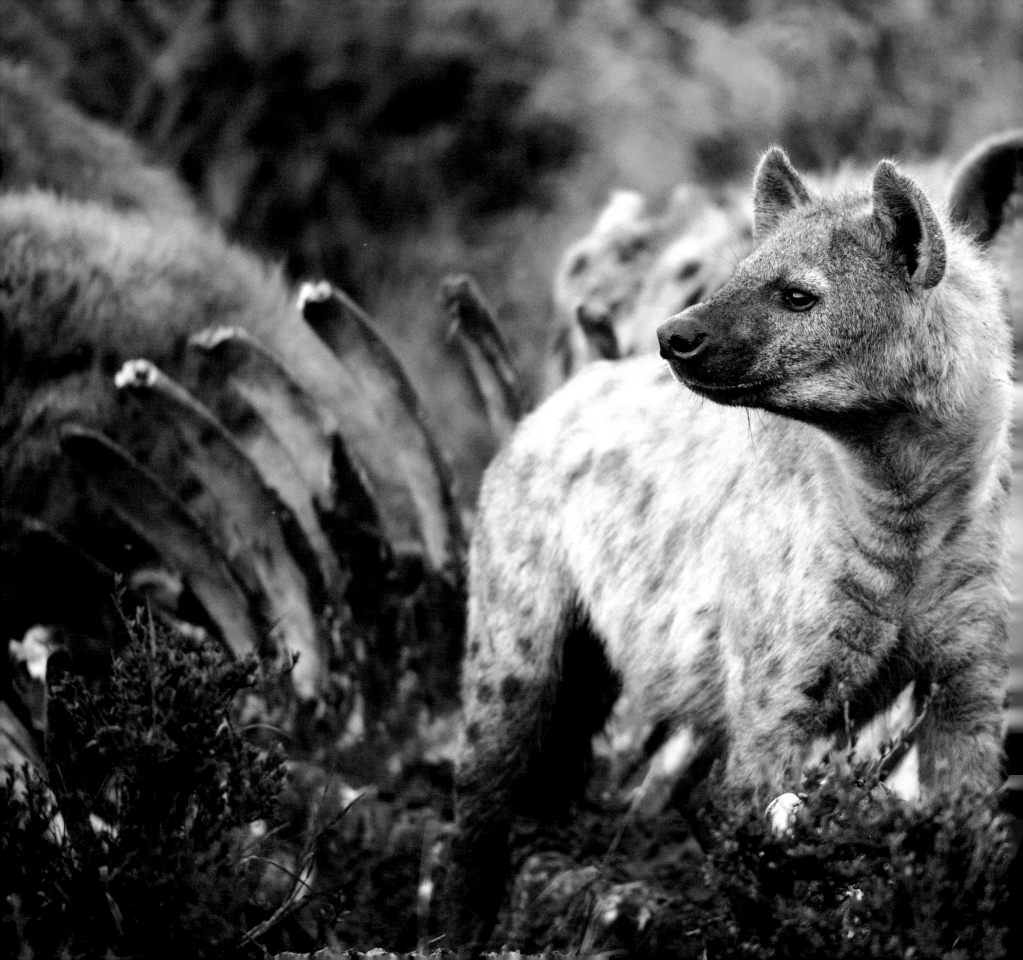

Spotted hyena standing in the ribcage of a dead hippopotamus
Maasai Mara

Possession of a carcass, it being such a valuable resource, will not just stop once the first group of hyenas has moved in; often neighbouring sisterhoods, stronger in number, will rush in and take control. On several occasions I have seen competition between more or less equally matched hyena groups over a carcass. This may involve groups rallying together and noisily charging in only to be repulsed by an equally strong counterattack. All the while, jackals, hamerkop, marabou storks and vultures may be darting in. If you can stand the smell and the brutality, it imakes for fascinating, high-octane action.

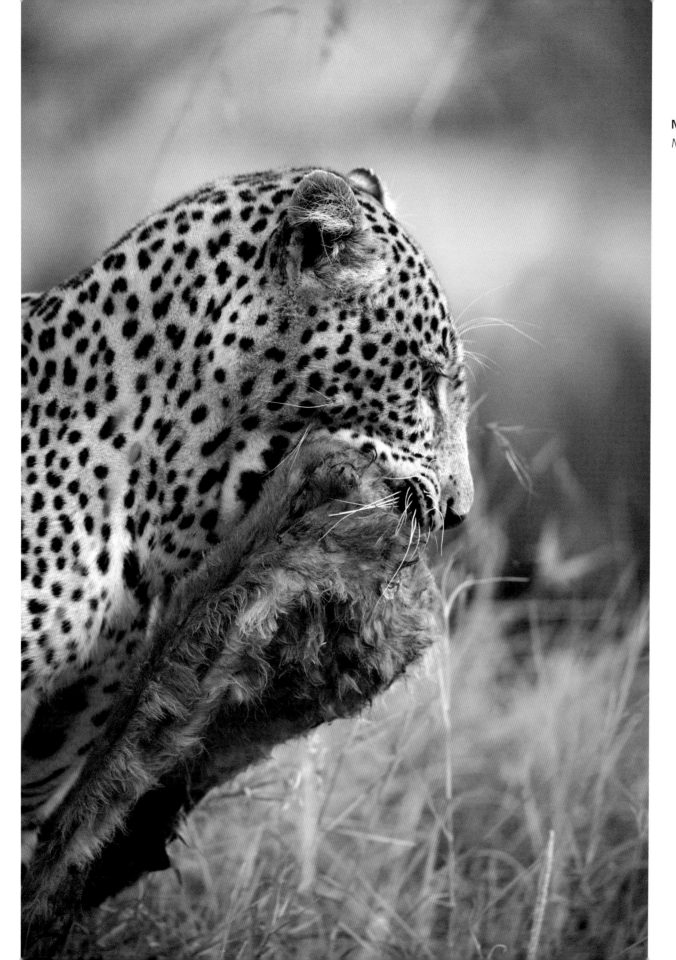

Male leopard
Maasai Mara

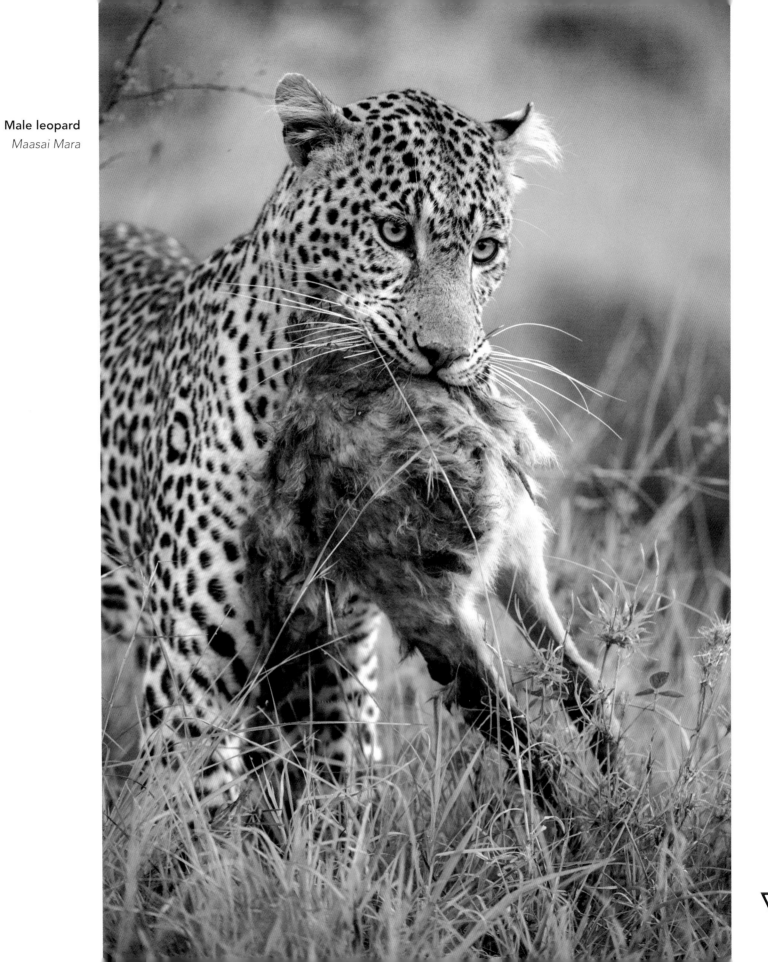

Male leopard
Maasai Mara

157

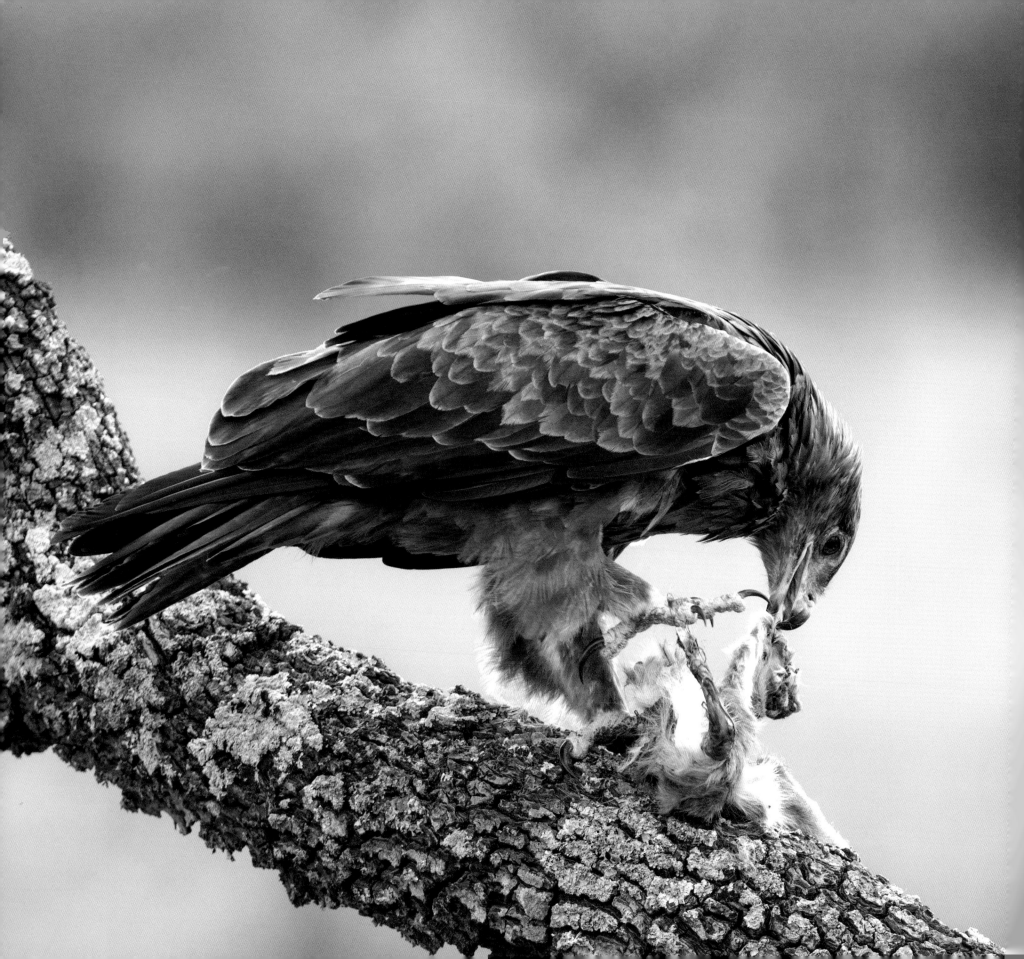

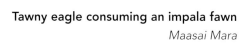

Tawny eagle consuming an impala fawn
Maasai Mara

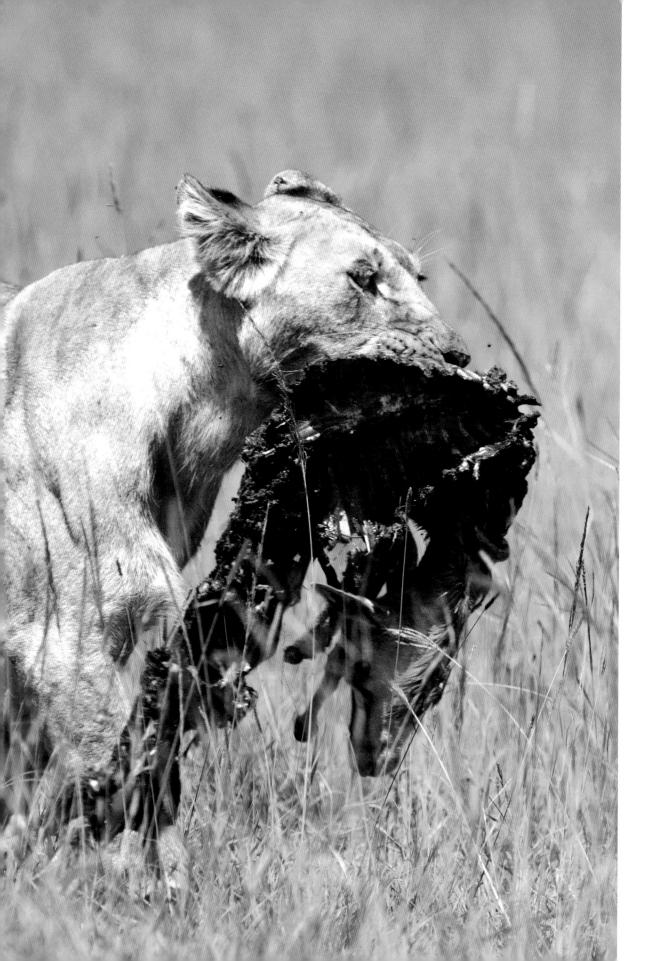

**(left) Lioness carries away a carcass
stolen from a cheetah**
Maasai Mara

At any kill there is always something bigger or faster to
steal your food. Many animals, such as this lone lioness,
will often snatch whatever they can and carry it to a more
secure location to devour.

(right) Lion cub in the rib cage of an eland
Maasai Mara

This image of a cute cub within the ribcage of a bull
eland that was killed overnight by the pride has become
very well known, although it produces polarised opinions.

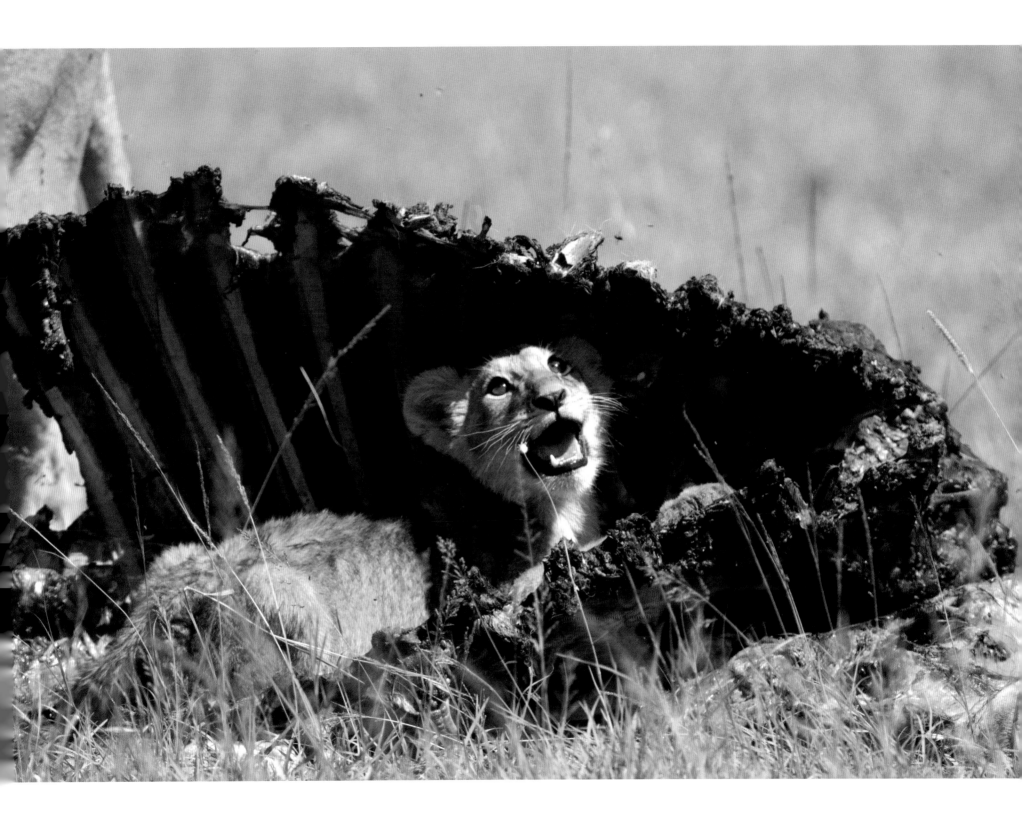

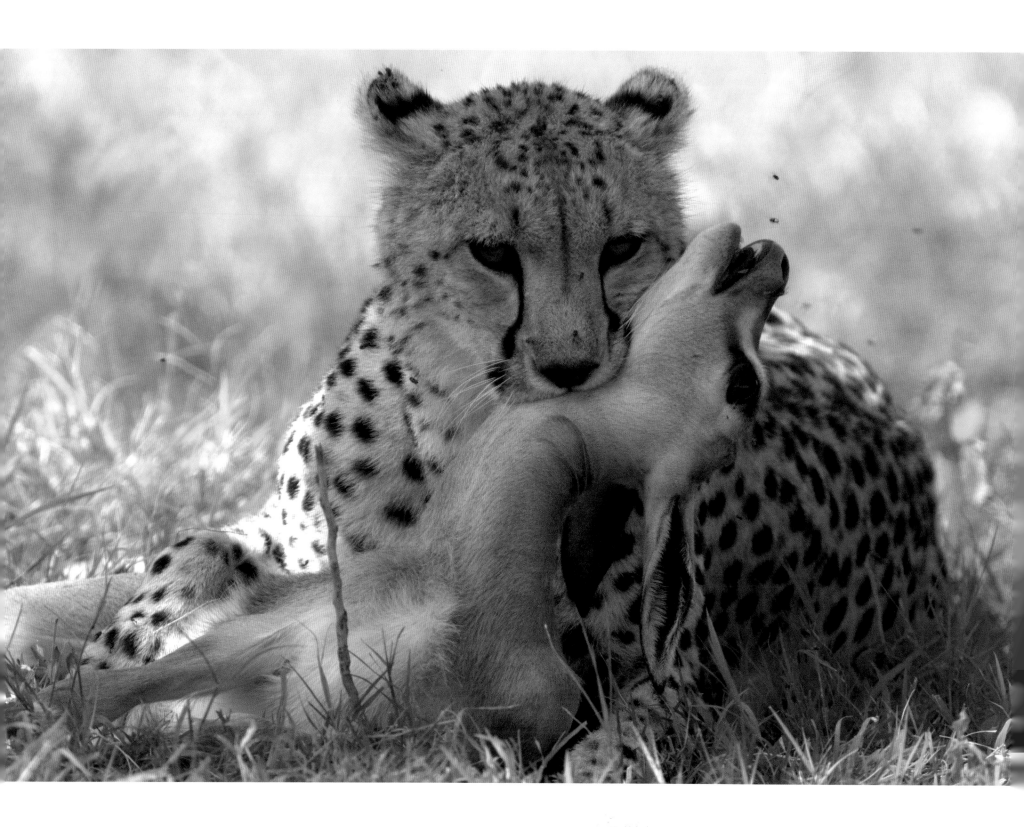

7 YEARS OF CAMERA SHAKE

(left and right) Cheetah throttles Thomson's gazelle

Maasai Mara

Cheetahs expend a huge amount of energy running in the chase, incurring an oxygen debt which has to be paid immediately. The violent panting of the cat can be heard loudly as it drags its prey, sometimes still kicking, to cover and shade.

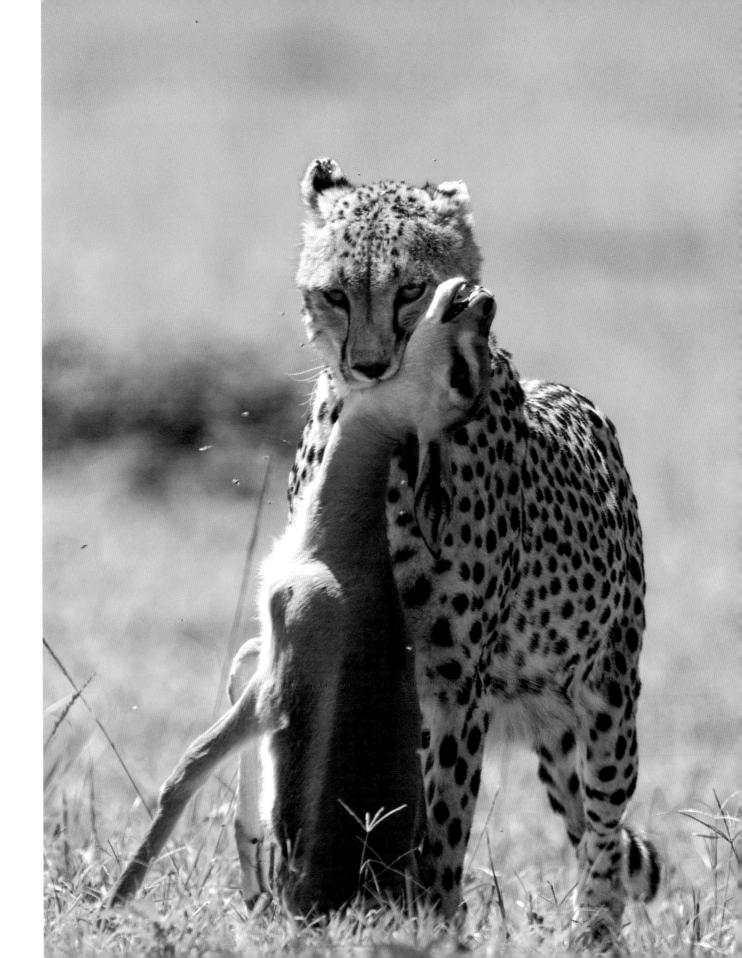

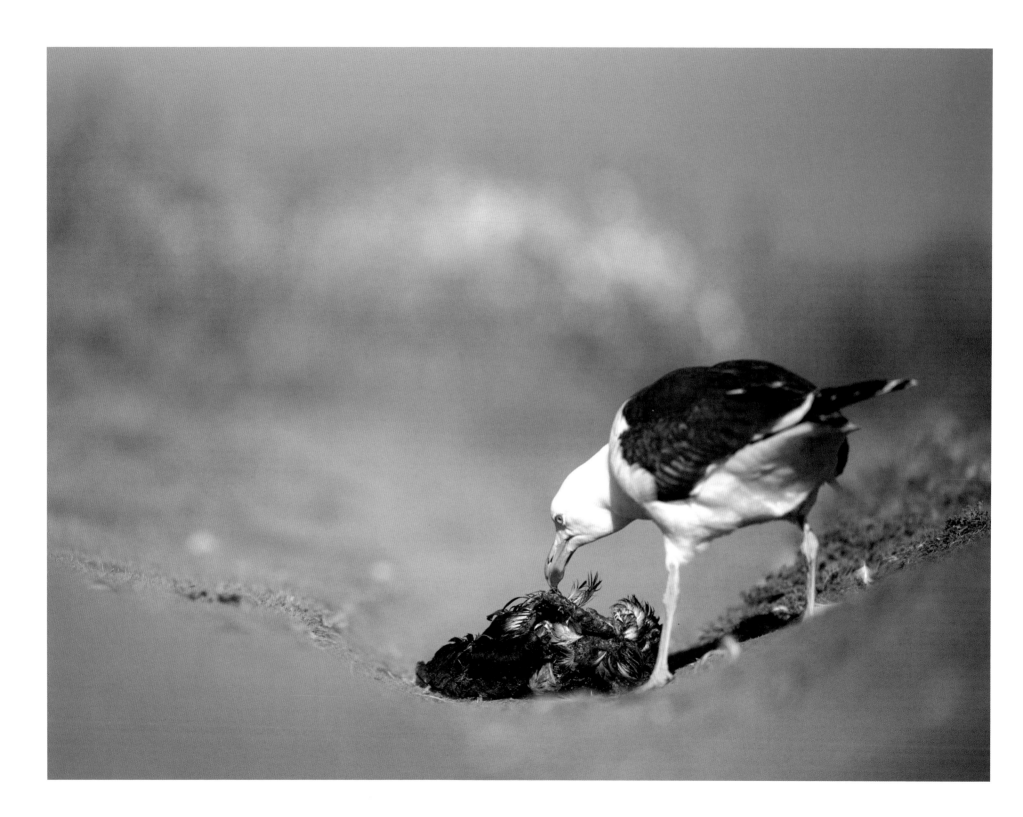

7 YEARS OF CAMERA SHAKE

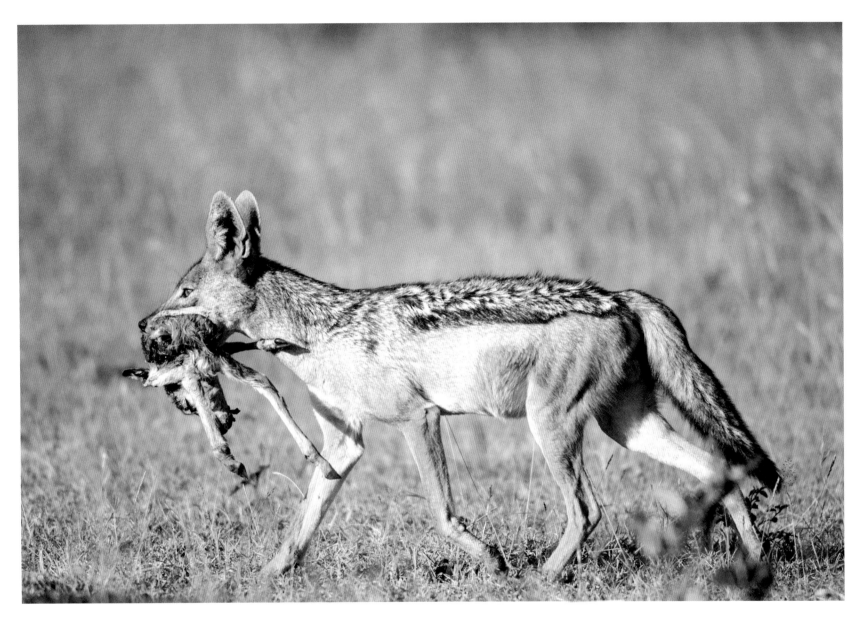

(left) Lesser black-backed gull eating Manx shearwater
Skomer Island, UK

(above) Black-backed jackal
Maasai Mara

Black-backed jackals are always around in the Maasai Mara
but they do not normally allow close approach; sometimes,
though, they have other things on their mind.

HOME GROUND

Despite travelling extensively abroad for up to four months a year, I adore coming home. I'm lucky enough to live in beautiful Sussex, with the South Downs as the undisturbed view from my rear garden. I love this area, and my wild garden is always like the jungle I've just come back from!

I'm also lucky enough to be resident photographer at the Knepp Wildlands, the exciting re-wilding project on the Knepp Castle Estate. So, I'm in heaven. I do still love my travel, but if I couldn't do it any more, I would be perfectly happy at home. Despite encroaching out-of-control development in recent years, the area is still incredibly rural and rich in wildlife. I develop extensive projects from my home ground and love devising gadgets and setups to use both here and in more exotic locations.

One of my obsessions in the area are the owls. On the Knepp Wildlands, I work with several pairs of owls, especially one pair of little owls that have set up home in a derelict barn. I have named the male of this pair Agrippa, as I name all the owls I deal with after Roman generals. It can be difficult to tell male from female owl, so apologies to the females because they still get male names. Currently I have Agrippa, Marcellus, Trajan, Scipio, Didius.

However, Agrippa has become the star, and after over eighteen months of working with him and Mrs Agrippa, I have seen them successfully fledge two broods in two years. I do bait for Agrippa, as part of my work is to guide other photographers, and he is now so used to my presence that sometimes he comes to perch close by, watching me, knowing he's probably going to be left a few mealworms. It's reached the stage, touchingly, that when I whistle he will come to the window of the barn.

From there he will ferociously stare at me as only little owls can do. They have intense yellow eyes and slanting white markings above them that give the face an angry look. They can also look incredibly cute perched on top of a fence post just staring at you, but despite their size, they truly are ferocious – natural-born killers. I actually think that the little owl and similar small owl species have possibly the largest prey range, in size, of any predator. They will often take very small beetles, but I have also watched Agrippa drop straight down onto the back of a half-grown rabbit that probably weighed two or three times what he does. I have heard it speculated that if little owls were the size of eagles, they would predate on humans.

Another bird that I obsess about are kingfishers, and they are possibly the one British bird that almost everyone wants to see, though sadly most people haven't. Or at best they've just seen the speeding cobalt bullet zipping across the water at a distance – they have a huge fear circle and will fly back down the river or pond at any approach. Working with hides, I see them daily at a range of about two or three metres. I just don't get bored with them, they are so dynamic in behaviour as well as their vivid mix of iridescent colours.

Owl and kingfisher populations can fluctuate massively; harsh winters take their toll on both. The non-native mink can be disastrous to any pair of kingfishers trying to breed on a stretch of river; they will raid the nest burrow and take the eggs, the young and even the adult birds if they are inside incubating. Just this year, my main pair of kingfishers on the Knepp Wildlands were believed to be raided by mink who killed the female bird. The barn owl's main acuity is hearing, so in a harsh winter any lying snow on the ground means they cannot hear their rodent prey in the grasses, and many die of starvation.

In 2005, when mortgages were easy to get, I bought just over ten acres of ancient woodland in Sussex. Yes, it was a bonkers purchase, where most people would have bought a bigger flat with another bedroom. However, not one to follow normal behaviour, I gained another huge occupier of my time and mind. The woodland is called Scrag Copse, meaning a scruffy small wood – which I am actually quite proud of – and it maybe sums up my character. This beautiful area of woodland has not been managed for over eighty years, and is derelict by most foresters' standards, almost wildwood in parts. Here are my other passions: the tawny owls and the badgers. I've watched badgers extensively for over twelve years, and there is surely nothing better than a warm evening in early May watching badger cubs play in a sea of bluebells. Years ago, I took my girlfriend at the time badger-watching on Valentine's night. Although, personally, I was thrilled at witnessing what appeared to be rut behaviour from the dominant boar, it was a bitterly cold night, and I don't think she saw the romantic side. The relationship did not last.

Of all the owls, the tawny owl is my favourite; indeed, it is my favourite bird. It is our most common owl and definitely our most commonly heard, but rarely seen as it is generally very nocturnal and its beautiful cryptic colouring hides it well. Being woken at night by the sound of tawny owls, both at home and in the old caravan at Scrag Copse, is an incredibly special experience. For me, the hoot of the tawny owl is the finest sound in the natural world – it's so nocturnal. Despite my love of tawnies, I have regrettably neglected them photographically, and this is one of my projects for the future.

Even when returning from extensive travels to glamorous wildlife locations, on the drive back from the airport, looking south on the A23, my first view of the Downs as I come over Bolney Hill tells me I'm home, and it's always a good feeling.

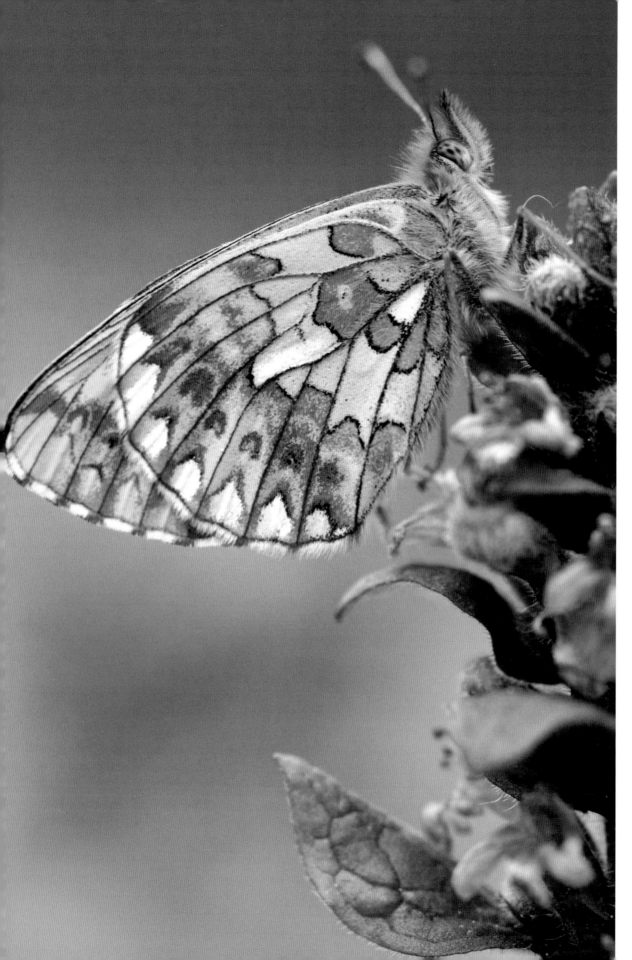

Pearl-bordered fritillary butterfly
Sussex, UK

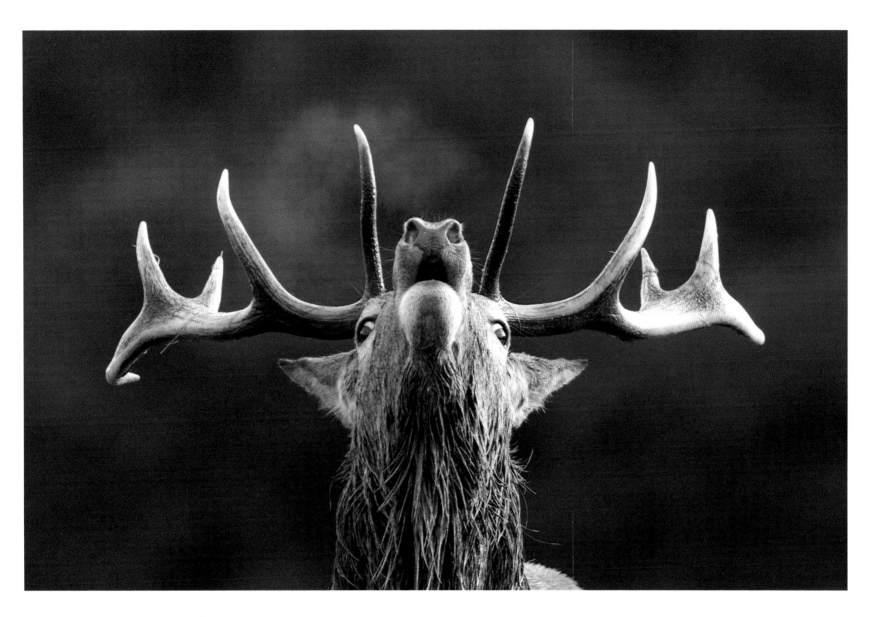

Red deer stag roaring during the rut

Sussex

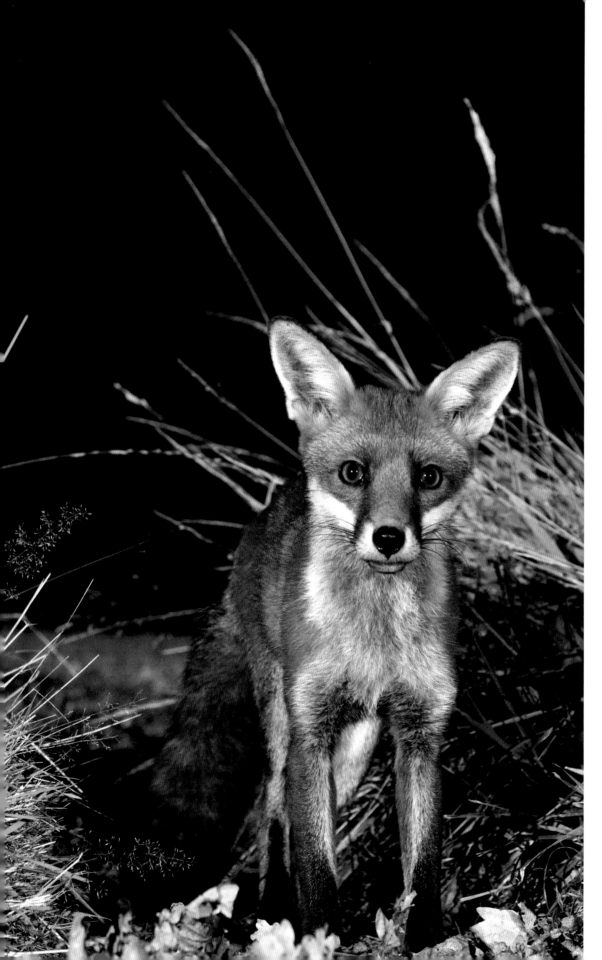

(left) Fox in the garden
Sussex

(right) Short-eared owl
Sussex

In good years if there are plenty of lemmings, short-eared owls
irrupt from Scandinavia and often winter in good numbers on
rough grassland or wetland areas around the UK. They are
diurnal and this can sometimes mean getting fantastic views
of this dramatic owl with its angry, lemon-yellow eyes.

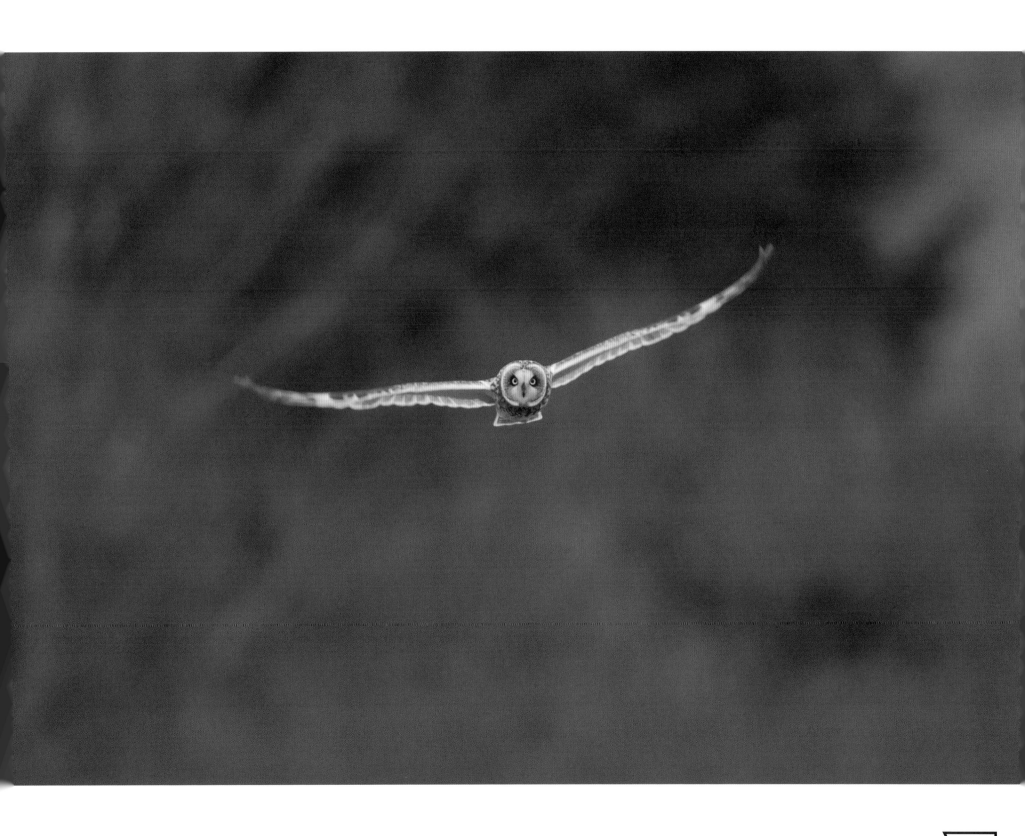

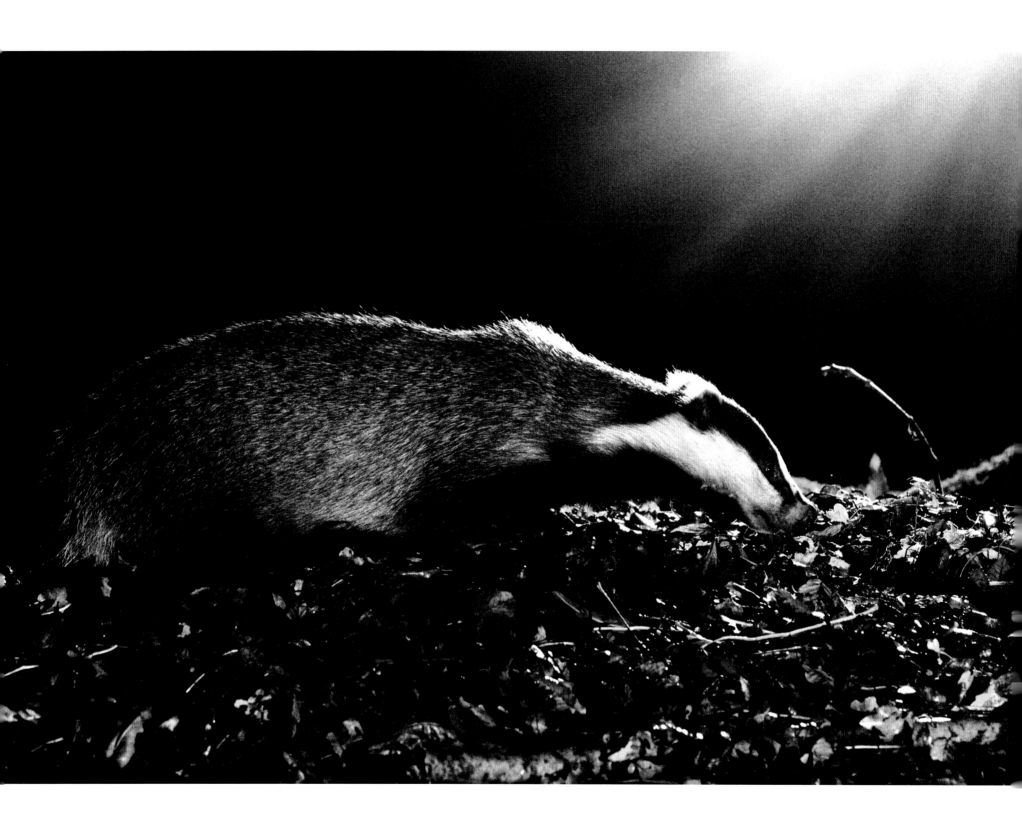

7 YEARS OF CAMERA SHAKE

(left) Badger in moonlight at Scrag Copse
Sussex

(right) Badger in the garden
Sussex

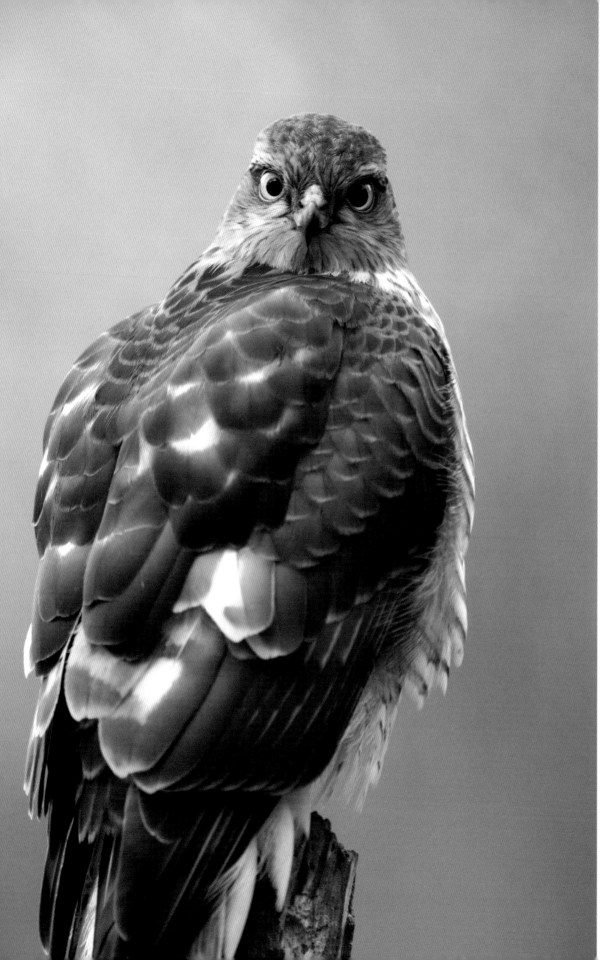

Immature sparrowhawk
Sussex

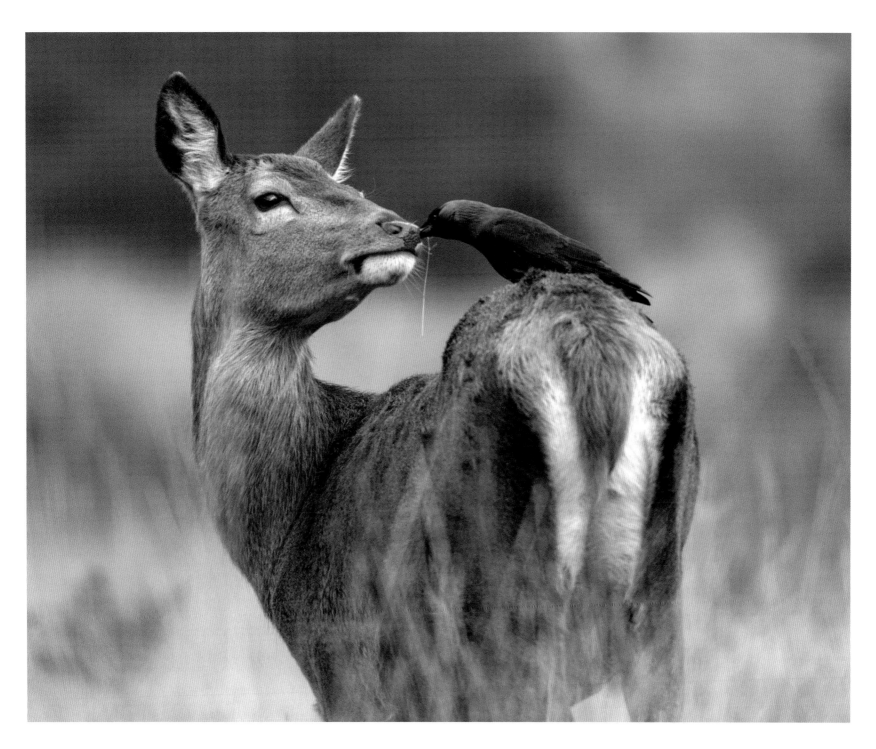

Jackdaw removing parasites from red deer hind

Sussex

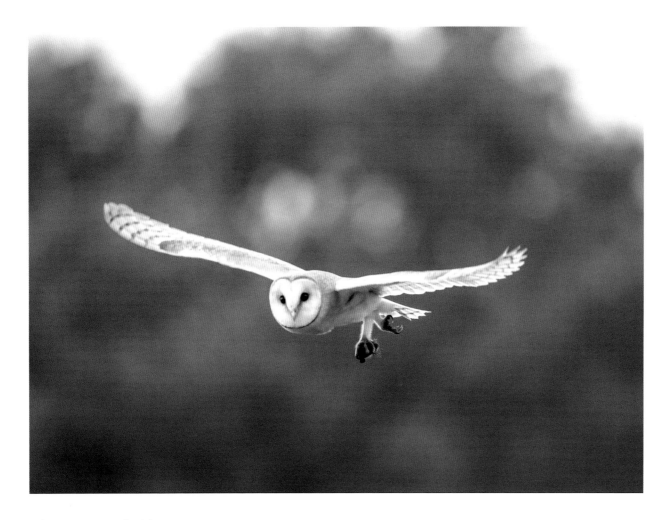

(above) Barn owl with prey

Sussex

(right) Barn owl

Sussex

Barn owls suffer from great population fluctuations often caused by harsh winters, when lying snow prevents them from locating their prey. However, if conditions are right, they can be prolific breeders, and on occasion they can be seen all hours of the day hunting to feed their young. Barn owl numbers also rise and fall relative to the population levels of their main prey, the short-tailed vole.

I 'm always trying to devise methods to help capture an image. I bought a remote-controlled MP3 player very cheaply on eBay, which apparently had a range of 100 metres. I downloaded the sound of squeaking mice and hid the tiny device in an area where I knew there were barn owls. It was the middle of the day and I was just testing the range of the control. On the first squeak, a barn owl flew straight out of the adjoining woodland straight towards the MP3 player and perched in a tree staring down at it. The camera was fortunately resting on a beanbag on the door of the 4x4. After a couple of minutes of intense staring and listening, the owl glided off, unaware of my presence. Interestingly, the device has never successfully lured a barn owl again.

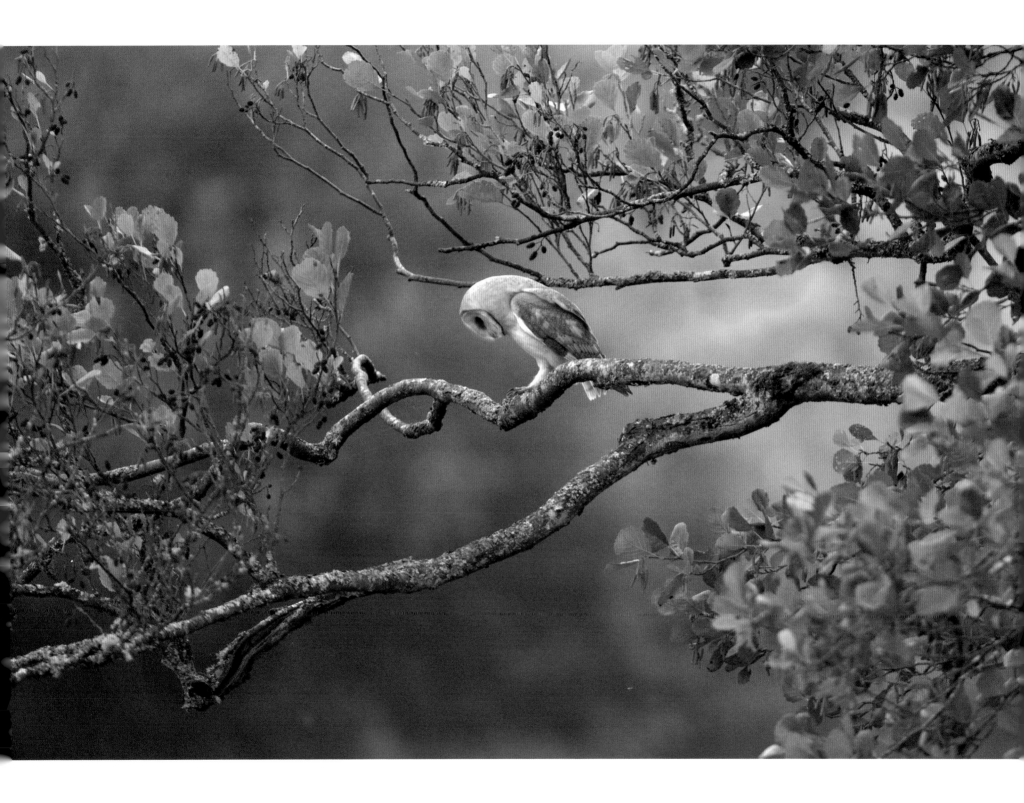

Barn owl having just emerged for the evening
Sussex

7 YEARS OF CAMERA SHAKE

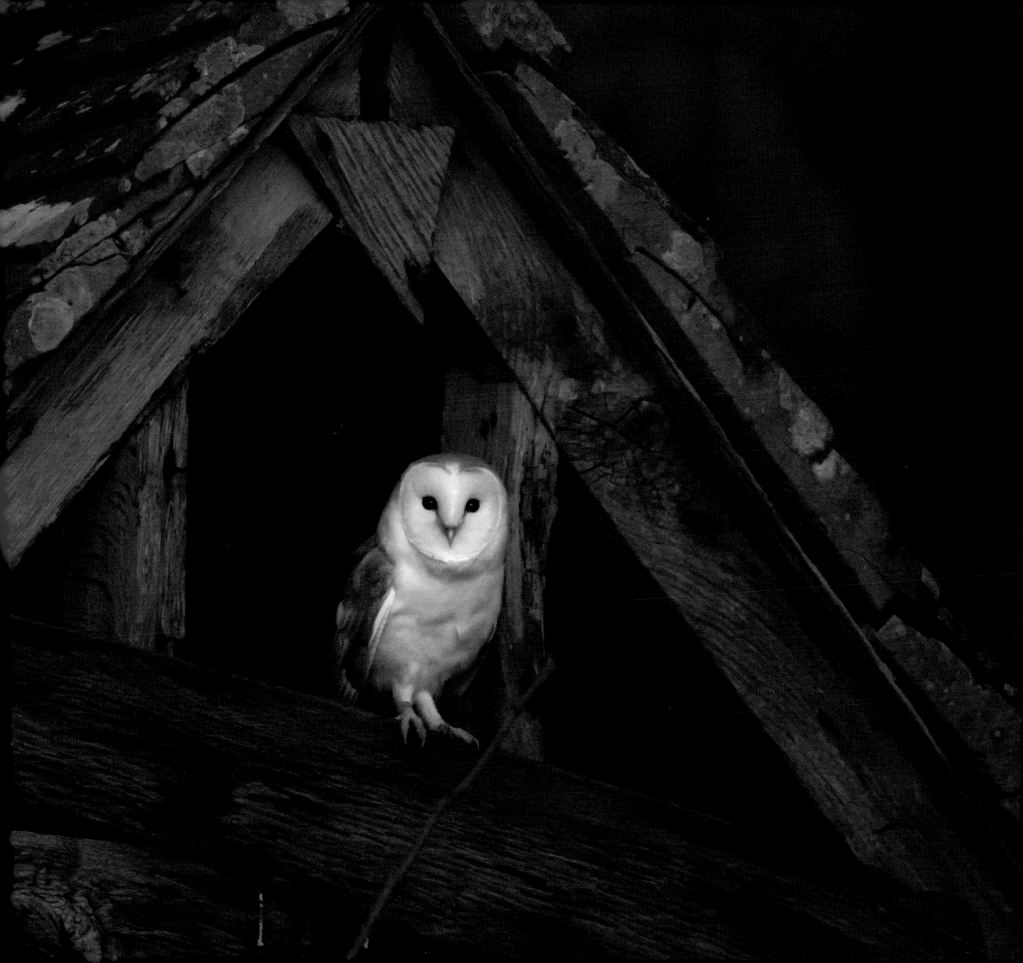

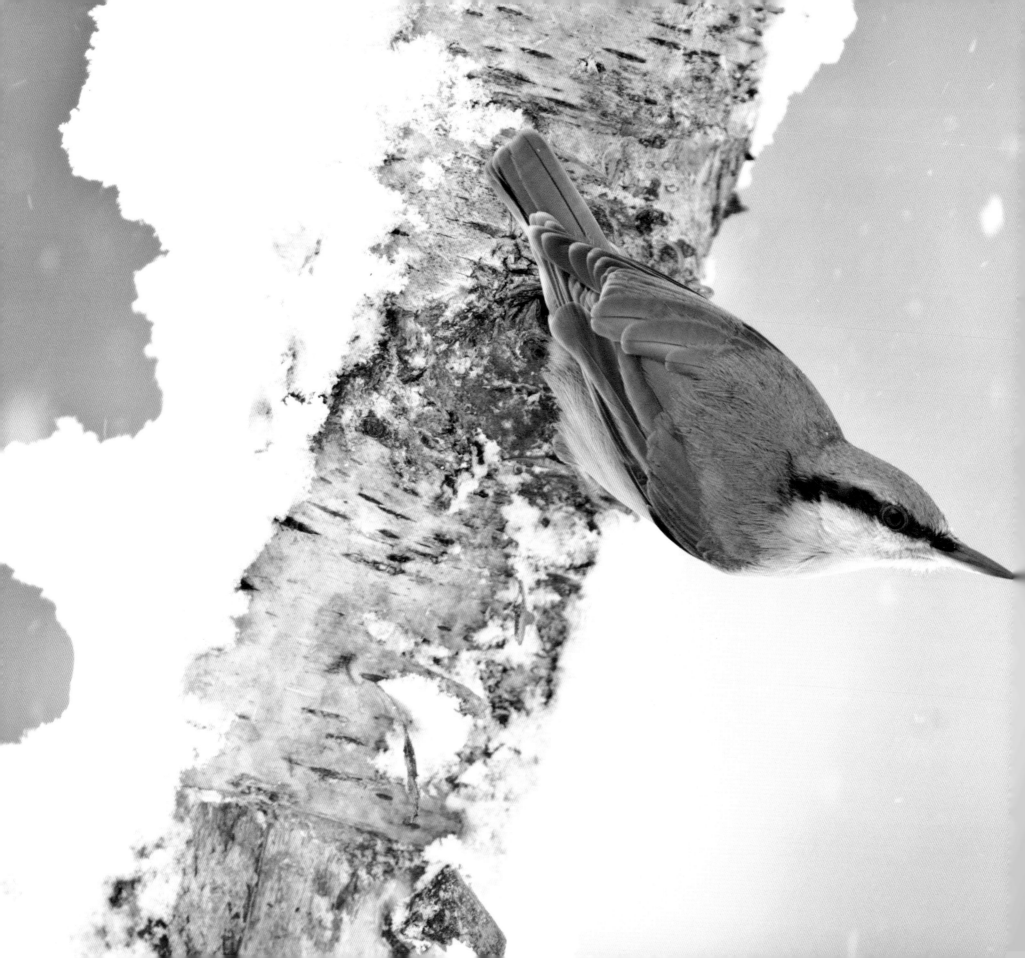

Nuthatch
Sussex

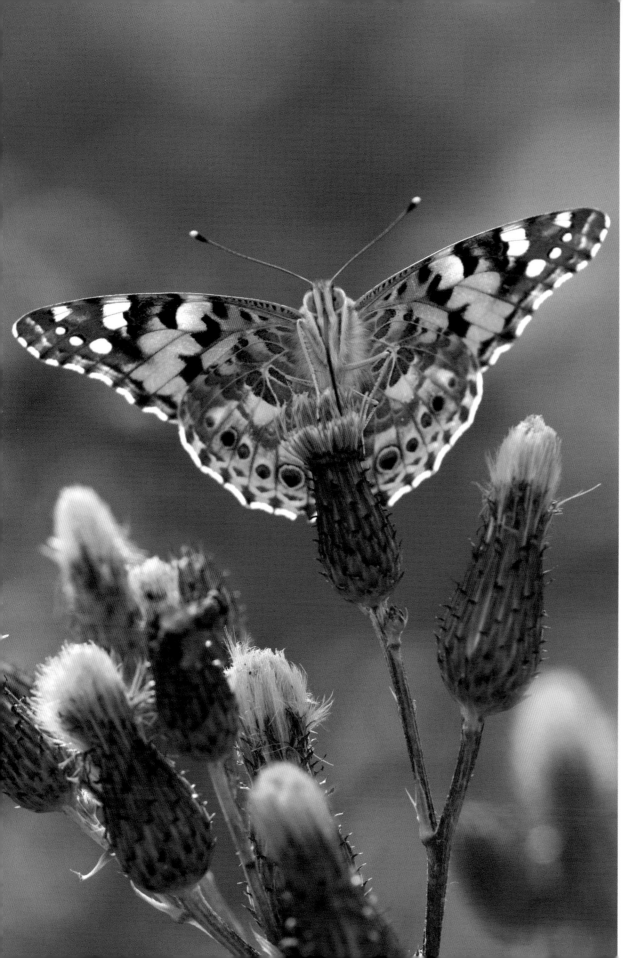

Painted lady butterfly
Sussex

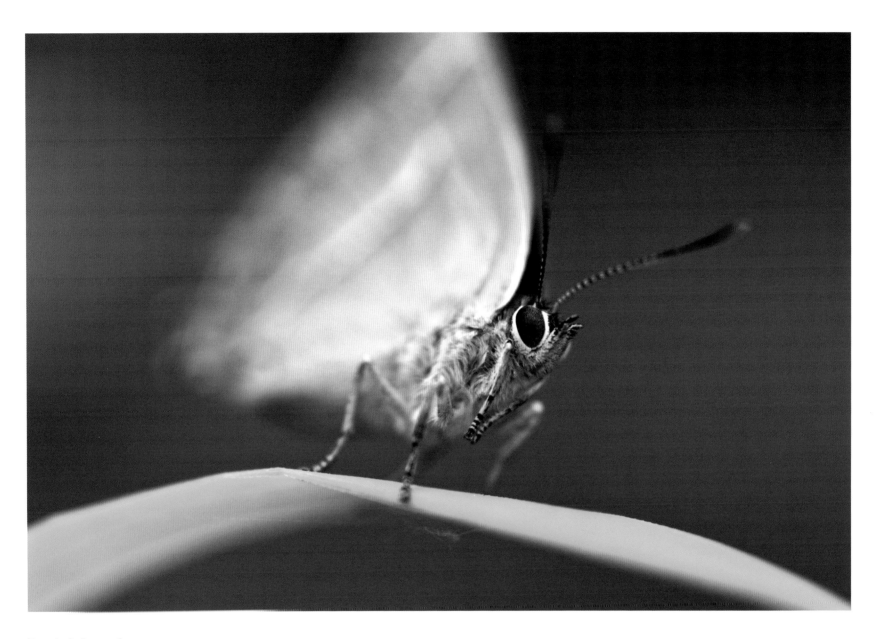

Purple hairstreak

Sussex

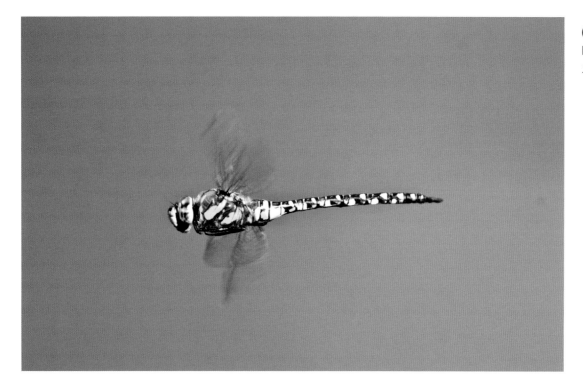

(left, above and below)
Migrant hawker dragonfly
Sussex

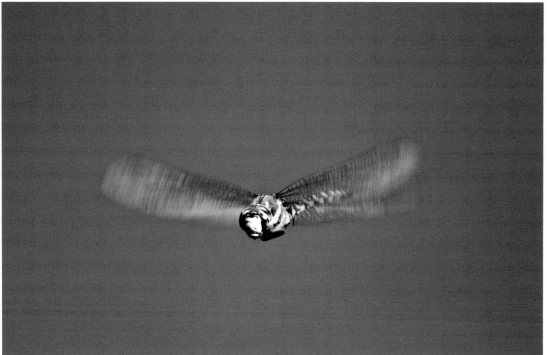

(right) Common lizard
Sussex

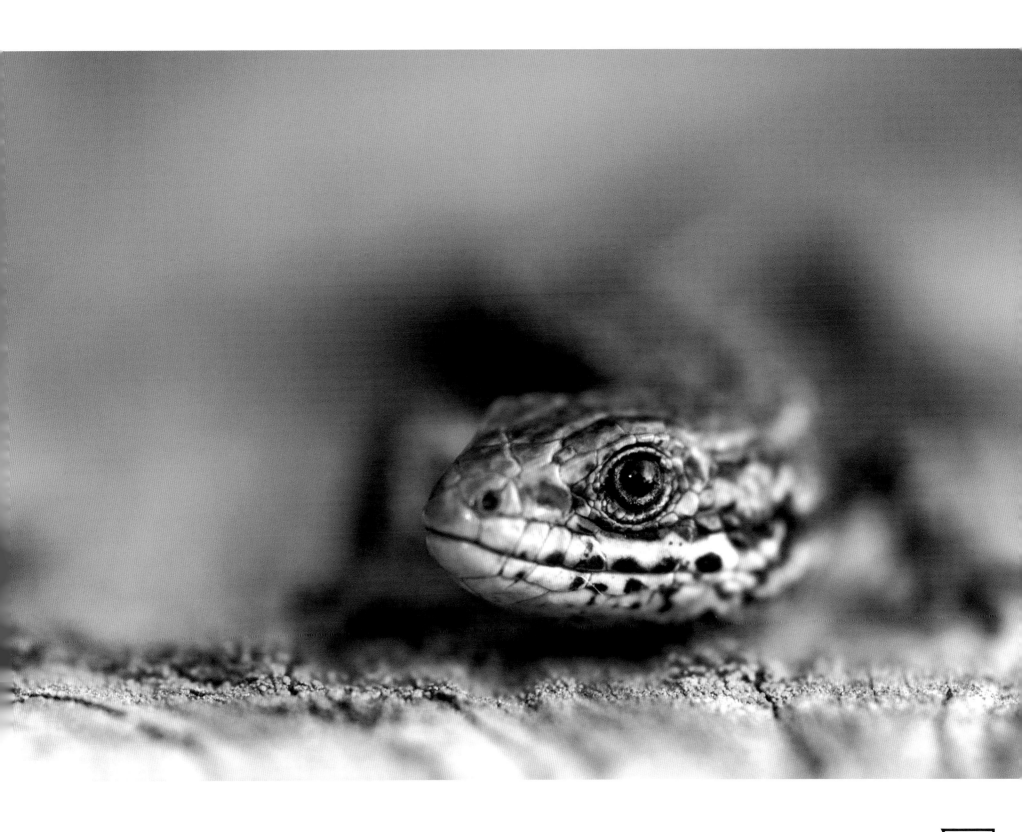

Tawny owl
Sussex

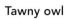

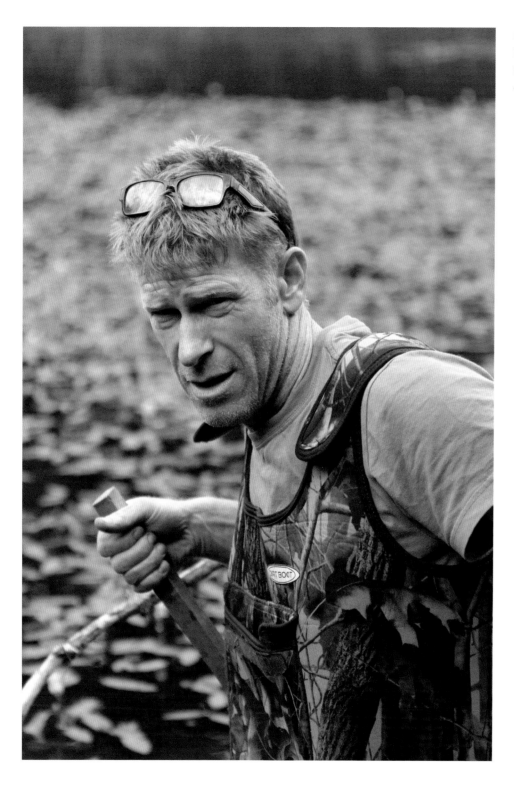

Maintaining setups for species such as kingfishers often involves wading out into a lake in chest waders worn in all conditions throughout the year.

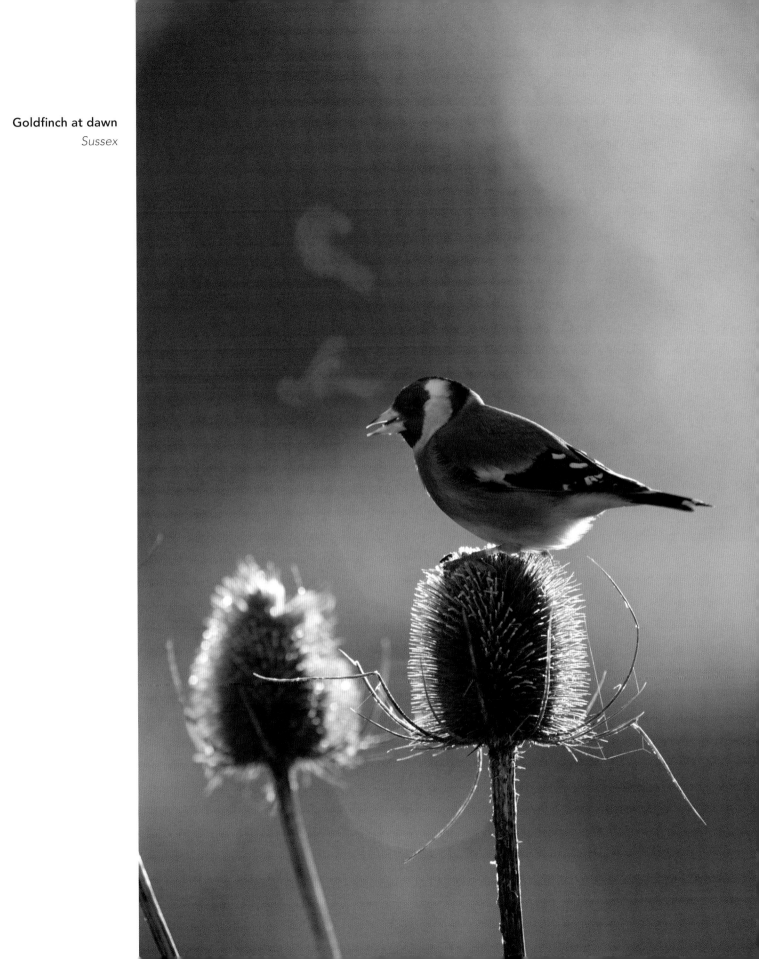

Goldfinch at dawn
Sussex

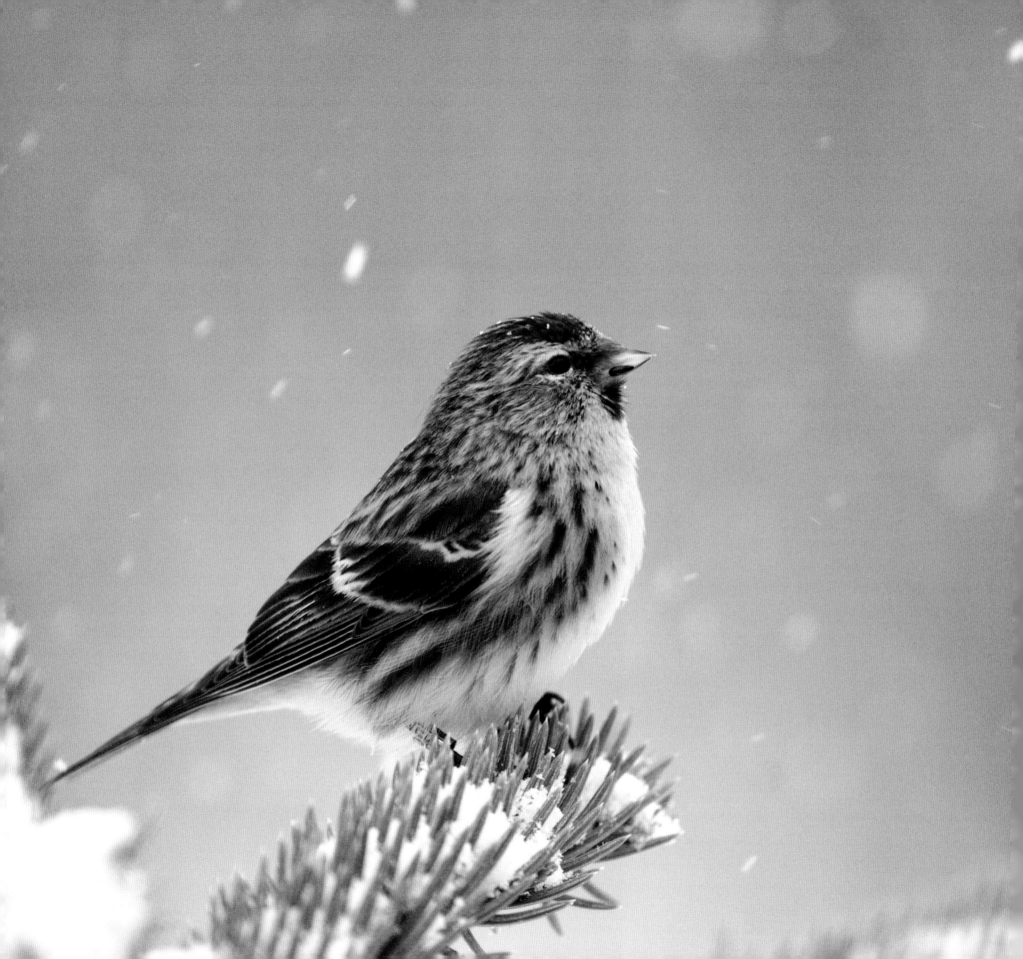

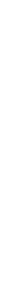

Lesser redpoll
Sussex

This image is actually a bit of a cheat. I regularly feed the birds in my garden in winter, and being in the Sussex countryside, I get some quite interesting visitors like this lesser redpoll, which was part of a small group regularly coming to the feeders. The spruce that it's perched on is actually my Christmas tree, which I propped up in the garden near the feeders. Snow in Sussex is rare so I always make the most of every opportunity and it adds a certain wildness to this image. With the hide set up in the garden and the conditions freezing cold, it wasn't too unbearable, as I could just nip in and out of the house to get hot drinks. So the image looks pretty wild and bleak but was actually quite comfortable to achieve.

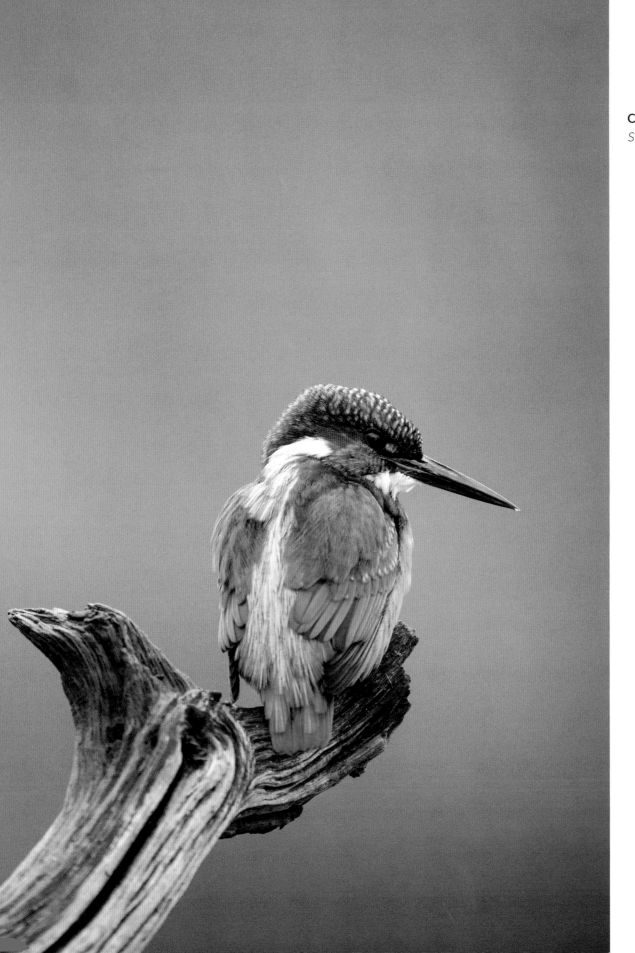

Common kingfisher
Sussex

Kingfisher bashing fish before and at moment of strike
Sussex

Tawny owl and prey
Sussex

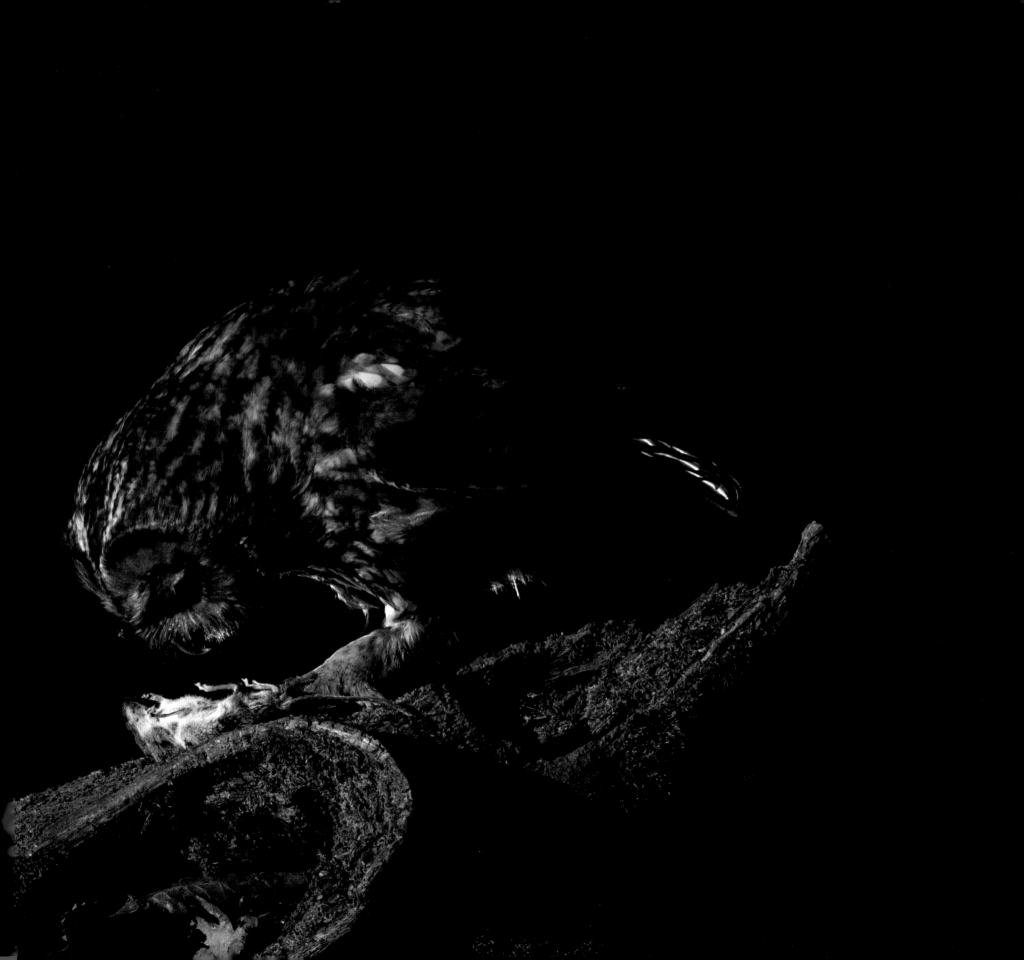

Little owl landing on prey

Sussex

I like this image as it shows the true character
of these cute owls and gives the owl almost a
Batman look about him as he goes in for the kill.

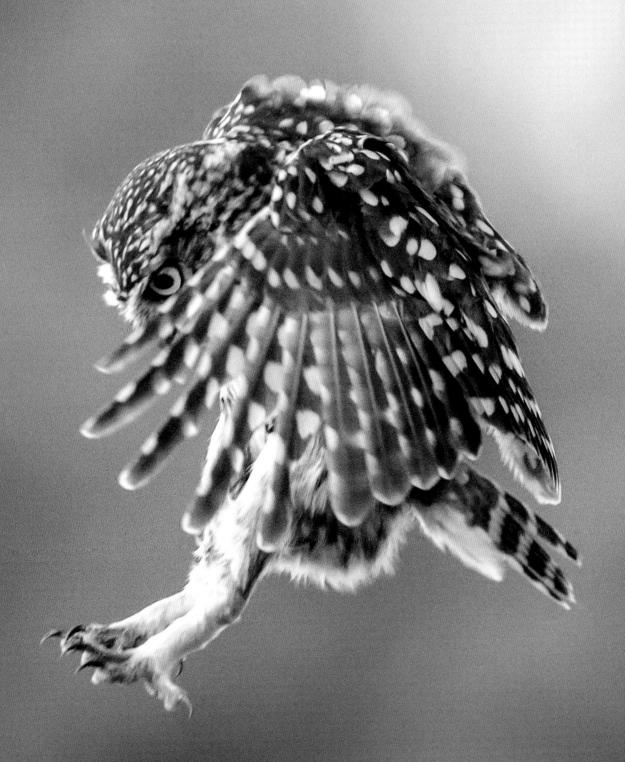

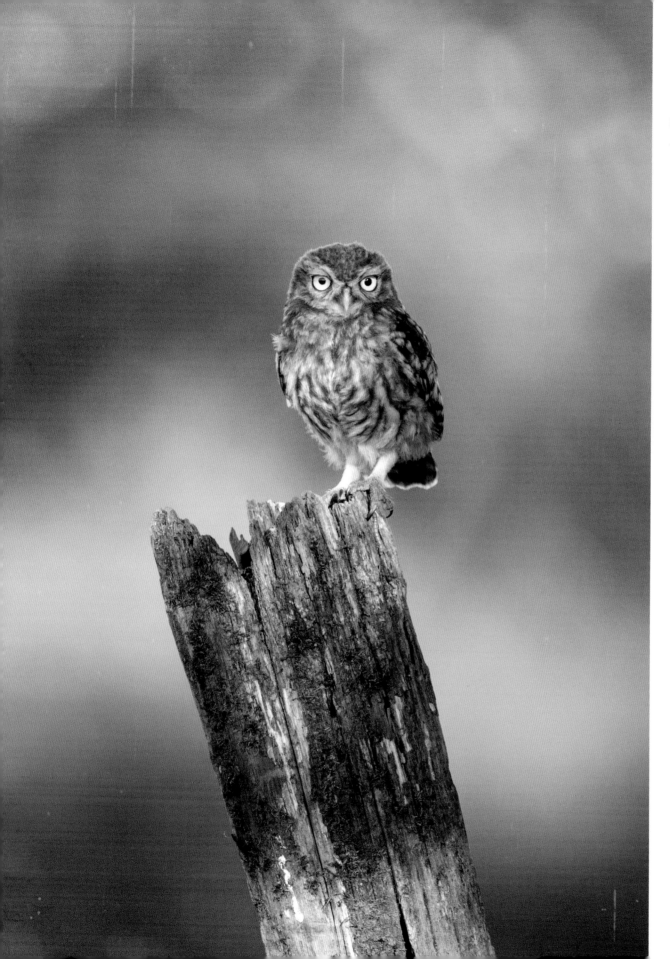

Little owl
Sussex

Agrippa, although wild, is my most reliable owl,
having become used to my presence over two years.

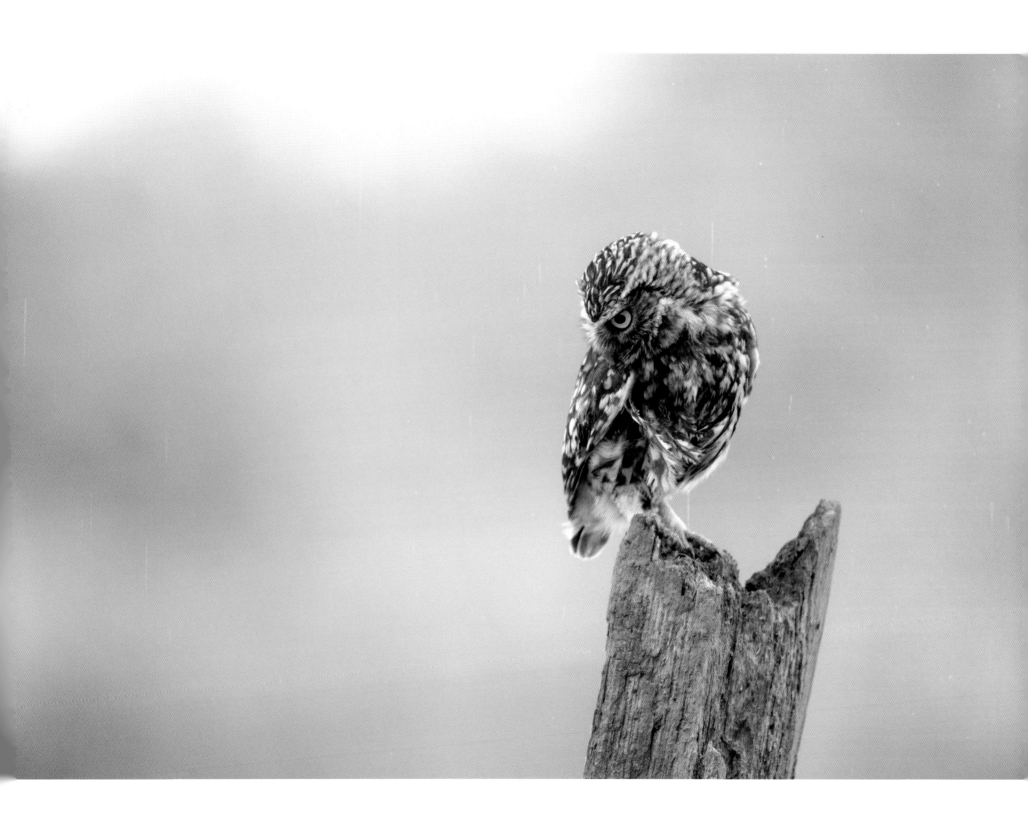

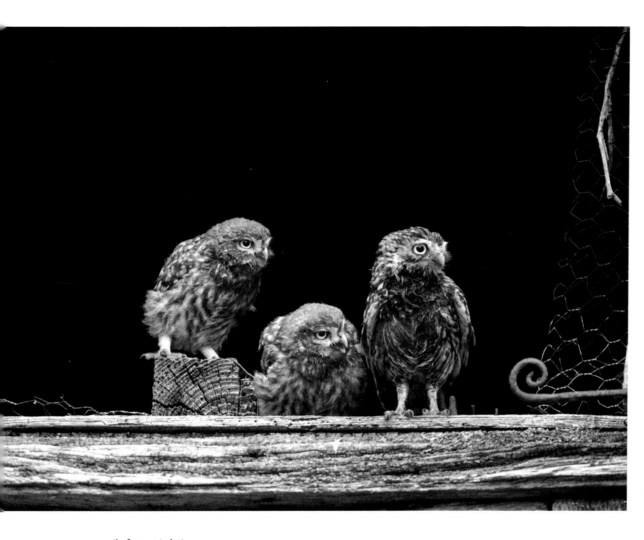

(left to right)

Agrippa the little owl with two of his youngsters

Agrippa leaving the nest site

Agrippa feeding young

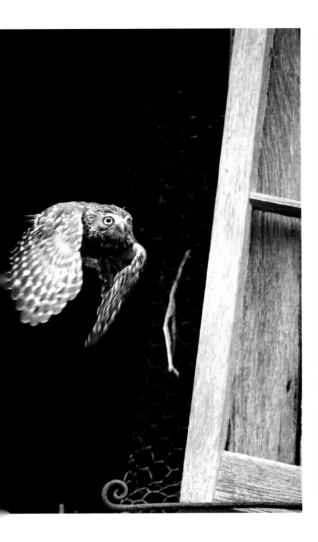
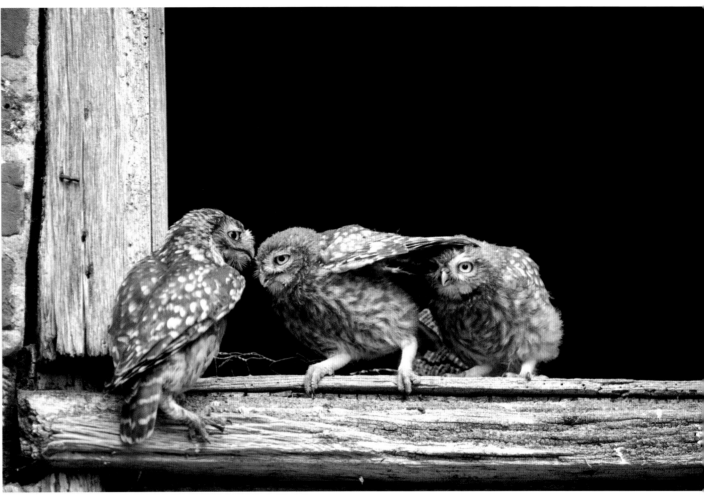

JAGUARS' PARADISE

The Pantanal region of Brazil in the huge Mato Grosso and Mato Grosso do Sul states, bordering Bolivia, is the largest freshwater wetland region in the world. Pantanal means marsh in Portuguese but the region is in fact a rich tapestry of habitats: marsh, river, gallery forest, savannah, and dry forest islands. With its tropical climate, the area supports a huge array of life. It is one of the greatest areas in the world for seeing wildlife. And, being more open than tropical rainforest such as that found in the Amazon region, it is superb for wildlife photography. I have been visiting the area regularly since 1999, sometimes up to three or four times a year. The birdlife is absolutely incredible, with iconic species such as the toco toucan and the hyacinth macaw. As well as birds, mammals thrive, including the big cat that I fear the most, the jaguar or onça as it is locally known. My first jaguar, seen from a boat on the mighty Cuiabá River, actually left me breathless with her beauty. Rather stupidly, as she walked away from the edge of the beach, I got off the boat and followed her. I thought I would be concealed and protected by a slight bank of sand as I approached. Judging the distance between us to be around twenty metres, I peered over the top of the sandbank. My heart raced as she lifted her head and glared at me, and I realised she could quite easily close that distance in half a second. I was alarmed but not afraid; I don't know why. After a few seconds of her glaring, she started to groom and relax. In the lowering sun, I photographed this captivating cat for over an hour. I did not sleep for the following three nights.

There is an expression in the Pantanal: if you do not fear the jaguar, you do not know the jaguar. The jaguar in the Pantanal has such a rich food source that it reaches huge sizes relative to other jaguars in Central and South America – 150 kilograms is not uncommon. I have seen them kill full-grown caiman. They also have an ability to remain motionless and virtually invisible at a very close range. I now know the jaguar, and although I love them, I now fear this cat too.

Searching for jaguars in this region involves exploring vast river systems by boat; jaguars love water, often patrolling their overlapping territories along the edge of a riverbank and, quite obligingly, lazing around on the many beaches that punctuate these rivers. They can also, quite frustratingly, lie for six hours in deep vegetation before getting up and walking off into even deeper vegetation, leaving the photographer with long, tedious waits in full sunlight while the cat enjoys the deep shade.

The Pantanal region is a colossal area and I visited many times before finally seeing a jaguar. Tourism was embryonic when I first started going there in the late 90s and I used to hire a Kombi van, which was the Brazilian version of the VW Camper. Sadly, they don't make them anymore, but it was a great vehicle to travel the area with. I used to stop by lagoons and pools to lie in the mud with the camera on a beanbag, surrounded by caiman – it's always surprising when you realise that there's been one right next to you for the last thirty minutes or so!

However, it is a dream to photograph this wetland paradise; on just about every prominent perch and post is some sort of predatory bird: a snail kite or a flycatcher. In the dry season, the diminishing pools concentrate fish and sometimes they are crammed full of birds, such as jabirus and American wood storks, making the most of the fish harvest. The fringes are alive with herons and egrets. The sunbittern, a migrant from the Amazon, is very shy and will fly at any approach. However, I've discovered that they're not fazed by your presence if you lie down. So if I see a sunbittern working its way along the edge of a pool, I quickly lie down some twenty or thirty metres ahead of it and wait. With a low camera angle, I just shoot as it approaches until – as has happened on several occasions – the bird is too close to even focus on. At that stage, I just stay in position and let it walk on past me. I love that experience, of photographing an animal without causing any disturbance whatsoever.

The Pantanal region is quite possibly my top overseas destination for wildlife photography. It certainly rivals the Maasai Mara, although photography in the Pantanal is much harder: the subjects are generally smaller, except in the case of the jaguar, and are not so obliging to people just driving up in vehicles. In this region you have to work harder under more taxing conditions, but the rewards can be great. It also used to be one of those destinations that wildlife photographers didn't visit, in comparison to places like the Serengeti or the Maasai Mara. Both are truly phenomenal places to photograph wildlife, but it was good for me to specialise in the Pantanal due to the lack of images coming out of the region at the time. It has certainly changed over the years as far as ecotourism is concerned, but the increased number of visitors help protect the region and, despite these changes, the Jaguars' Paradise is still very dear to me.

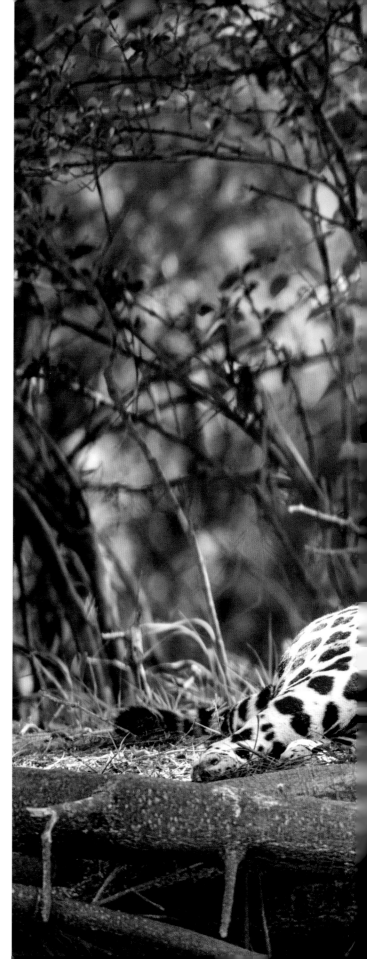

Female jaguar sleeping along the roots of a tree
Pantanal, Brazil

7 YEARS OF CAMERA SHAKE

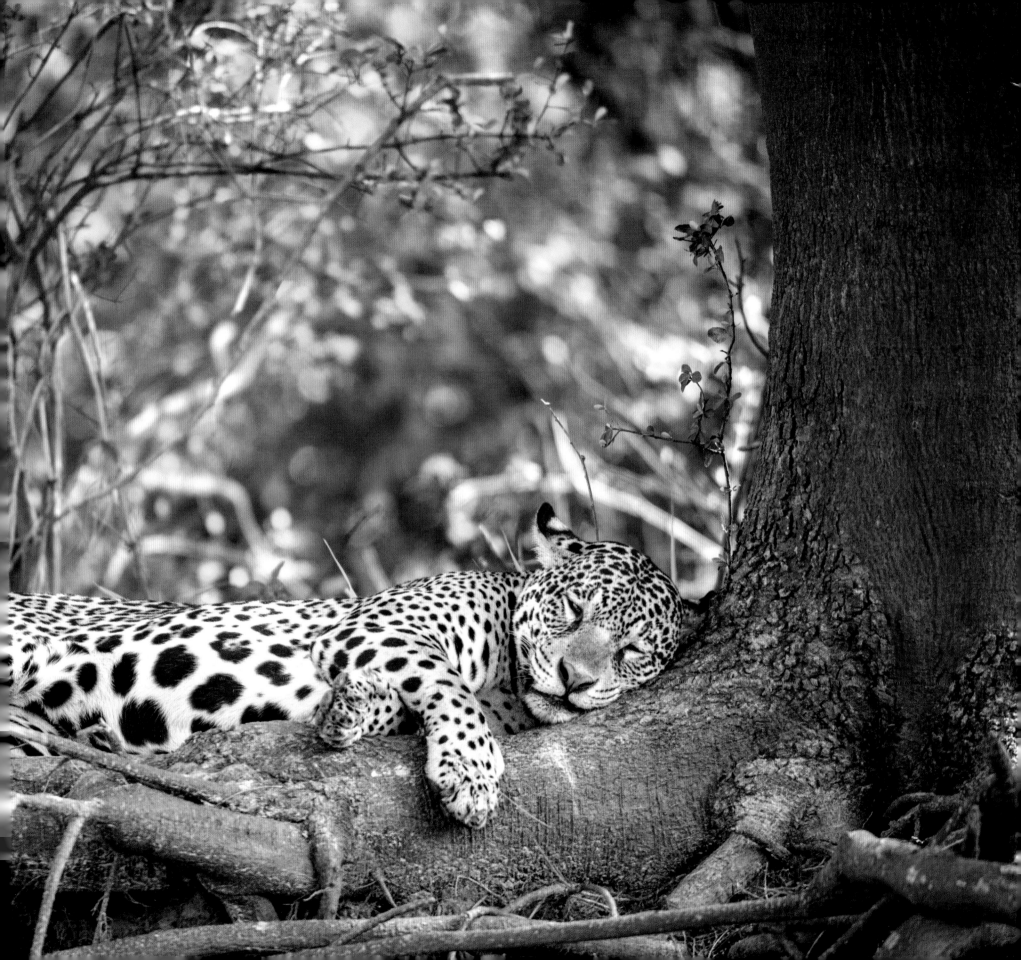

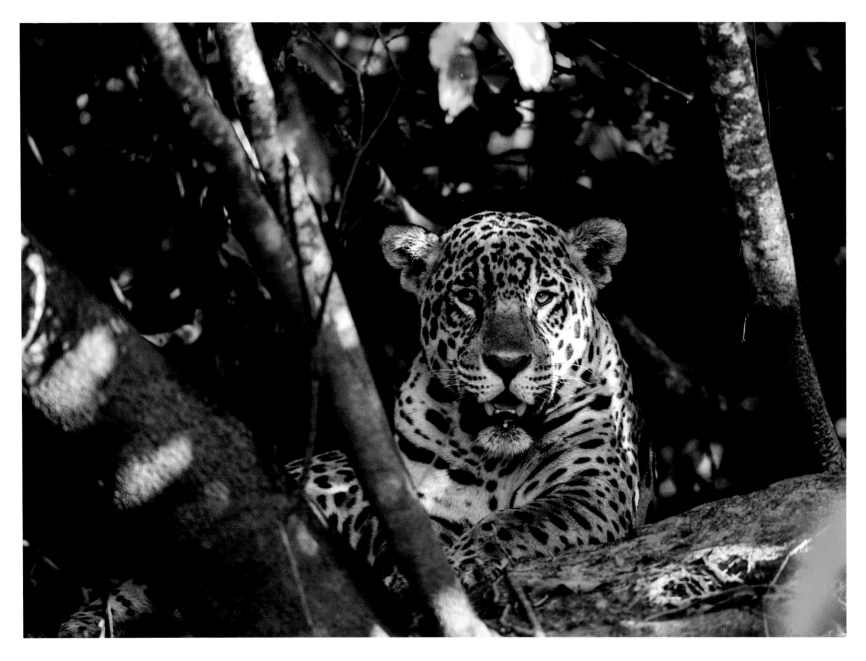

(above) Relaxing jaguar

Pantanal

(right) Jaguar emerging from the forest

Pantanal

7 YEARS OF CAMERA SHAKE

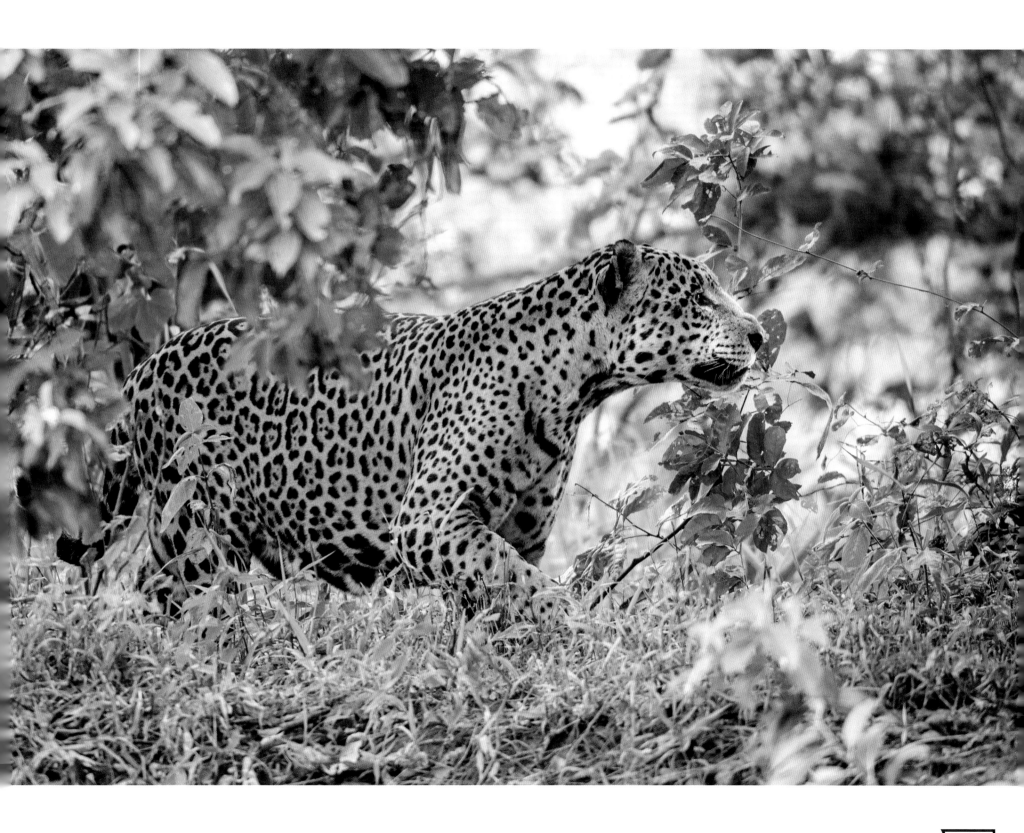

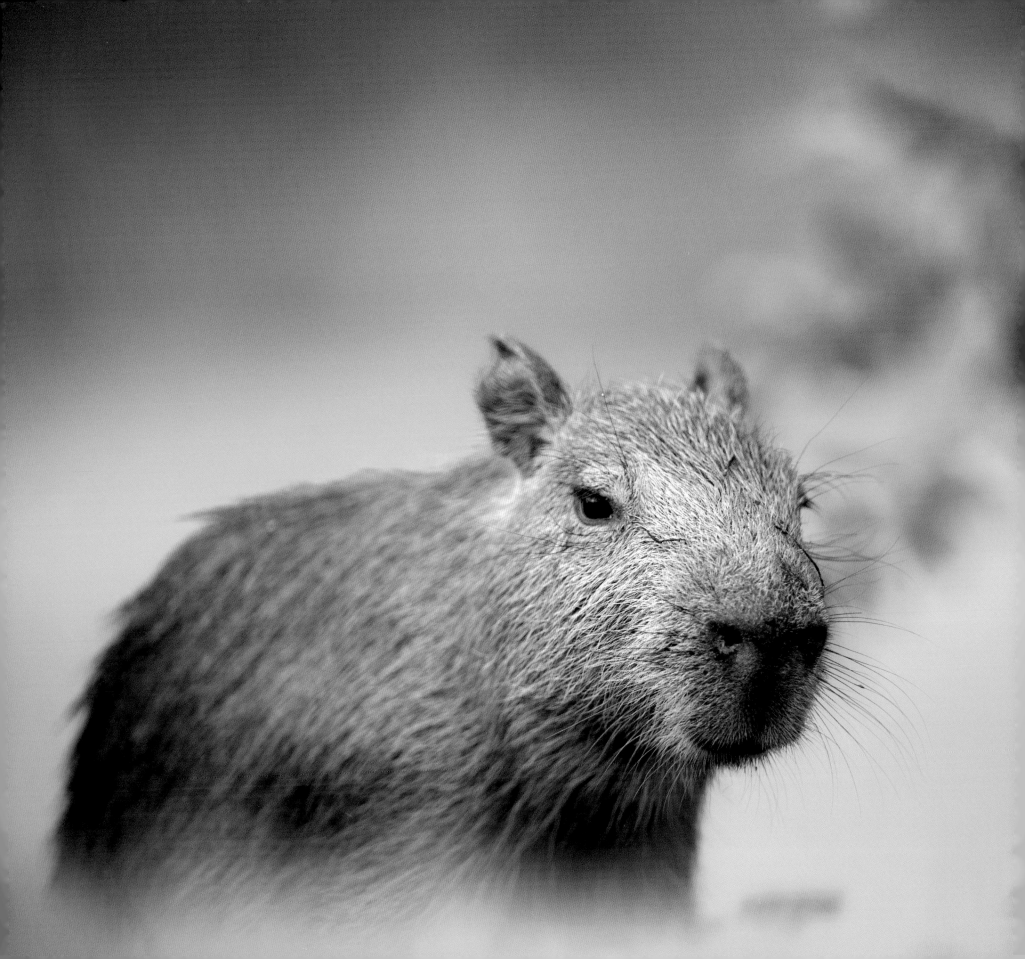

Young capybara
Pantanal

The capybara is the world's largest rodent and a favourite food of jaguars.

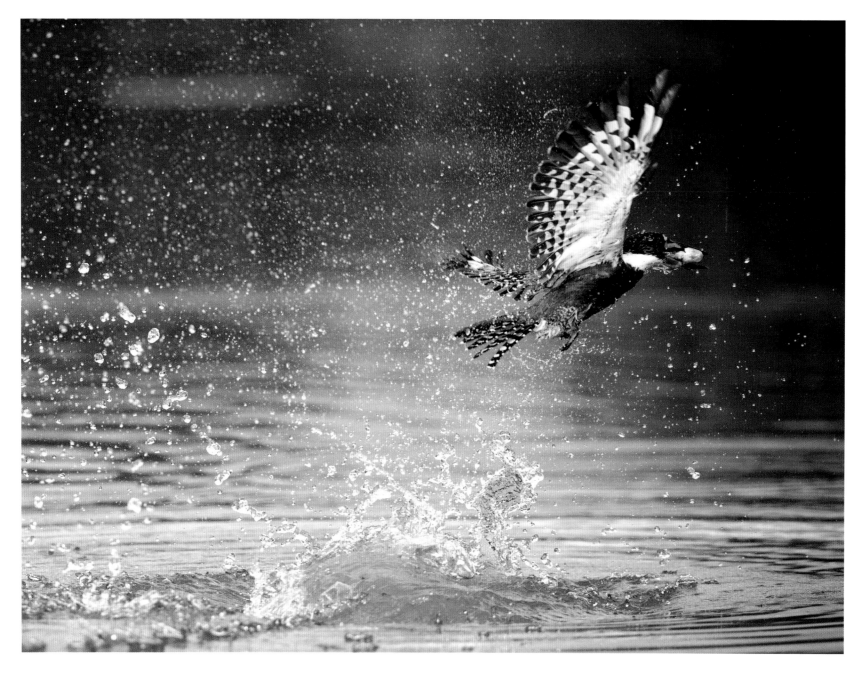

(above) Ringed kingfisher catching fish

Pantanal

(right) Black skimmer

Pantanal

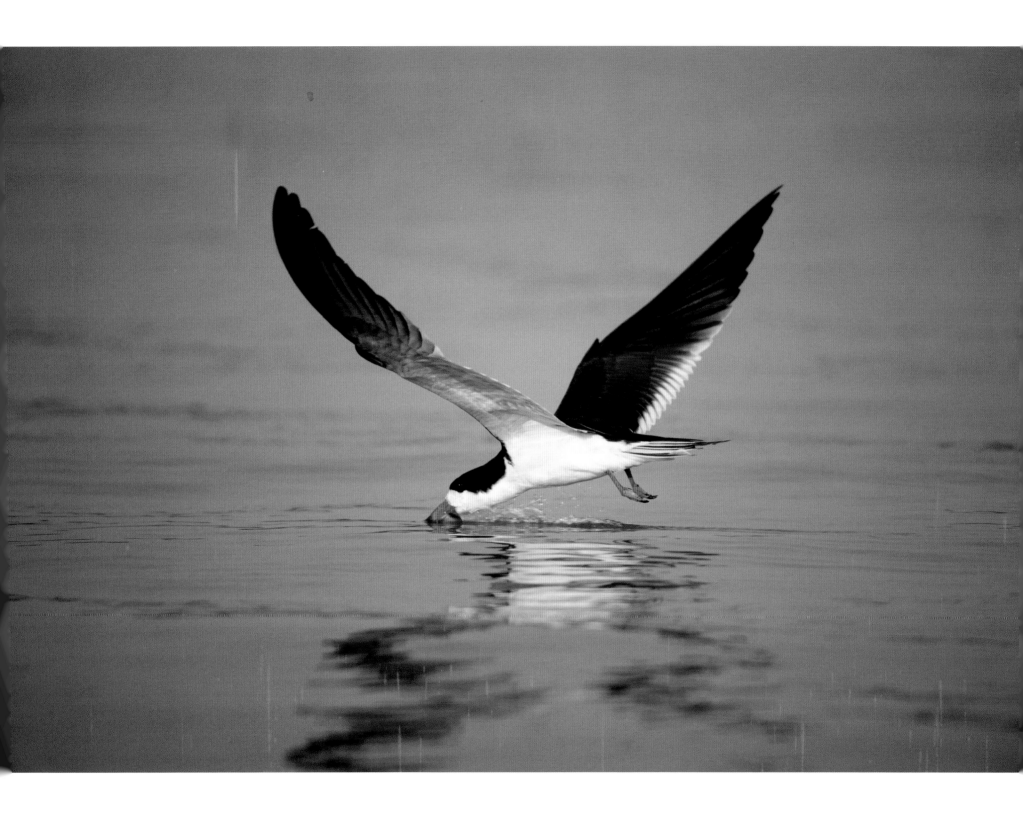

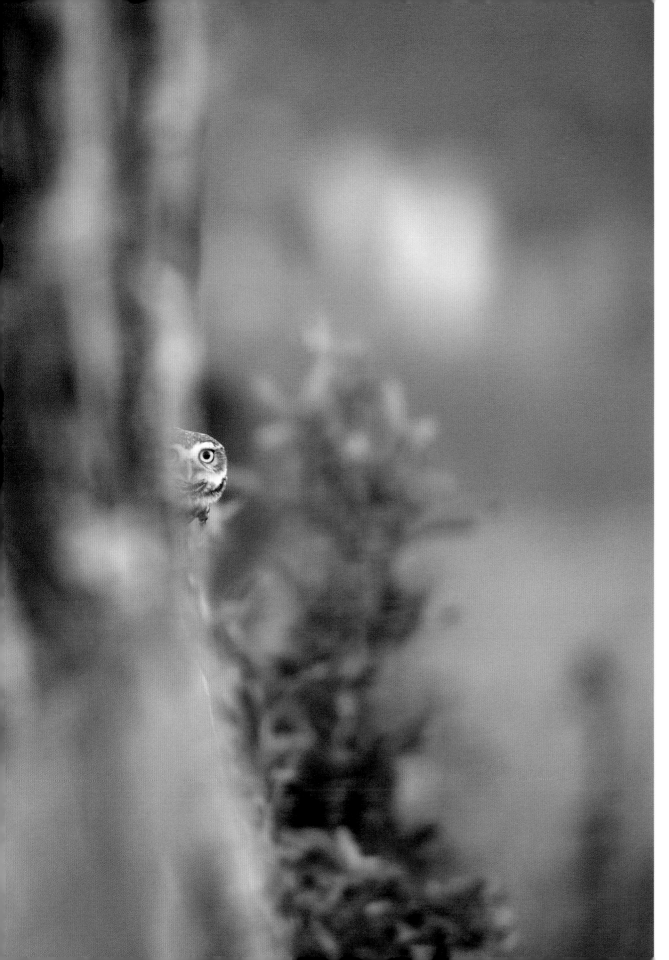

Burrowing owl keeping a lookout
Pantanal

Burrowing owls are tolerant of humans to a point. I find the best way to approach them is to crawl along the ground, pushing my camera on a beanbag ahead of me, and I adopt this technique for other animals as well. I also avoid looking directly at the animal. Even humans can tell at a very great distance if somebody is looking directly at them. It's an evolutionary thing; it's vital to know if something is looking toward you, especially if they're a predator. With these owls, I'm pretending in effect to be a cow or some sort of herbivore and therefore harmless. If I want to look at the owl on the approach, I just look through the viewfinder. Using this method, I can get pretty close. They will always carry on watching you though, and you'll soon know when you've pushed your luck.

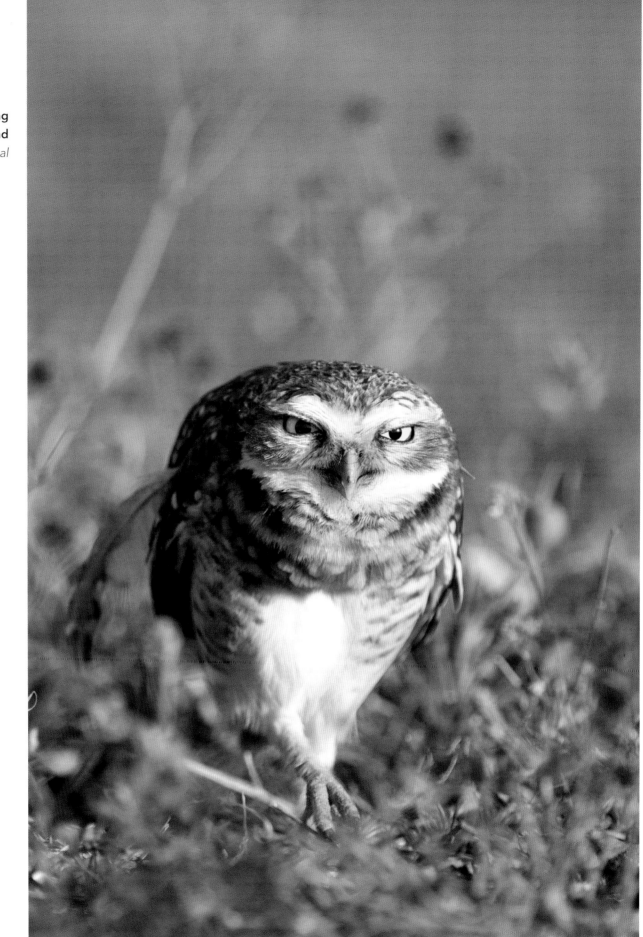

Burrowing owl running along the ground
Pantanal

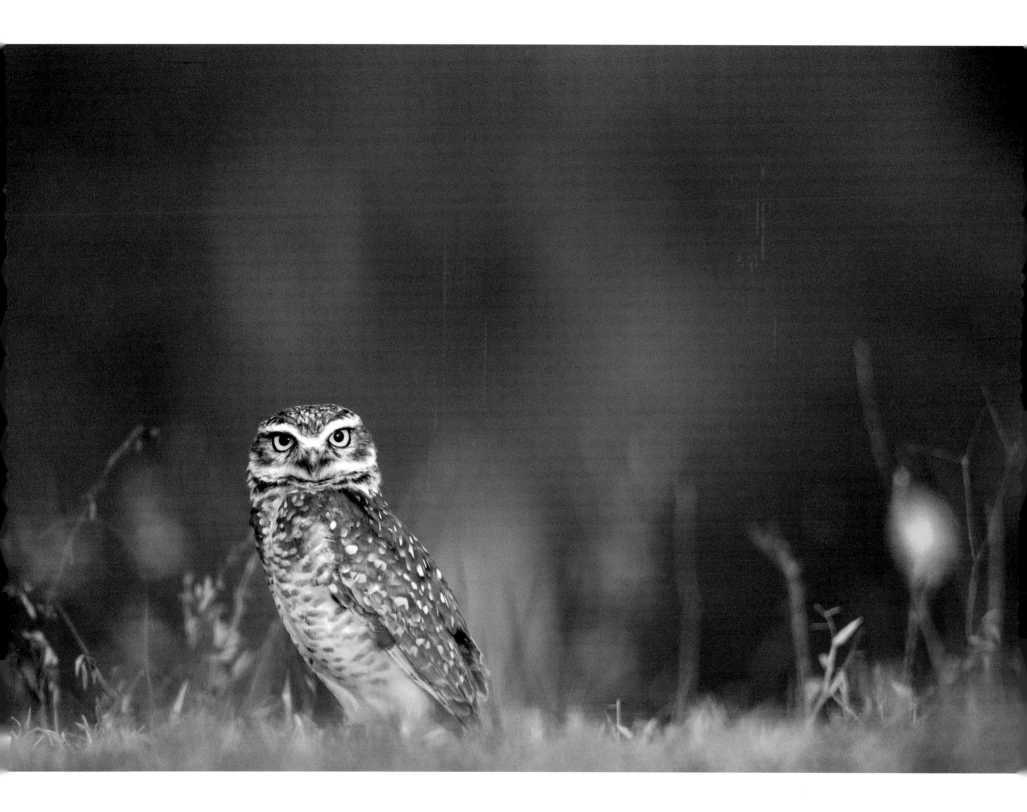

7 YEARS OF CAMERA SHAKE

(left) Burrowing owl guarding the nest site
Pantanal

(right) Yawning burrowing owl
Pantanal

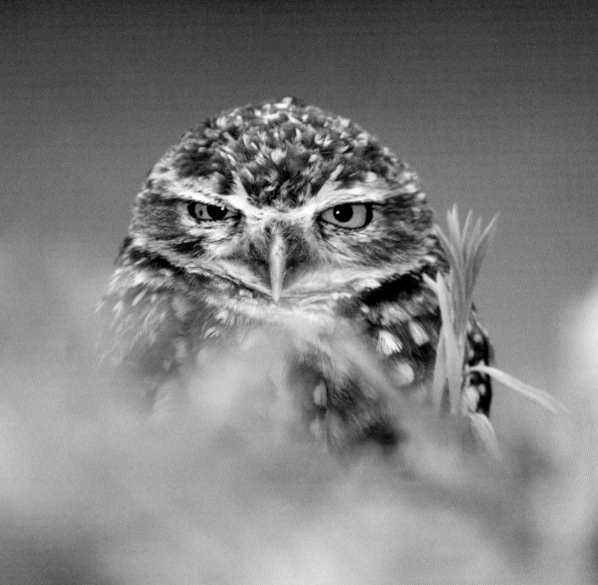

Burrowing owl at nest site
Pantanal

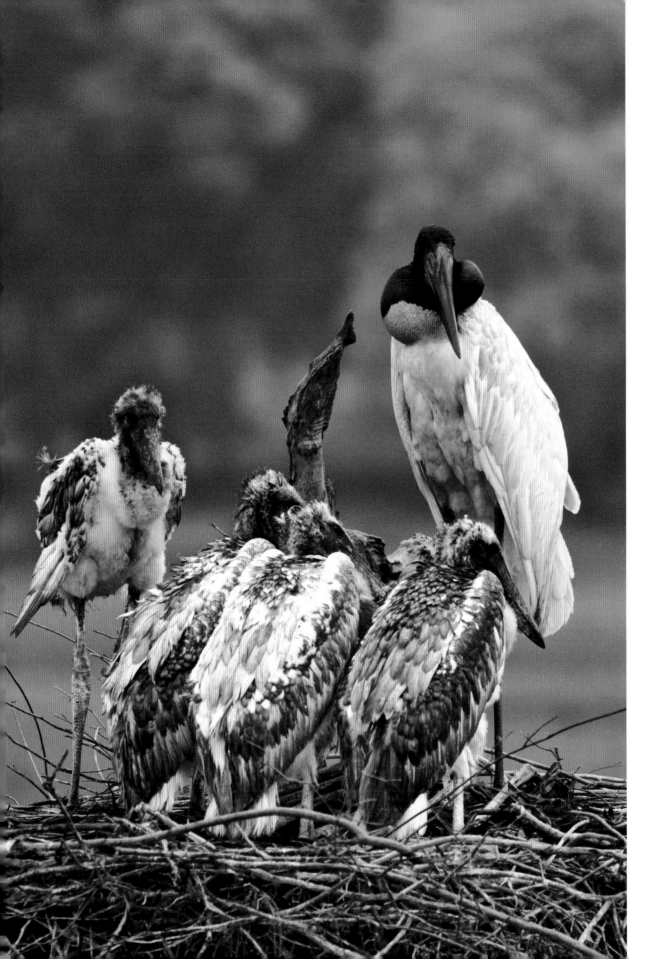

Jabiru stork nest
Pantanal

These storks make huge nests often in dead, open trees – however the viewpoint can be a little uninteresting from the ground, as you often just get a shot of the bird poking out of the top of the mass of nest material. Fortunately, one of the lodges in the Pantanal region has built a tower next to one nest at a height of about twenty-five metres, giving a lovely, level viewpoint.

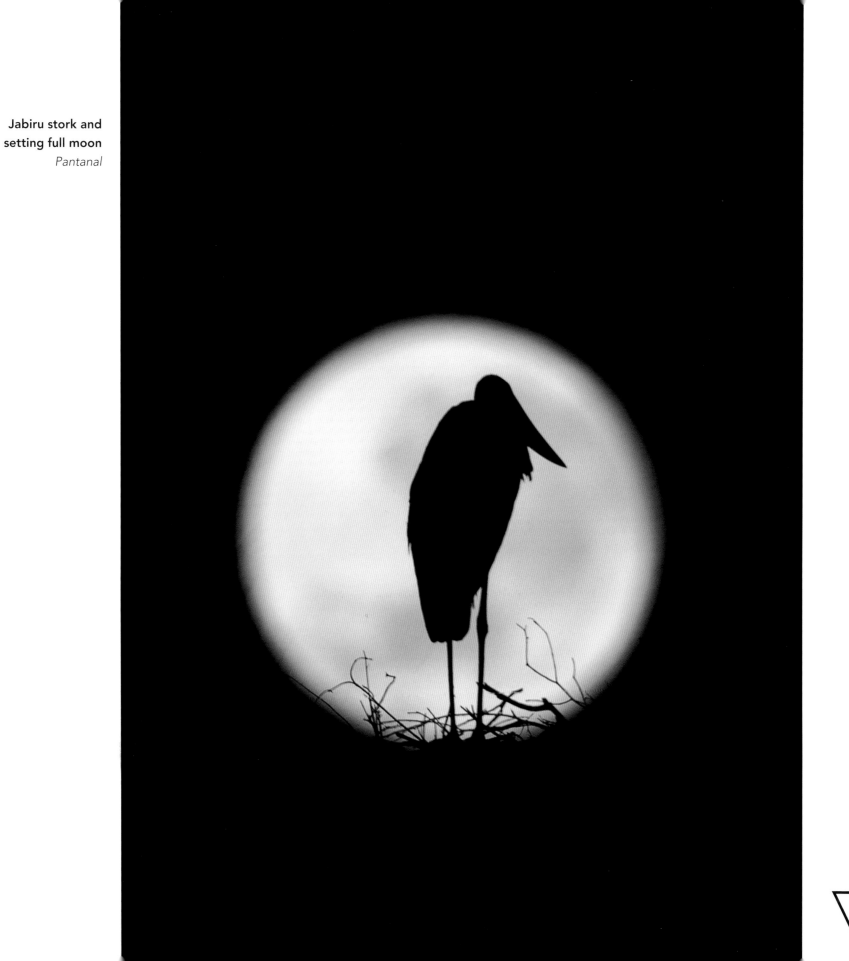

Jabiru stork and setting full moon
Pantanal

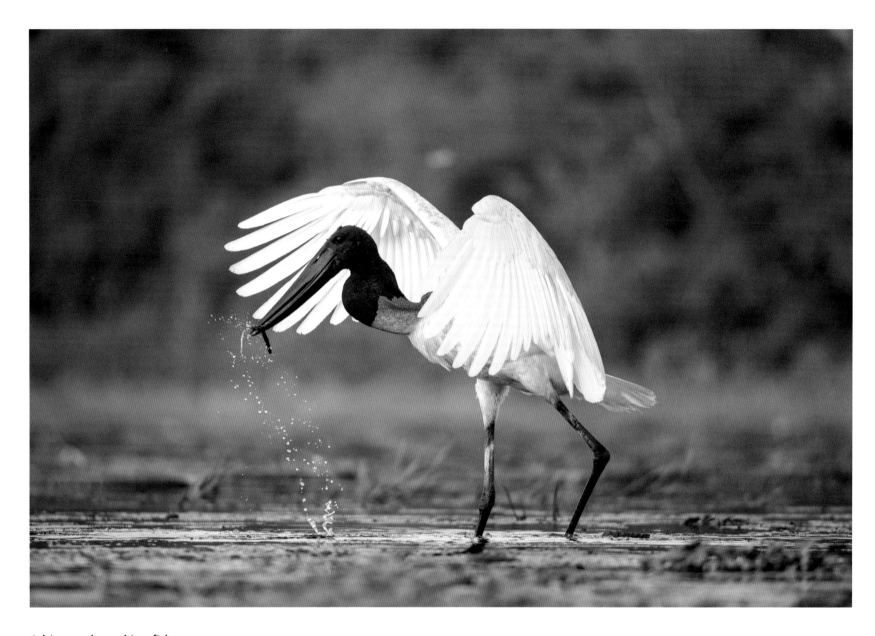

Jabiru stork catching fish

Pantanal

My role as a wildlife photographer is not just to photograph rare things, but also more common scenes, hopefully in a beautiful and artistic way. Jabiru storks are possibly the largest birds in the Pantanal, and they're pretty ugly to be honest, but watching them hunt through the marsh catching fish, they sometimes do a little dance, dashing forward with their wings outspread and snatching their prey.

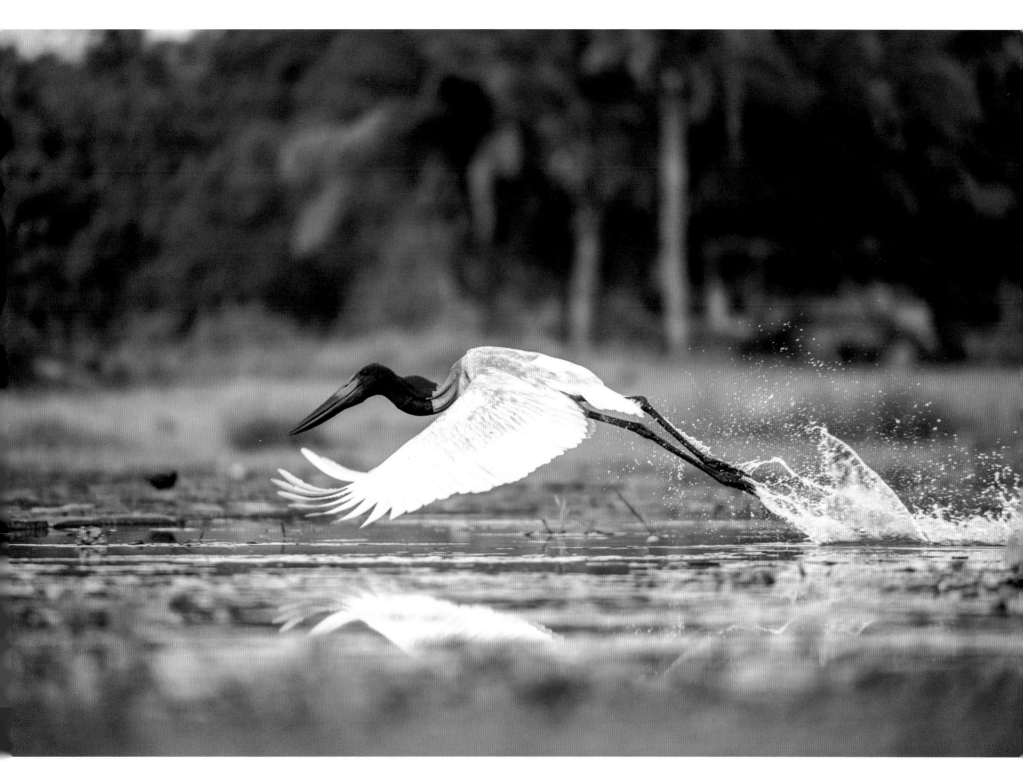

Jabiru stork in flight

Pantanal

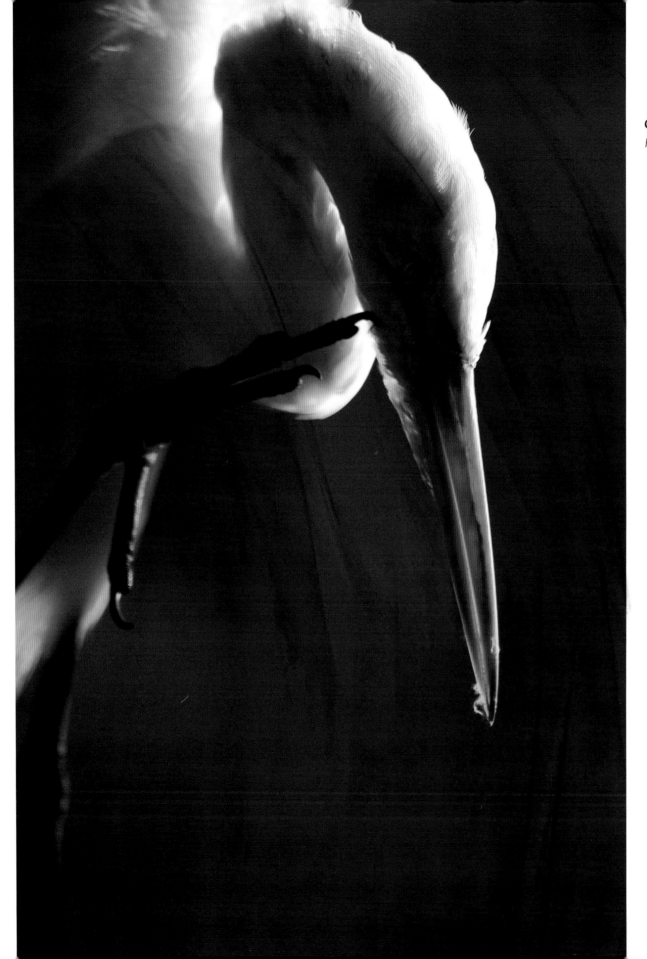

Great egret preening
Pantanal

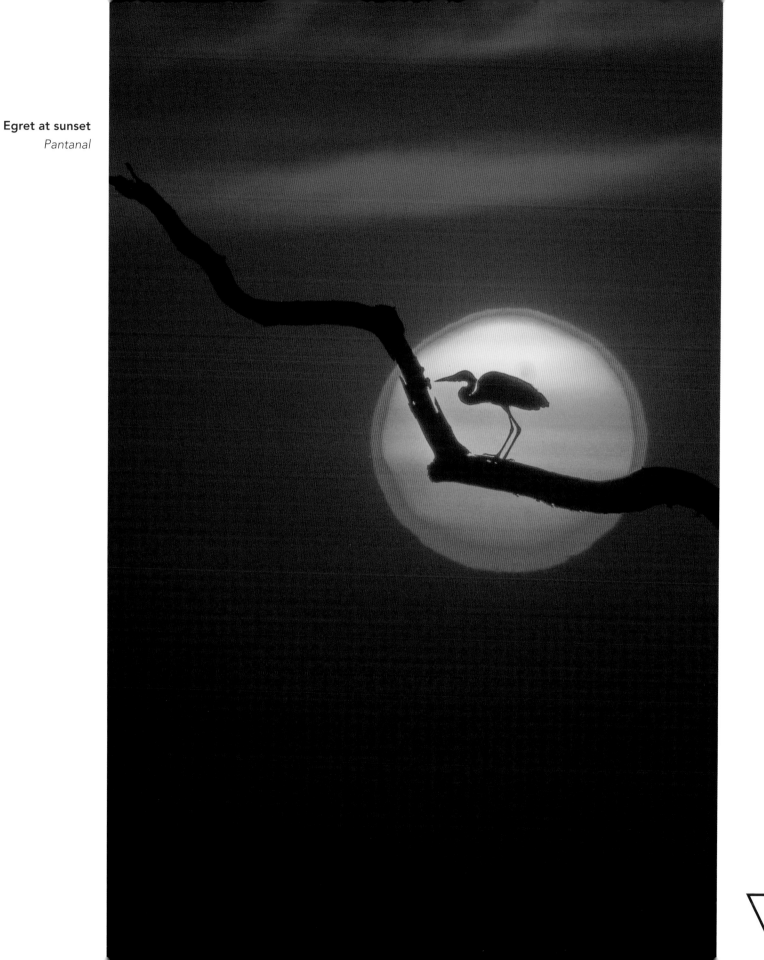

Egret at sunset
Pantanal

223

Striated heron

Pantanal

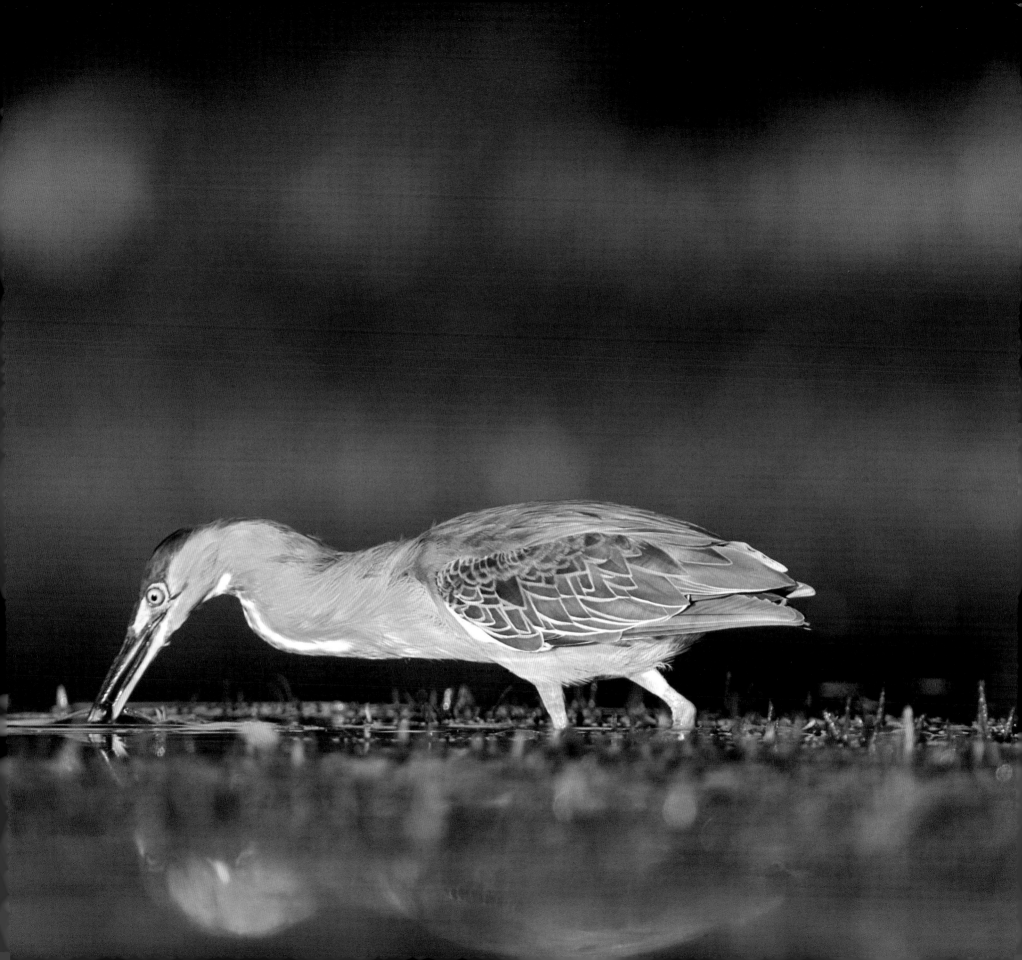

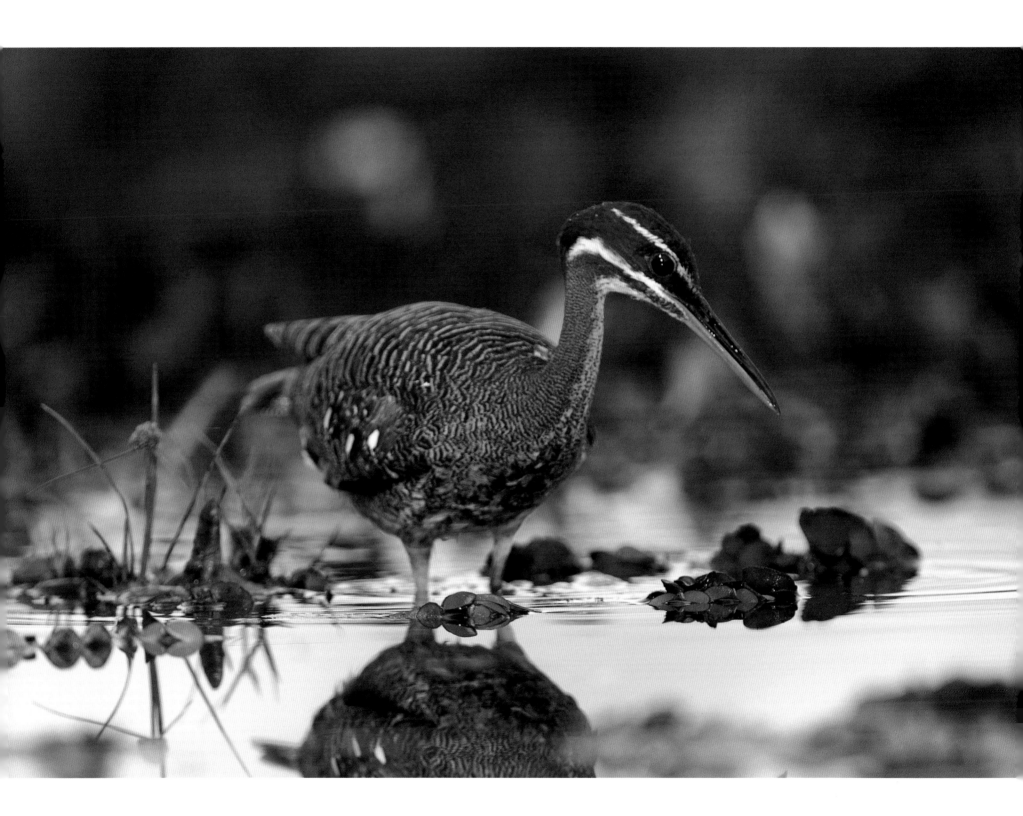

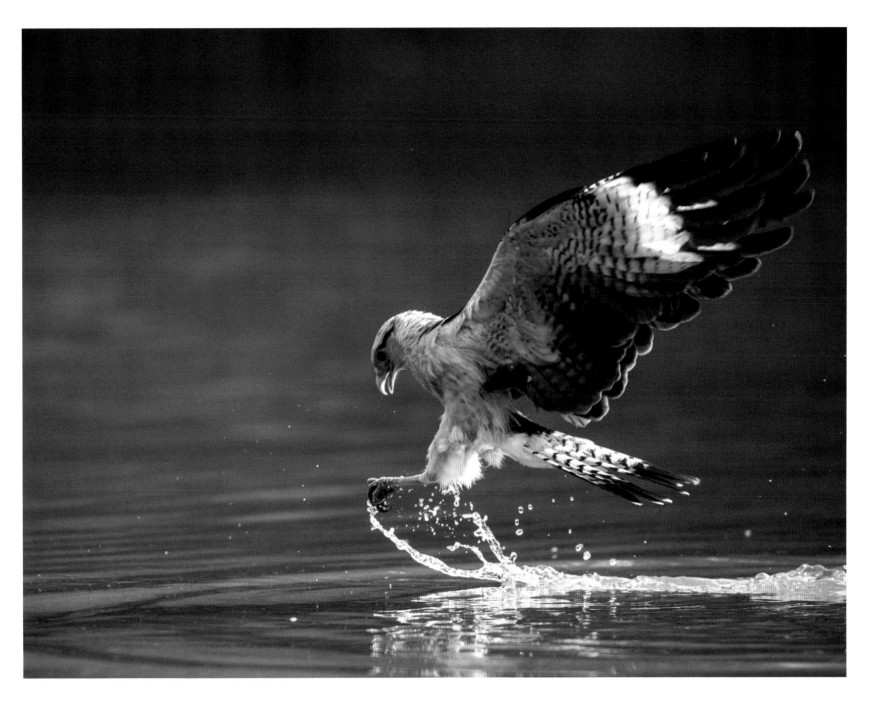

(left) Sunbittern

Pantanal

(above) Yellow-headed carcara

Pantanal

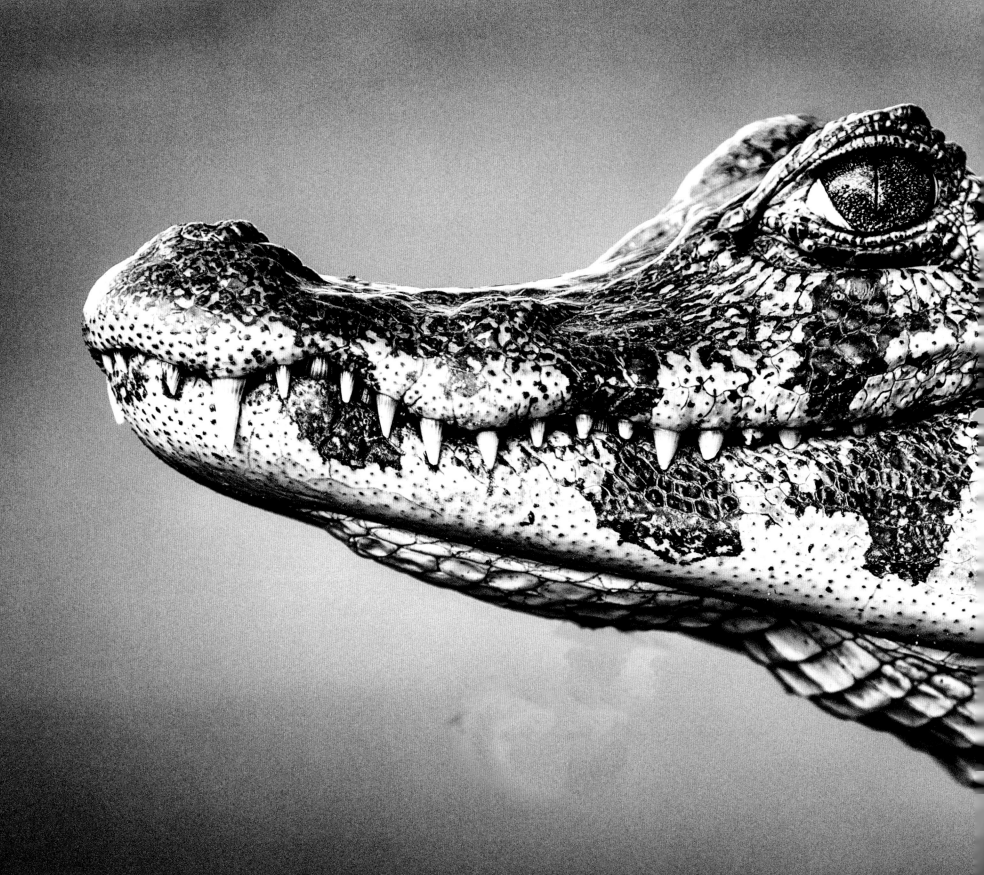

Spectacled caiman
Pantanal

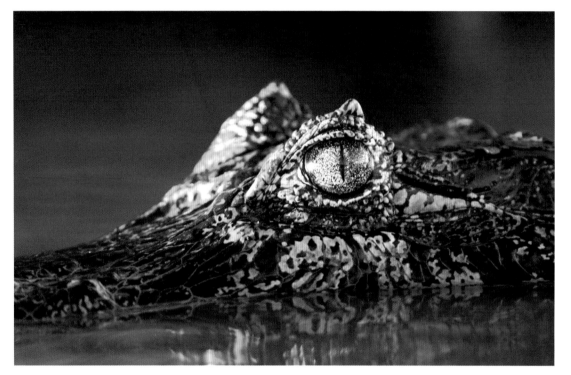

(left) Spectacled caiman at dawn
Pantanal

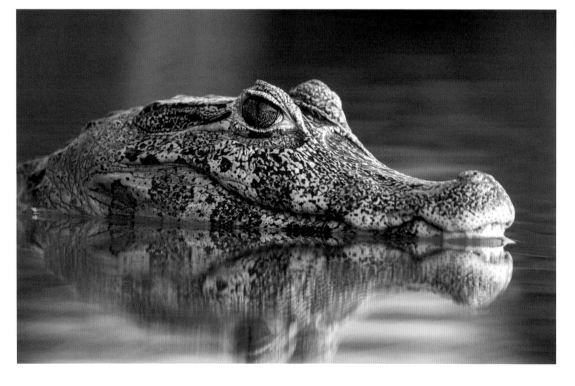

(left) Spectacled caiman
Pantanal

(right) Spectacled caiman roaring
Pantanal

Crocodilians announce their claim to territory by roaring; this sounds like three very deep barks. The actual sound, though, is transmitted through the water by resonance. They raise their head and their tail and emit the barks, and the water lying on their back forms a mist of droplets as the resonance is created by their lungs.

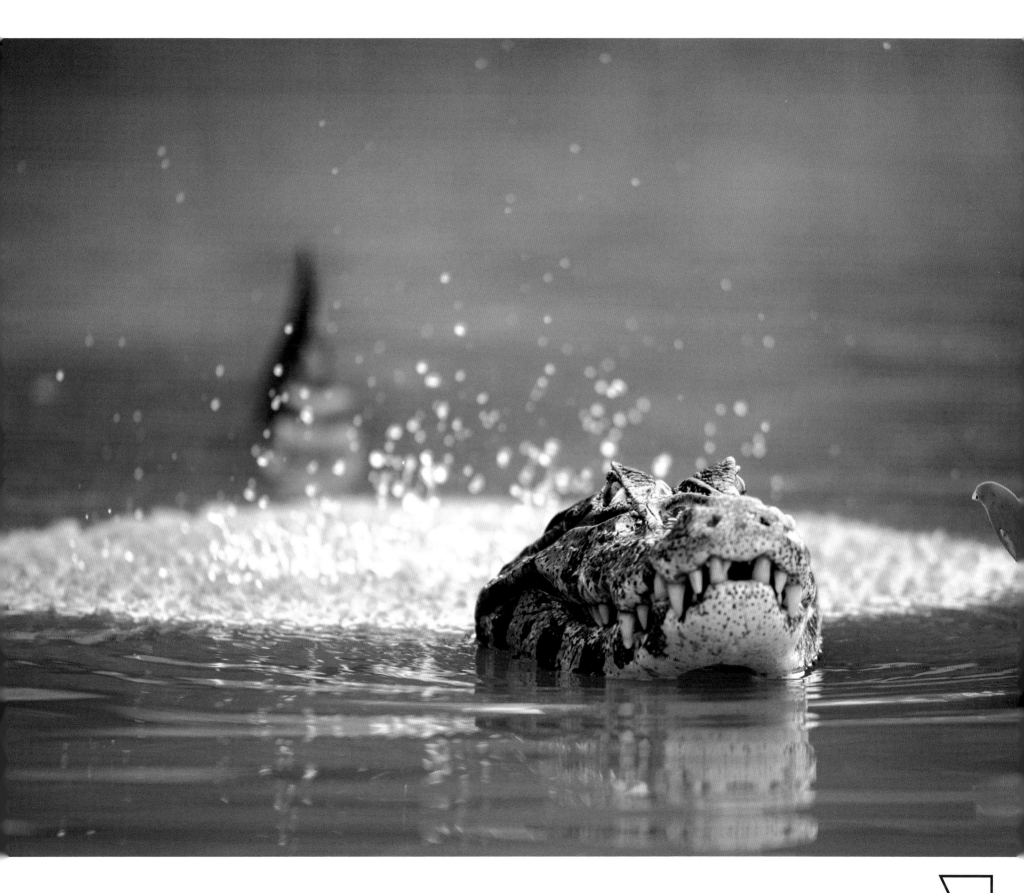

Giant anteater at sunset
Pantanal

I react quite badly to ant bites, so I am a big fan of anteaters. As their name suggests, giant anteaters are huge at over two metres long with claws of eight to ten centimetres, despite having a diet that consists entirely of termites and ants. The first time I approached an anteater in Brazil with my friend Ricardo Casarin, it was ridiculous; we didn't consider the wind or their acute hearing. We learnt well from this failure and now treat them like badgers; always trying to stay downwind of them and controlling any sounds we make. We've now been able to approach within two metres, or rather move into a position so that they sometimes just keep walking straight towards us. Occasionally, considering their size, this can be a little alarming.

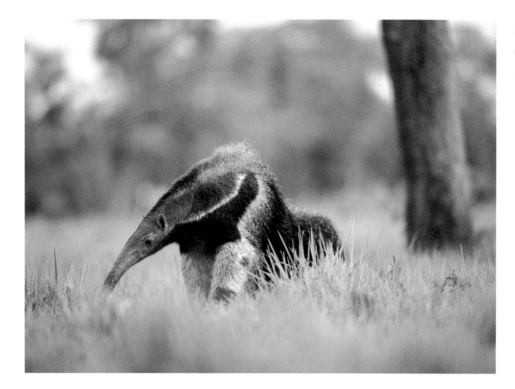

(left, above and below)
Giant anteater
Pantanal

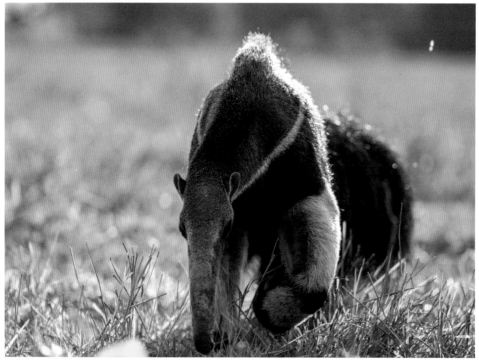

(right) Giant anteater and young
Pantanal

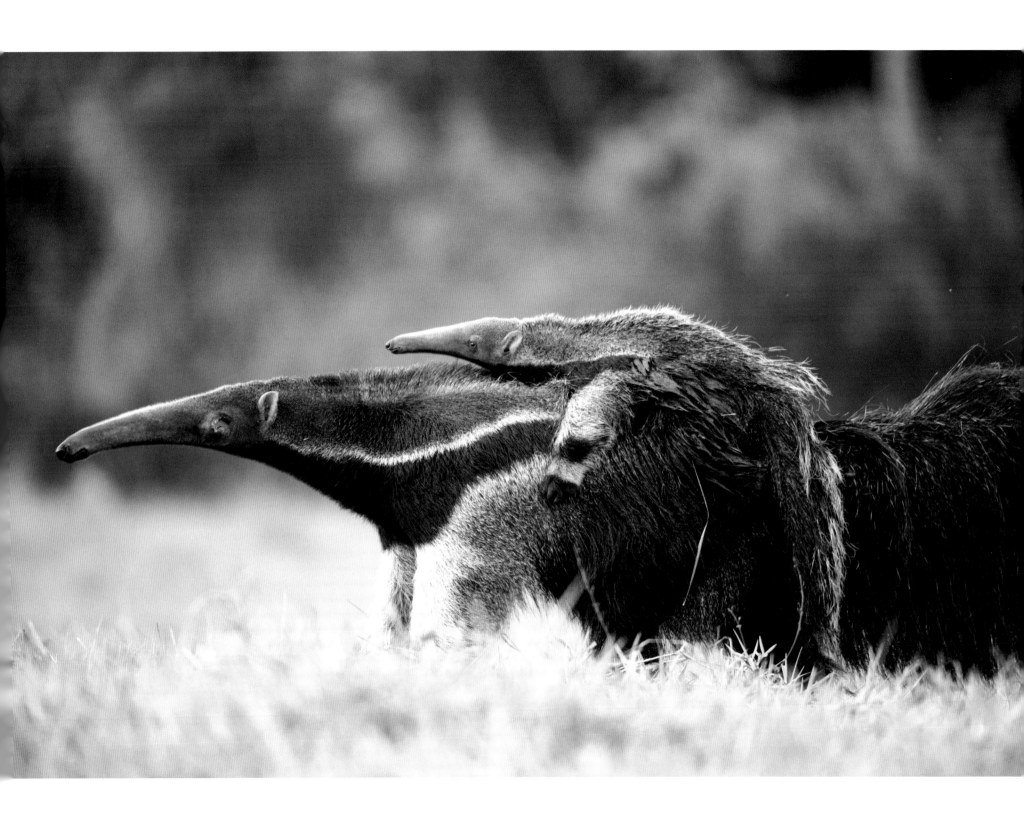

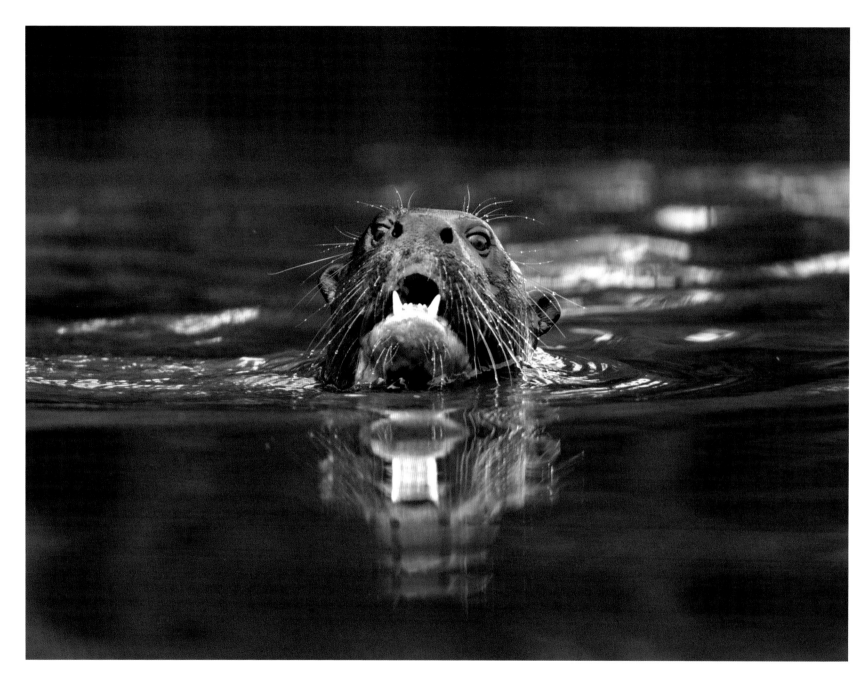

(above) Giant river otter

Pantanal

(right) Toco toucan feeding

Pantanal

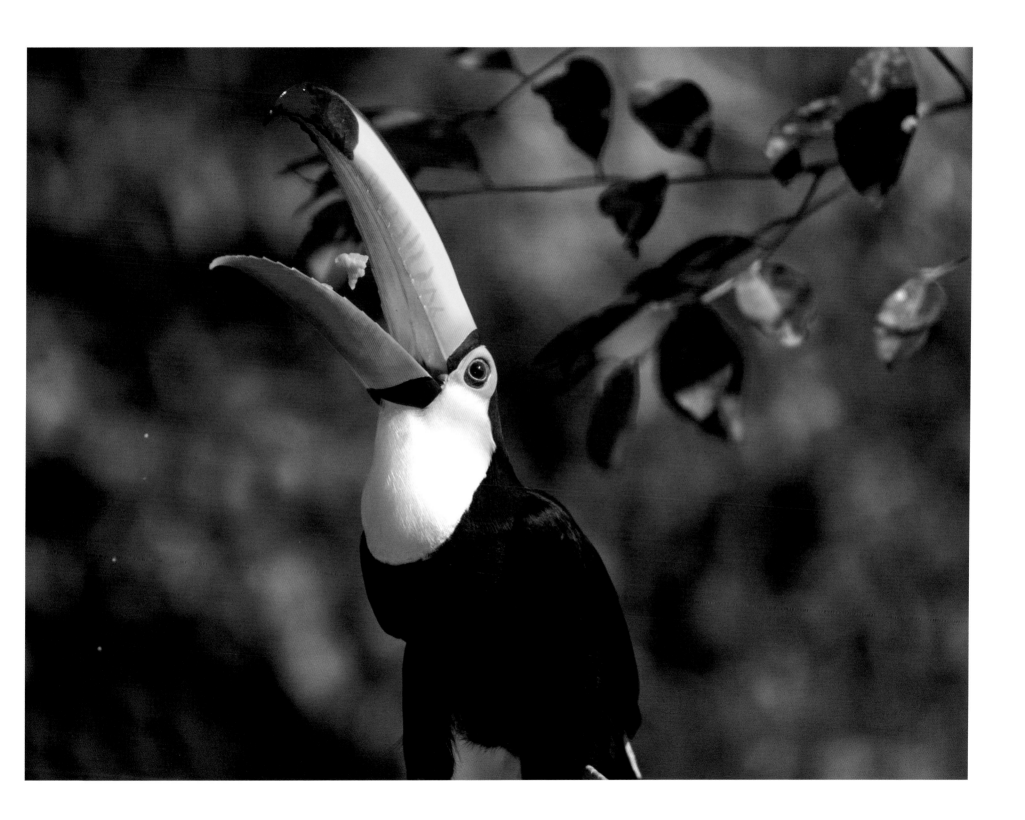

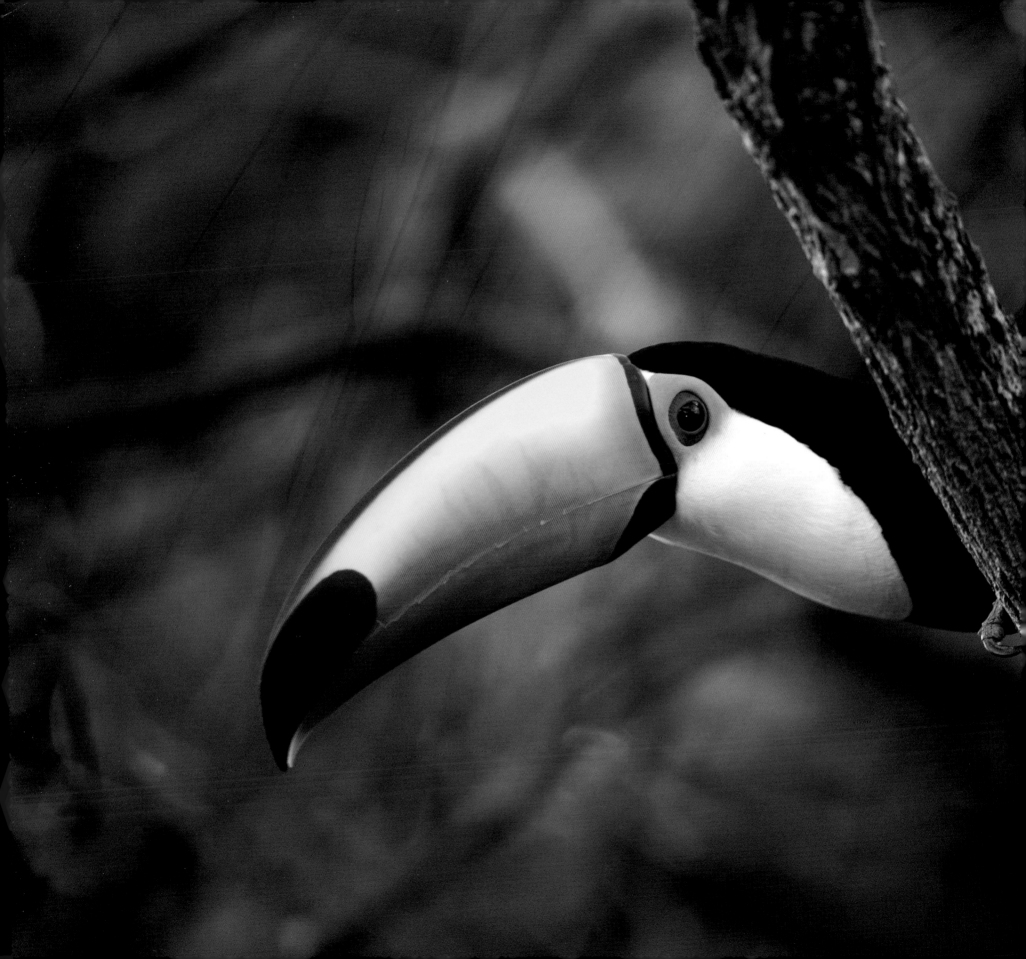

Toco toucan
Pantanal

Jaguar emerging from forest
Pantanal

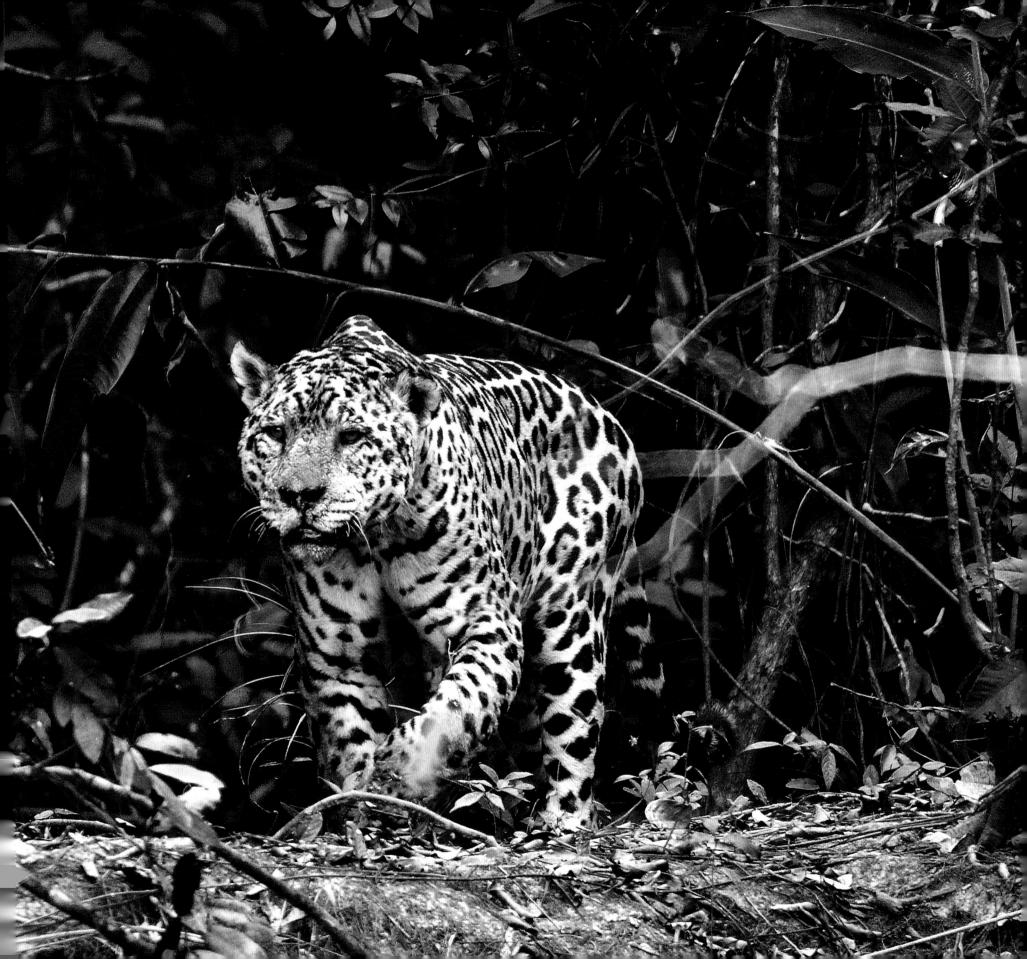

Scanning for jaguars
in the Cuiabá River
region
Pantanal

Grabbing some handheld shots
Pantanal

Stability in a small boat can be a challenge, and I like to be as low and level with my subject as possible, so I often have to scrunch down and support the camera on a beanbag.

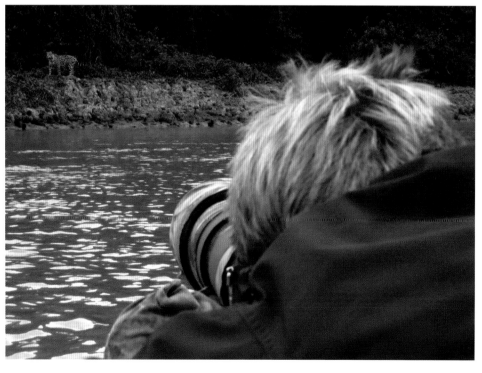

The search for jaguars can be quite relentless, always looking ahead, hoping for that dream shot of a jaguar on a sandbank in beautiful light.

Often, however, the jaguar avoids the harsh heat of the day by sleeping in deep shade, sometimes for hours. A long wait may ensue, during which the jet lag, early mornings and long days can take their toll.

Then all hell lets loose as the jaguar starts walking.

The author, working in the Pantanal region, Brazil.

7 YEARS OF CAMERA SHAKE

AFTERWORD

On 11 November 2009, after various tests, I was diagnosed with Parkinson's disease at the age of forty. A period of adjustment was inevitable, during which I entered what I now call the 'dark days'.

Most people will readily agree I'm fairly belligerent and no-nonsense about life, but I cannot lie, this diagnosis tested me. Despite my naturally pragmatic and almost nihilistic view of life on earth, I came to an intense realisation: as organisms like any other, we have absolutely no control over what happens to us or around us – it just happens. However, we do have absolute control over our reactions to these events. We have choice. I chose positivity. For me there was no middle ground; I could not afford the luxury of a negative thought about my condition. I feel that negativity is potentially accumulative and can lead to a downward spiral. I eliminated any negative thought that entered my head.

I am not going to deny that everyday life is a challenge, and it is an increasing one. Many people think that Parkinson's disease is merely a shaking of the body. While that is clearly one of the more undesirable symptoms – certainly as a photographer – Parkinson's disease also involves a whole gamut of other symptoms: extreme fatigue, stiffness, insomnia, uncontrolled movements, cramps… Some days, just functioning is hard. Modern medications relieve symptoms but they all have serious side effects, and their efficacy does not last.

However, I am fortunate enough to have a passion that forces me out of bed every day, and I pinch myself to remind me of what I do – I am lucky enough to have an incredible life. I travel all over the world, see and experience things many people only dream of. Life is good. Better than good; it's more than I ever could have hoped for.

General public perception is that Parkinson's disease is pretty much a showstopper. It's not necessarily. People with disabilities are often sidelined, even in our enlightened society, and disability can be a challenge, no doubt, but it need not be the end of the show. I hate the expression 'you can still lead a useful life'. Why thank you, I hope I can still be of use to society. No, I can still lead a phenomenal life and intend to do so for a long time. Disability is a hindrance but with the right motivation it is not the end. Passion for my work and wildlife continues to fuel me and I do not plan on stopping.

With this attitude, instead of giving up photography, which had previously been a consideration, I decided to attack it, to raise my game as maybe I had to get things done quicker. So seven years on, despite physical deterioration, I'm still going. I am still pushing my photography into new areas. I did not want this book to be a collection of images that are 'pretty good for someone with Parkinson's'; rather, I wanted it to be a collection of stand-alone images that just happen to have been taken by a photographer with Parkinson's disease. And as proof of what can be achieved, all of the images have been taken since my diagnosis. This book is not about what Parkinson's has done to me; it is about what Parkinson's has not done to me.

Fifty per cent of the profits of this book will be donated to Parkinson's UK, the UK's leading Parkinson's charity. They fund research as well as providing valuable support for Parkinson's sufferers and, importantly, their carers. With the work of Parkinson's UK we may find a cure for this pernicious disease, or at least better solutions to its symptoms.

Thank you so much for buying this book. With your valuable support in the fight against Parkinson's disease and other neurological conditions, we shall never surrender and we can always fight.

The author in the Maasai Mara, Kenya

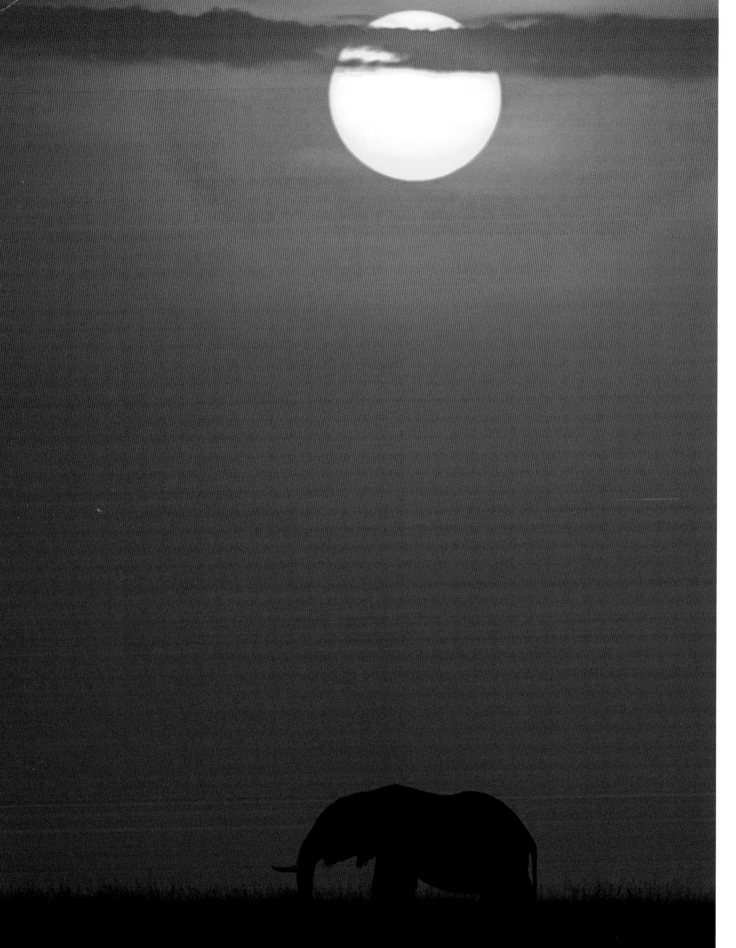

African elephant at sunset
Maasai Mara

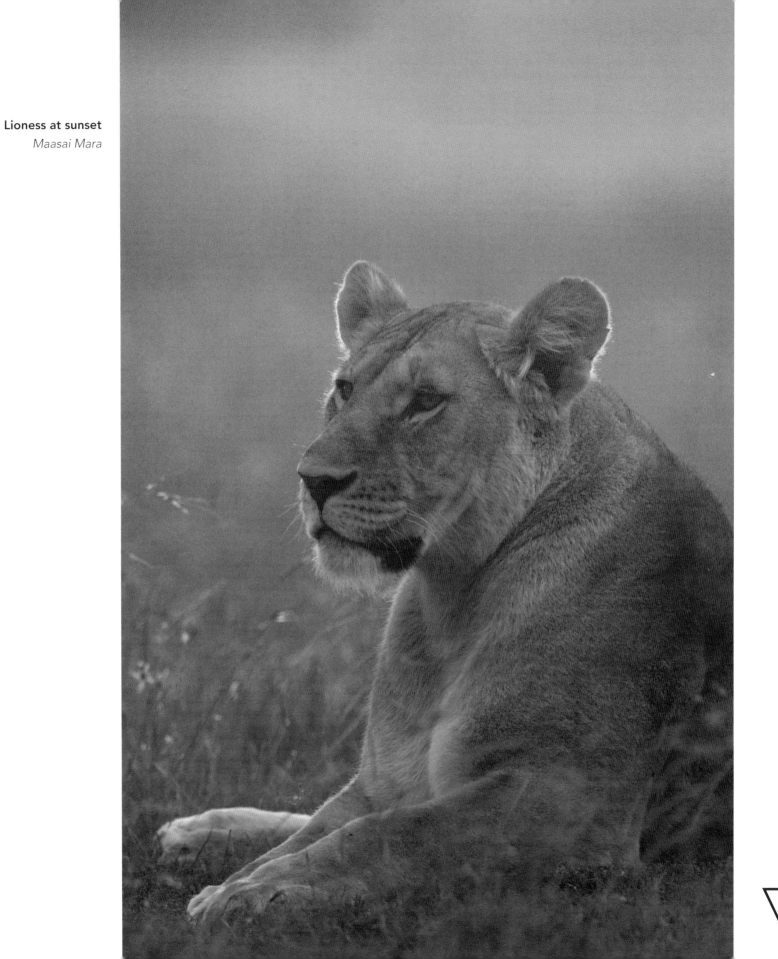

Lioness at sunset
Maasai Mara

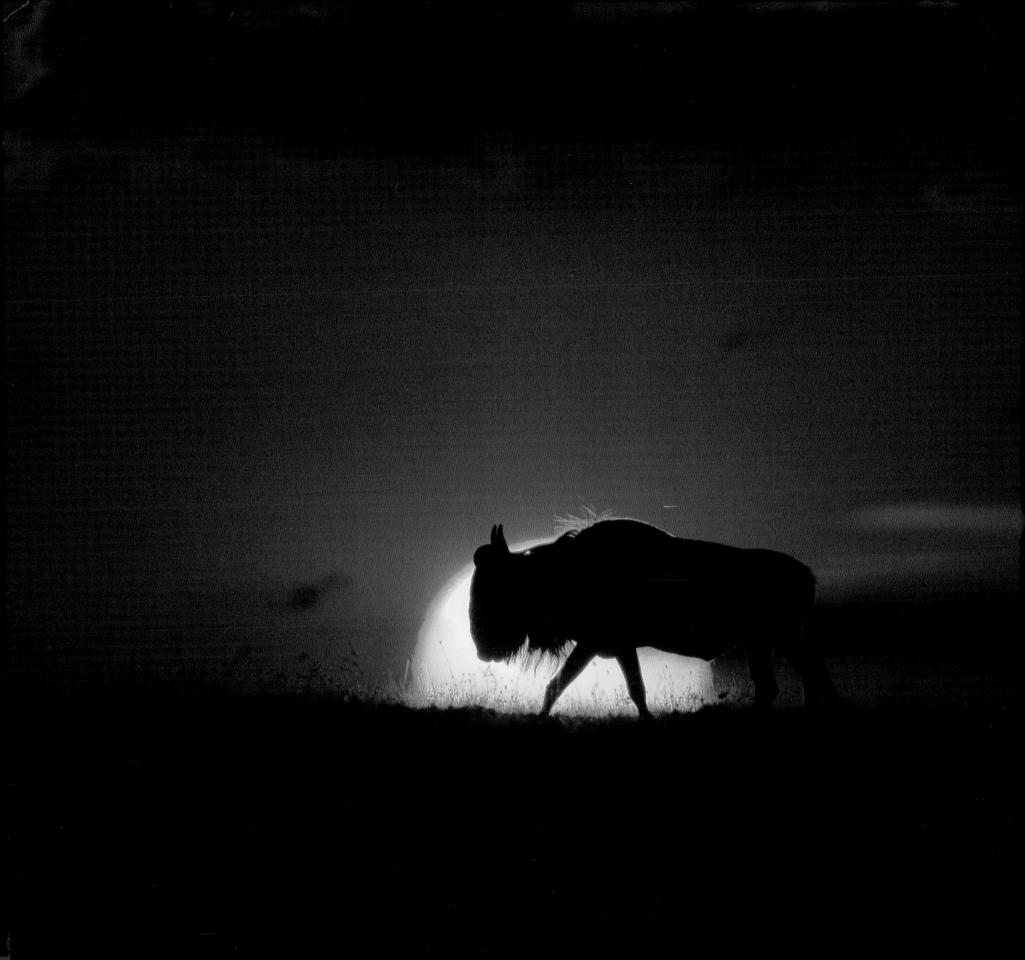

Wildebeest at sunset
Maasai Mara

ACKNOWLEDGEMENTS

Wildlife photography is essentially a solitary occupation; however, certain people and organisations have helped and assisted me, way beyond the call of duty, through the years. They have certainly become more than work colleagues; they have become friends.

First, to reiterate the dedication at the start of this book, huge thanks go to my close friends and family who have always maintained their faith and tolerance of my eccentric ways from the earliest years to the present day.

Beyond that, I must thank the Sussex Wildlife Trust, and especially Amanda Solomon, their long-standing press officer, who has tirelessly promoted my work for many years.

In Brazil, my dear friend and guide Ricardo Casarin. We have now worked together for over 11 years, operating as a team, but we have also become great friends and had many hilarious experiences. Thanks Ricardo.

In Hungary, Istvan Bartol, director of Kiskunság National Park. Istvan has been my guide but more importantly has become my friend, helping me in many ways over the years. My visits to Hungary are not only some of the most productive wildlife photography I do throughout the year but also great fun and some of the most relaxing times I have.

In Kenya, my thanks go to all the staff and managers at Kicheche Camps in the Maasai Mara. The Africa shots would just not exist without the expert help from the great guides Charles Mwangi Wandero and Joseph Sigeny as well as all the other staff that make my prolonged stays at Kicheche a pure pleasure.

A lot of the images from this book were taken while running my photographic tours. These tours, let alone the images, would never have been achieved without the loyal support of the clients, many of whom have become close friends, notably Sheila Bouton and Viv Nicholas – they have sat with me way beyond their comfort zone sometimes as I possibly selfishly wait for a particular image, which may or may not have worked.

I would also like to thank Verity Ludlow, my neighbour and close friend – she not only sews and repairs my hides and work clothes, and allows me to store gear in her garage, but also tolerates my often unsociable comings and goings.

Also thanks to all the Unbounders, staff, friends and supporters who helped crowdfund this book in record time of just over three weeks.

With this in mind, thanks and special mention to Richard Taylor-Jones, BBC cameraman, for the beautiful and sensitive film he made which drew great attention to the production of this book.

Thanks to Charlie and Issy Burrell, Jason Emrich, Penny Green and all the staff and workers at the Knepp Estate and Rewilding project, tolerating me traversing the estate, allowing me to put up rudimentary hides and occasionally leave tyre tracks where I shouldn't!

Finally, thanks for my dear friend Rachel Lowe, who truly made this book possible. I have deep respect for both your personal drive and your faith in me, and for making me do it.

SUPPORTERS

Unbound is a new kind of publishing house. Our books are funded directly by readers. This was a very popular idea during the late eighteenth and early nineteenth centuries. Now we have revived it for the internet age. It allows authors to write the books they really want to write and readers to support the books they would most like to see published.

The names listed below are of readers who have pledged their support and made this book happen. If you'd like to join them, visit www.unbound.com.

Nathan Adams
Graham Alderson
Robert Anderson
Shella Anderson
Stewart Anderson
Mark Andrews
Stephen Ansell
Paul Appleton
Louise Arscott
Michelle Arundale
Dilan Athauda
Sarah Atherton
Debra Avery
Clare Axton
Martin Balderson
Jason Ballinger
Clare Barnett
Alan Barrett
David Battensby
Teresa Beadle
Graham Beale CBE
Clare Beck
Sally Beckwith
Vivienne Beer
Sue Beere
Adam Berger
Rachel Bicker
Tony Bicker
Anne Biggerstaff
Tim Blackman
Paula Blake
Michael Blencowe

Antonio Bonacci
Peter Bond
Paul Botting
Sheila Boughton
Sophie Boulton
Angela Bowler
Mary Braddock
Sheri Bredeson
Nicola Brewerton
Dee Brewster
Vivien Briggs
Bob Brind-Surch
Liz Brinklow
Neil Bromley
Mike Brooke
Anthony Brown
David Brown
Maria Brown
Andrew Buggey
Jenifer Bunnett
Claire Burbidge
Andrea Burden
Kathryn Burrington
David Burt
Karen Bussey
Dave Butler
Leanne Byrom
John Carney
Helen Carr
James Carter
Maureen Carter
Simon Cash

Robert Cassey
Terry Caton
Rodney Chadwick
Rick Challener
Maggie Chamberlain
Louise Chambers
Philip Chambers
Paul Chapman
Paz Chauhan
Melody Cheal
Judy Clayton
Julie Cleaver
Suzanne Clough
Kenneth Coates
Richard Cobden
Deborah Colgate
Gail Collett
Edward Colyer
Lesley Colyer
David Cooke
Martyn Cooke
Chris Cosgrove
Frank Cottage
Toby Coulson
Denise Courne
Gary Cowan
Andrew Cox
Philip & Jane Craske
Pete Crawford
Alison Criado-Perez
Paul Cripps
Philip Crosby

Steve Cullinane
Richard Dannatt
Mark David
Nichola Dean
Sue Dixon
Stephanie Dougherty
William & Maria
 Douglas
Jackie Downey
John & Elizabeth
 Draisey
Susan Drake
Lyndsay Driver
Christine Duffy
Tom Dullage
George Dyne
Chris Eade
Gordon Edwards
Tricia Edwards
Keith Elcombe
Catherine Elliott
Mark Elliott
Jason Emrich
Alan English
Tania Esteban
Peter Faulkner
Mark Fellowes
John Feltwell
Nick Fenley
Jacky Field
Alex Fiennes
Susan Finlinson

Allen Firman
Gill and Sam Fletcher
Darren Flynn
Fiona Foat
Patricia E. Forbes
Stuart Forrest
Jenny Foster
Nina Fowkes
Emma Fox
Tim Fox
Paula J. Francisco
Helen Franklin
Susan Freedman
Anne Freeman
Mark Freeman
Robert Friel
J Stuart Frost
Keith Fuller and
 Deborah Hardy
Mark Gamble
Lawrie Garland
Catherine George
Denise Ghalebi
David Glover
Derek Godfrey
Colin Gordon
Andrea and Tommy
 Gorrie
Sue Gould
Simon Graham
Jan Green
Judith Green

Rosemary Green
Arthur Greenslade
Colin Gregory
Natasha Greig
Derek Grieve
Shona Groat
Michelle Guite
Phil Hacker
Deborah Haffenden
Pat Haines
Sarah Hales
Eric Halfhide
Judy Hallas
Sue Halse
Hannah Hancock
Donna Hanley
Trevor Hanson
Andrew Harman
Catherine Harper
David Harris
Matt Harris
Alex Harrison
Dot Harrison
Dave Harwood
William Hastings
Andrew Hawkins
Clive Hawkins
Andrew S Hayes
Claire Hayhurst
Deborah Hearnden
Caroline Hedger
Joanne Hedger

Alex Hobden
George Hodson
Clare Hogston
Ash Holden
Lisa Holdsworth
Julie Holmes
Helen Hood
Tom Hook
Brett Hornby
Dawn Hough
Christine Hoy-Meaker
Peter and Sally
 Hubbard
Alexis Huggins
Keith Humphrey
Rita Humphrey
Geoff Hunt
Lord Nicholas Hurrell
Mark Huxley
Lorraine Inglis
Jane Ironside
David Jackson
Victoria James
Katariina Jarvinen
Lisa Jenkins
Isabel John
Adrian Jones
Nicholas Jones
David Judge
Lorie Karnath
Joe and Lynda Kearns
Nick Kenney
Simon Keslake
Dan Kieran
Vic Kincer
Marie Knight
Nichola & Adrian
 Knight
Patricia Knight
Maike Kruse
Graham Kyte
Brian & Anne Lambert

Geoff Lamy
Ruth Lanigan
Neil Law
Philip Lawson
Jake Lea-Wilson
Ishbel Leddy
Russell Lee
Allison Leslie
Liz Lester
Vic Lewis
Kathryn Limoi
Adam Little
John Loader
Ludi Lochner
Freddie Lowe
Rachel Lowe
Ray Lowe
J R Luck
Jean Lymer
Penelope Lynch
Peter and Sue
 MacCallum-Stewart
Irene Maclennan
Gordon Macleod
Tom Maguire
Chris Mahalski & Paul
 Laffey
Eva March
Mark and Kate
Paul, Dri, Caio & Davi
 Markwick
Debs Marriage
Geoff Martin
Debbie Maslen
Philippa May
Iain McCallum
John McCormack
Maria McGrath
Mike McGratten
Barry McKeever
Kate Mcphee
Fiona Meads
Sally Meads
Gregg Mearing
Andrew Merifield
Janice Milton
John Mitchinson
Jomo Mitchismus

Richard Montagu
Jason Moore
Jim Morgan
Anita Morris
Tim Morris
Gillian and William
 Morton
Kurt Mueller
Jan Murphy
David Murray
Anne Nagle
Christine Nauwelaerts
Carlo Navato
Gary Neville
Angela Newbery
Vivian Nicholas
Carole Nicholson
Jez Nicholson
Gary Nicol
Sallie-Ann Nicol
Marian Norrie-Walker
John O'Reilly
Karen O'Reilly
Anthony & Deborah
 Ockerman
Christopher Orgill
Ali Packham
Alison Paget
Richard Pantlin
Lev Parikian
Penny Park
Ian Parker
Simon Parker
Ivan Parnell
Sarah & David Parr
Ellis Parsonage
Geoff Patterson
Sylvia Pavey
Louise Pemberton
Geoff Pennock
Christine Phillips
Michael Phillips
Matthew Phippen
Julian and Kim Piercey
Anne Platt
John Plumb
Iris Plummer
Ron Plummer

Richard Polhill
Justin Pollard
James Poots
David Pottinger
Laura Pottinger
Gemma Pratt
Claire Prettejohn
Jess Price
Mike Prime
Rose Pule
Judith Pullman
Gillian Quick
Rina Quinlan
Susan Quinn
Richard Raworth
Geraldine Rea
Ellie Willow Reid
Carol Richardson
Karen & Andy
 Richardson
Jean Roberts
Leanne Roberts
Tim Roberts
Joan Robertson
Glynn Roche
Sarah Rohan
Annah Ross
Alan Ross-Fry
Linda Rothwell
Gail & Nick Rundle
Stephen Russell
Lloyde Sargent
Petra Savage
Lisa Saw
Graham Saxby
Lisa Scott
Sarah Seaholme
Paul Sellwood
David Sentinella
Laurence Shapiro
Colin Sheppard
Hels Sheridan
Roger Shone
Alix Shore
Sue Simpson
Elizabeth Sinclair
Julie Singleton
Starla Sireno

Jacqueline Berit Notoy
 Smith
Karen Elizabeth Smith
Nigel Smith
Robert Smith
Paul Sopp
Lizzie Sparkes
Andrew Splawski
Ruth Spokes
Aysha St Giles
Elle Stark
Florin Stavarache
Chris Stenton
Fiona Steven
Sally Stevens
Helen Stewart
Francis Stickings
David Stogel
Tom Streeter
Mark Struckett
Ann Stuart
John Stuart
Joanna Sturges
Karnika Sturgess
John Sumner
Isobel Sutton
Mark Swan
Tracy Swinfield
Alexandra Taylor
Madeleine and Amelie
 Taylor
Rachel Taylor
Robin Taylor
Richard Taylor-Jones
Barbara Temple
Mike Temple
Gill Terry
Derek Tetley
Dan Thompson
Rosemary & Malcolm
 Tomlin
Simon Tomlin
David Torr
Isabella Tree
Richard Tustian
John Tyson
Tony Utting
JC Wakeham

Roger Waldram
Brian Wall
Peter John Walton
Sarah Watson
Madeleine Wayt
Jim Webster
Jean Weddell
Glenn Welch
MImi Welch
Keith Welsher
Mick West
Brenda Weston
Bethany Wheatley
J. Jane Wheatley
Barbara and Dave
 Whetlor
Kate White
Nick White
Andrew Whitmarsh
Joanne Whittaker
Sarah Whittle
Jude Wilkins
Nikki Wilkins
Rob Wilkinson
Alison Williams
Martin Williams
Richard and Hilary
 Williamson
Lindsay Willmott
Steve Wilmot
Ian Wilson
Michael Wilson
Richard Wiseman
Louise Woodhouse
Val Woodhouse
Christopher Woodroofe
Caroline Woods
Mike Wright
Peter Yarrow
Anne Yates
Anthony Yates
Giles York
YT
Janette and Jim Yule